778.99791
KOP

WITHDRAWN

- 9 JUN 2022

Photography and the Performing Arts

THE UNIVERSITY COLLEGE OF RIPON AND YORK ST. JOHN
RIPON CAMPUS

Please return this book by the date stamped below
- if recalled, the loan is reduced to 10 days

17 DEC 1998

CANCELLED

99

RETURNED
2 6 MAY 2008

RETURNED

12 DEC 2008

D0541092

Photography and the Performing Arts

Gerry Kopelow

Anola, Manitoba, Canada

LIBRARY, UNIVERSITY COLLEGE
OF RIPON & YORK ST. JOHN
RIPON HG4 2QX

Focal Press
Boston • London

Focal Press is an imprint of Butterworth–Heinemann.

Copyright © 1994 by Butterworth–Heinemann.

ℛ A member of the Reed Elsevier group.

All rights reserved.

No part of this publication may be reproduced, stored in a retrieval system, or trans-mitted, in any form or by any means, electronic, mechanical, photocopying, recording, or otherwise, without the prior written permission of the publisher.

⊗ Recognizing the importance of preserving what has been written, it is the policy of Butterworth–Heinemann to have the books it publishes printed on acid-free paper, and we exert our best efforts to that end.

FRONT COVER PHOTOGRAPH: This untouched photo was made for a Canadian Airlines na-tional advertising campaign called *The Art of Flying*. During the promotion the airline gave $5 from every ticket to a performing arts institution. The miniature room (with exag-gerated perspective built in) was fabricated by the props-maker at the Manitoba Theater Center. The violin is a 1/16 scale instrument used by very young students. All the artifacts were suspended by carefully positioned 1/16" metal rods extending from the back wall of the room. The floating ribbons were actually two ribbons sewed together over thin strips of sheet metal. The designer was Dorothy MacMillan, McKim Advertising Ltd. [Toyo G 4" × 5" view camera, 150mm lens, Kodak VPS film.]

BACK COVER PHOTOGRAPH: Principal cellist of the Winnipeg Symphony Orchestra, Bryan Epperson. This shot was posed during a break in dress rehearsal. [Hasselblad, 40mm lens. Kodak VPL film, available light and 1 sec. exposure. Kodak Panalure paper.]

COVER CONCEPT: Leo Kopelow

PHOTOGRAPHS: Gerry Kopelow, unless otherwise indicated.

Library of Congress Cataloging-in-Publication Data

Kopelow, Gerry.
 Photography and the performing arts / Gerry Kopelow.
 p. cm.
 Includes index
 ISBN 0-240-80168-7 (acid-free paper)
 l. Stage photography. I. Title.
TR817.K67 1994
778.9'9791--dc20 93-48177
 CIP

British Library Cataloguing-in Publication Data

A catalogue record for this book is available from the British Library.

Butterworth–Heinemann
313 Washington Street
Newton, MA 02158

10 9 8 7 6 5 4 3 2 1

Printed in the United States of America

To my wife Lorna, who tended the home fires all those long, late rehearsal nights. And to all the performers, designers, and crafts people who work so very hard both in front of and behind the curtain.

Contents

6 Formal Photo Call and Studio Techniques 81

7 People Skills for Performing Arts Work 99

8 Photographic Needs of Individuals 115

9 Variations of Performing Arts Photography 131

10 Marketing Performing Arts Photography 151

Interviews 163

Index 189

Acknowledgments

I want to thank Pat Armstrong, Pat Elsworth, Barbara Mills, and George Einarson—as communications/public relations directors, they helped immeasurably to make my work in the performing arts a real pleasure. Special thanks to Steven Rosenberg, master of the performing arts poster, and still my favorite client after all these years. I am grateful to Walter Kaiser, Peter Synchychyn, and the gang at Custom Images, whose support and technical backup helped immeasurably in the preparation of this book.

Technical Notes

Unless otherwise noted, all photographs were made on Kodak film (Tri-X, High Speed Ektachrome, Ektapress 400 and 1600) and Kodak photographic paper, hand processed by me and by Dwain Payment.

My early work was shot with Leica rangefinder cameras, which were later superseded by Nikon F3HP single lens reflex cameras for 35mm, and by Hasselblad equipment for medium-format studio work. I am now using Minolta 9xi autofocus cameras and lenses for my available light photography, and—in combination with Kodak Ektar 25 high-resolution color negative film—for studio portraiture.

Introduction

How I Got This Way

When I first considered producing this book, the fact that I never worked in L.A. or New York caused me to hesitate. How could a photographer who has not shot Broadway or Hollywood put himself forward as an expert in the specialized field of performing arts photography? Finally I decided I had something to offer, not because I regularly photograph celebrities and big box office shows, but because I am an accomplished generalist with twenty-five years' experience serving a variety of performing arts institutions, big and small.

I live in a geographically isolated prairie city with a population of 600,000 and a disproportionately active cultural life. Propelled by waves of ambitious and energetic immigrants from eastern and western Europe, Winnipeg was soon home to two accredited universities and dozens of professional and amateur organizations dedicated to music, dance, theater, and film production. Here is a partial list:

Winnipeg Symphony Orchestra

Manitoba Theater Center

Royal Winnipeg Ballet

Winnipeg Folk Festival

Winnipeg Fringe Festival

Winnipeg Mime Festival

Winnipeg Film Group

Winnipeg Jewish Theater

Prairie Theater Exchange

Winnipeg Contemporary Dancers

Chai Folk Ensemble

Manitoba Opera Association

Canadian Broadcasting Corporation

National Film Board of Canada

My involvement with some of these groups extends back many years. For example, the very first professional assignment I ever had was to photograph the famous Russian violinist David Oistrach when he played with the Winnipeg Symphony in 1966—I was sixteen years old at the time. The Manitoba Theater Center—a large regional theater with a multimillion-dollar budget—has been a client for over twenty years. I've shot regional and network productions for the Canadian Broadcasting Corporation, acoustic musicians at the Winnipeg Folk Festival, album covers for rock 'n' rollers and children's performers, as well as award-winning posters for the Manitoba Theater Center. My photos have appeared on the covers of published plays and novels as well as side by side with reviews and articles on the performing arts in regional and national newspapers and magazines. In the late sixties, I received a grant from the Canada Council for the Arts to photograph music festivals across the country. I believe that my own experience is proof of the potential for professional and financial rewards, even in modest-sized urban centers.

Overview

Performing arts photography involves the photographic celebration and documentation of all the performing arts—the work encompasses the traditional disciplines of theater, dance, opera, and acoustic music, as well as recent manifestations like radio, television, film, and electric music. The specialty attracts photographers of all levels of skill and experience, from rank amateurs who want a snapshot of a favorite production all the way up to highly skilled professionals who earn six-figure incomes by catering to the performers and promoters of Hollywood or Broadway.

This book is intended for those who want to produce—or make the best use of—excellent performing arts photography. It includes a comprehensive review of film and equipment as well as detailed advice about techniques specific to each of the many performing arts disciplines.

Since much of the very best photography is done for pay, I have included business and marketing advice of interest to aspiring and established commercial photographers and arts marketers, promoters, and fund raisers. In addition, through interviews with arts administrators, film producers, magazine and newspaper editors, designers for the stage, and graphic artists, you will learn about the opinions and experiences of some of those who buy or use performing arts photography professionally.

Who Can Photograph the Performing Arts?

Whether working for love or for money, photographers specializing in performing arts work must be familiar with the technical limitations of the various venues, they must understand their position within several types of administrative structures, and above all, they must be patient, considerate, and inconspicuous when shooting.

Amateur productions can often benefit from the services of inexperienced photographers, but professional productions usually can't. There will always be exceptions, but generally the sophistication of the show determines the acceptable level of sophistication of the show's photographer. This condition flows from the simple fact that performing arts photography assumes a more significant role as budgets increase: When lots of money is involved, expectations are very high, and excellent photographs must be produced quickly, without disturbing the production schedule or the concentration of the performers. This does not mean that amateur photographers can never shoot professional performing arts events, but it does mean that only those photographers who can demonstrate technical competence combined with a tactful working style should try.

The Potential of Performing Arts Photography

Powerful photography promotes and sustains a wide range of desirable cultural activity within our society. Photographers are inevitably intellectually enriched and emotionally inspired through intimate working contact with the artistic community. On a commercial level, highly motivated amateurs can earn as they learn, while aspiring professionals who consistently demonstrate the necessary skills can look forward to substantial incomes.

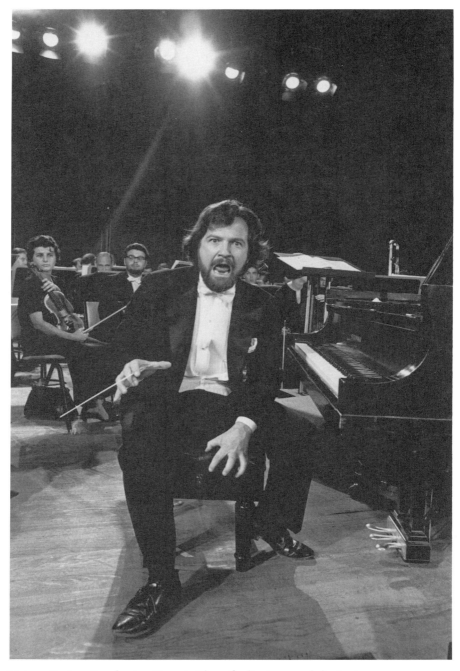

Figure I - 1. Conductor George Cleve fooling around during a
dress rehearsal of the Winnipeg Symphony Orchestra. This uncon-
ventional image was actually used in the symphony program.
[Leica camera, 35mm lens, Kodak Tri-X film.]

Current Practice

In the early days of photography, those interested in documenting performing arts events and personalities were severely limited by the available technology—cameras were frustratingly slow to operate, films were painfully insensitive, and both photographic and stage lighting was primitive, even dangerous. Happily, much progress has been made in the last hundred years: Photographers working today are blessed with truly incredible tools and materials; in fact, there are so many tools that simply choosing what to use for specific applications is becoming a very real problem.

To narrow things down, it is necessary to remember that except for those rare events staged outdoors during the day, all performing arts productions take place under artificial light. This means that light levels are generally low by photographic standards, so achieving high-quality results demands careful attention to the selection, exposure, and processing of high-sensitivity films. As recently as 1980, there were only a handful of emulsions to choose from, but today there are many designed specifically for available light shooting under dim conditions. The abundance of new color films is particularly gratifying.

Happily, cameras and lenses have progressed at the same rate as advances in film technology. The first miniature-format camera for still photography was introduced in 1930 by Ernst Lietz, a German cinematographer who was seeking an economical way to test short strips of 35mm movie film. Immediately hailed as a technical breakthrough among the photojournalists of the period, 35mm format equipment quickly altered the working methods of stage photographers as well. Light-weight cameras and fast lenses permitted previously tripod-bound photographers to capture the spontaneity of live performances, provided the available light was extremely bright. Nowadays, virtually anything that is sufficiently illuminated to be seen by the human eye can be recorded with a hand held 35mm camera.

It is necessary to recognize, however, that even today the ultimate limit of miniature-format photography is determined by the relatively small size of the image. The 35mm frame is still the same 24 × 36mm rectangle specified by Ernst Lietz. To put this in perspective, consider that the 4" × 5" format technical camera—popular for high-quality commercial product and architectural photography—benefits from an image area twelve times greater. Since all photographic images are initially formed from discrete particles (or *grains*) of light-sensitive silver bromide, larger image size means more particles and consequently

more detailed photographs. This limiting relationship between film size and image quality is further aggravated by the fact that larger grains are more sensitive to light.

Technically speaking, the dilemma and the challenge for performing arts photographers is to acquire a technique that maximizes the potential of contemporary small-format equipment in low light situations: This is the task to which a substantial segment of this book is dedicated.

Photographic Diplomacy

The performing arts have always attracted dedicated, highly motivated perfectionists. Only a fortunate few rise to a level where money and public recognition adequately compensate for the long hours and painstaking attention to detail: For all the rest, whatever joy they find in the creative process must be the main reward. Unfortunately, the very nature of the enterprise encourages already strong-minded individuals to view an outsider as a distracting nuisance. The intimacy developed over an intense period of preparation molds a performing arts company into a tightly knit family—since a work is inevitably photographed at the very end of the rehearsal process, a photographer is often considered an intruder.

Decent photography requires, at the very least, a polite cordiality between subject and photographer—great photography requires nothing less than respect and mutual appreciation.

Establishing and maintaining a working rapport in a highly charged show biz environment involves the political dexterity of a diplomat and the patience of a saint, so this book also explores the nonphotographic tools necessary for successful photography of the performing arts.

How This Book Is Organized

The many skills and techniques required to produce excellent photography are interrelated and interlocking. I believe, however, that if they are examined one at a time in a formal, rigorous manner, much of the pleasure and excitement of the photographic process is lost. Therefore, throughout the text I will take a gradual, layered approach. Facts and concepts necessary for a preliminary appreciation of particular aspects of the discipline are introduced wherever necessary, and then revisited in more depth—sometimes two or three times—later on, as

an awareness of their implications grows. The idea is to build a technical foundation, followed by a highly practical tool kit, followed by a comprehensive creative Gestalt.

Please note: Sometimes the words *theater* or *stage* will be used in the text to denote the entire spectrum of performing arts production, including opera, musical theater, live music productions, and the like.

1 Overview of the Performing Arts

Anyone who is interested in the performing arts will have a general idea of what distinguishes one type of production from another. However, before launching into a detailed technical discussion from a photographic point of view, it is worthwhile to take a quick look at how each of the main performing art disciplines is structured. Since amateur productions are typically less sophisticated than professional productions, I will concentrate on the professionals first. The special characteristics of outdoor events will be examined separately as well.

Theater

There may be one actor or dozens, but theater always happens with real people looking on: A script is created by a playwright, interpreted by performers under the guidance of a director, and then offered up for the entertainment and illumination of a live audience.

Any theatrical performance is carefully contrived—the written material is brought to life through the imaginations of a number of gifted individuals. Whoever wrote the script will have certain general intentions and expectations, but in the hands of the artistic director, the intellectual vision of the author starts to take on material form. A fundamental characteristic—the way the words are spoken—is determined through a cooperative effort between the actor and the director. Photographers, however, are concerned more with how things look than with how things sound.

The process of staging a production begins when a play is selected for presentation by an artistic director—the person responsible for the philosophy or vision of a particular theater company. The artistic director may choose to be the director of the selected play or else hire someone else to do the job. The director chooses the actors and all the other necessary specialists. Living authors of contemporary works may or may not be invited to become involved.

Through a series of preliminary phone calls months before opening night, the director will consult with set, costume, and lighting designers—these may be people the director has worked with previously or people with reputations that suggest that there is potential for a fruitful collaboration. Sometimes conversation will uncover differences in personality or interpretation that rule out certain individuals working together, but once a creative team has been assembled, the real work begins.

At first the individual designers, who may be located in different cities or countries, work separately. Sketches or detailed drawings may be exchanged by fax or courier. The real-life possibilities of any consultations occur with both the theater manager—the person who has overall fiscal responsibility—and the technical producer—the person who is responsible for overseeing all the mechanical aspects of the production. Prop and costume makers, electricians, carpenters, and stagehands are asked for input and suggestions as the concepts brought forward by the designers become more specific.

While all this is going on, the director is searching for the perfect performers. Photographs, written résumés, and video tapes are reviewed, and a list of potential actors is compiled. Phone calls to agents and managers determine who might be interested in the project and who is available. The final selection is made after a series of live auditions.

Six to four weeks before the first performance, all the actors and all the technical people are brought together at the theater. The rehearsal process begins, as does the construction of the sets, the gathering and fabrication of props, and the creation and fitting of costumes and wigs. Whenever elements of the sets, costumes, and props become available, they are incorporated into the ongoing rehearsal process. The physical appearance of the production becomes apparent as the interaction between the actors and the set—the *blocking*—is mapped out. Every movement is analyzed and every gesture is discussed. Absolutely nothing is left to chance or serendipity.

Since thriving theaters present a series of productions during a season, the stage is usually occupied with ongoing performances while

the next show is being prepared in a separate rehearsal hall. This means that rehearsals move to the stage just a short time before opening night. If the production is running on schedule, most of the interpretive work will have been done by this point, so the focus shifts to fine tuning sets, lighting, sound effects, and music—this involves several stop/start technical run-throughs, or *tech-runs*. Typically, only two or three full-scale dress rehearsals are possible, and these occur in the last couple of days. During this period, responsibility for the production is gradually transferred from the director to the stage manger and crew, who will collectively insure that the performances that audiences pay to attend go smoothly.

There are so many variables involved in mounting a stage play that tensions naturally run high toward the end of the process. The situation can get out of hand if creative or technical problems take longer to resolve than expected. Frustration can lead to short tempers and rudeness.

Unfortunately, even blameless outsiders are sometimes the lightning rod for various degrees of abuse. In the vast majority of situations, a photographer is called in during the critical time around final dress rehearsals—precisely the point when any difficulties become most obvious.

Ballet and Opera

The process of consultation, preplanning, and rehearsal for live theater is pretty much standard procedure for ballet and opera production as well. In addition, the complications of choreography and singing call for separate music, dance, and artistic directors. Each of these people needs specialized technical support and extra rehearsal time for voice and/or movement work with the cast. More performers and understudies are required due to the increased sensitivity to illness and the potential for injury. All these extra bodies, plus the fact that well-established companies often run schools for aspiring singers and dancers, make a large administrative staff inevitable. Each administrator, director, and technical person occupies political space, so interaction with a photographer is more complicated.

On a strictly technical level, three photographically important factors overshadow diplomatic considerations. First, both dance and opera require an orchestra. The musicians and the conductor are positioned in the *pit*—a sizable area located directly in front of and below the stage. The pit, therefore, is a barrier that compels a photographer to work significantly farther away from the action than in

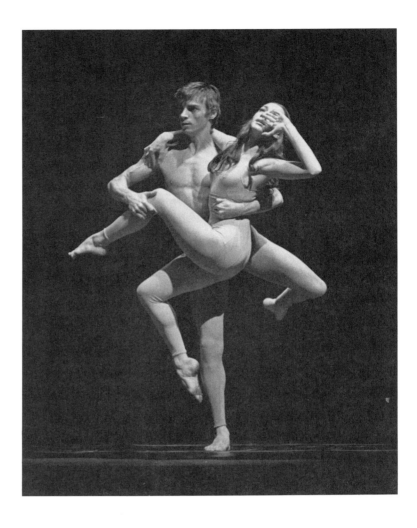

Figure 1 - 1. Two dancers from the Royal Winnipeg Ballet shot during a dress rehersal. [Leica camera, 90mm lens, Kodak Tri-X film, f4 at 1/15 sec.]

conventional theater, and this in turn requires a markedly different photographic technique. Second, the physical movement involved in ballet and opera is usually much faster and much larger in scale than ordinary drama—this also makes photography more difficult, particularly in the low light favored by many lighting designers working in these disciplines. Third, the various musical theater styles use sound to create mood. The performers in these venues tend to be singers and dancers first and actors second, so photographically appealing configurations of posture, gesture, and facial expression are consequently less abundant than in non-musical theater.

It is interesting to note that some of the restrictions listed above apply to drama from time to time. Think of an exciting, highly choreo-

graphed Shakespearean sword fight, for example. Special effects involving explosives or strange lighting are universal, as well.

Contemporary Dance and Musical Theater

Modern dance is typically produced on a much smaller scale than classical ballet. Live orchestral accompaniment is rare, so the horrors of the pit are not usually an issue. A small group of musicians or a solo player might be positioned to one side of the stage or in the wings, although well-reproduced recorded music is most common. Experimental groups are accommodating to photographers, and more tolerant. When movement and gesture are not rigidly prescribed by tradition, there is more artistic latitude when photographs are evaluated. Rehearsals dedicated to photography are easier to schedule because costumes and sets are simpler and because fewer performers and technical people are involved.

Some musical theater (productions of Gilbert and Sullivan, for example) can be as complex and sophisticated as the opera, with all the attendant photographic restrictions and limitations. Many musicals, however, are really conventional theater animated with occasional tunes or short interludes of dance.

Live Music

Productions concerned only with music force the performer/actor disparity to an extreme. Since the focus of artistic concentration is sound—which is virtually unphotographable—any visual accouterments, however haphazard they might be, assume an exaggerated significance. Generally, concessions to appearance depend more on budget than on musical format. Even so, it is safe to say that shows aimed at rock 'n' roll or country music fans tend to be much more visually interesting, or at least less subtle in visual style, than classical or traditional folk performances.

From a photographic point of view, a noticeable difference between the staging of live musical events and that of other theatrical performances is the general absence of full-scale dress rehearsals. In many musical genres, clothing is dictated by tradition or fashion, so costume is not a big factor in putting performers into the correct frame of mind for performing. Photographs must be made during performances whenever rehearsals in costume are omitted, but shooting

around an audience means restricted points of view and fanatically enforced limits on camera noise. Furthermore, unlike actors or dancers who make a living through their looks, musicians as a group are not primarily interested in appearances—photographs are required and usually commissioned by managers or promoters, who are often regarded as necessary evils by their clients. Pop, rock, and folk musicians tend to be more cooperative with photographers than classical musicians, although stars and superstars in any musical category can be very fussy and unpredictable.

Television and Film

Using electronic or photo-mechanical technology to record theatrical performances for later rebroadcast or distribution physically disconnects the performers and their audience. This means that rehearsals and performances intended for tape or film need not be linear, uninterrupted events: Scenes and parts of scenes are often recorded as disjointed, nonchronological snippets that are later assembled into a complete work by a process of editing that takes place long after all the principals have gone home.

The typical production pattern for both film and video involves very short rehearsals followed by equally short *takes*. The mechanics of movie work are such that lighting and camera setup dictate the pace as the production crew and actors move from location to location around a city or country or simply from place to place within a room or studio. Because of the disjointed time line, emotional and logical continuity are difficult to maintain. Add to this the fact that the production of a major motion picture costs literally thousands of dollars per minute, and it becomes easy to understand how tensions can run high.

On set, still photographers must navigate the formidable obstacles created by such filmmaking paraphernalia as lights, cameras, sound equipment, and the many technical support people who attend them. Photographers must have an understanding of the significance of each scene to the larger story. Like the actors themselves, photographers must be ready to leap into very intense action for very short periods and then just as quickly fade away into the background.

Some film and video production involves the straightforward recording of theater or dance or live music on stage or in a studio. In such instances, dress rehearsals are similar to those for conventional productions, and still photography is only moderately complicated by the presence of the extra technicians and technology.

Outdoor Performances

There are two basic types of outdoor performances—I will call them formal and informal. Formal outdoor theater (or dance or live music) is regular theater without a roof—that is to say, all elements of set, lighting, costume, and the like are preserved on a specially created outdoor stage or by the use of a permanent structure built for that specific purpose. Such undertakings are functionally similar to indoor theater, with the technical bonus (as far as still photographers are concerned) of the much higher lighting levels required to compete with daylight in the early evening hours.

Informal outdoor productions are less sophisticated events, usually intended to promote community involvement or appreciation of the arts or to raise money for charity. Barriers between performers and the audience are minimal, and technical accouterments are generally quite spare. For the still photographer, this means opportunities for unusual camera angles and a higher level of interaction with the performers and technical people.

Amateur Productions

Amateur productions run the gamut from the very modest to the very sophisticated. The more sophisticated the work, the greater the similarity in structure and organization to that of the professionals. One critical difference is constant, however—amateur work is primarily undertaken for the enjoyment of the participants and not for profit. Two corollaries that derive from this fact make life easier for still photographers. First, professional reputations are not at stake, so pressures are reduced. Second, access to amateur productions is much easier, so experimentation or reshoots are more easily accommodated, even welcomed. Unfortunately, there is a bothersome flip side to working with amateurs—busy photographers will find that amateur rehearsal schedules are somewhat plastic, unexpected cancellations are more frequent, and unproductive waiting time can get disagreeably long.

Despite the above-mentioned provisos, a natural career path for a photographer interested in making a living in the performing arts field begins with very simple amateur productions and proceeds over one to three years, through escalating levels of sophistication, shooting the offerings of high school, college, and adult enthusiasts. Early on, one's photographs will receive enthusiastic acceptance in the community, followed shortly by modest sums of cash. A little later,

one's best photos will be incorporated in posters and newspaper reviews and the portfolios of those amateur actors, directors, and designers who aspire to professional status. The opportunity to work for professional companies will inevitably follow.

2 Basic Available Light Photography

Introduction

There are two fundamental approaches to photography: The first is a straightforward documentation of things as they appear, while the second involves active manipulation of subject and lighting to achieve a preconceived result. Performing arts photography is mostly an exercise in documentation—the photographer as observer or visual historian, if you will. Nevertheless, we know from the study of physics that it is impossible to observe events without somehow influencing them: The performing arts photographer interacts with the theatrical world partly by choosing specific equipment and materials and partly by choosing the exact moment at which to press the shutter button.

In Chapter 1, I described the process of mounting a theatrical work, and I emphasized how carefully every thing, every person, every condition is managed. In fact, the stage is a manufactured world where all physical parameters are determined by the director and the various designers—still photographers are not consulted or even considered while this is done. Unfortunately, being left out of the creative loop creates a dilemma. The simple truth is that photographers of the performing arts must cope with conditions set up by others. This kind of work is called *available light photography*.

Since it is true that all successful photography requires the careful management of a series of mechanical and chemical steps, much of the following discussion will focus on film, processing, and equipment. In a later chapter, I will discuss the many special techniques associated with making the preplanned photographs necessary for special purposes

like posters, portraits for publication, and direct mail pieces—work very similar to that of commercial photographers who serve advertising agencies and the marketing departments of large corporations—but first we must address the basics.

Film

The foregoing discussion is not intended to imply a totally passive role for the photographer. Although direct intervention is an impossibility, there are many technical choices that can and must be made in order to best accommodate what the designers have done.

Because light is our basic working tool, we are concerned mainly with the work of the lighting designer, so the first question is: How much light has been provided? Intensity will vary from scene to scene as artistic purpose demands, but in general it is possible to determine an average level for each production. For example, full-scale musicals with upbeat themes are typically very bright—small operas with very serious themes are typically much darker. Every type of photographic film is assigned a number (the ISO or ASA number in North America, the DIN number in Europe) that quantifies its sensitivity to light. For our purposes, all films can be grouped into categories as follows: *Slow* speed film has an ISO number of 64 or less. *Medium* speed film has an ISO of 100 to 250. *High* speed film is rated at ISO 320 to 1000. *Ultra-high* speed film is rated at ISO 1600 and beyond.

At first glance, it would seem to be a simple matter to choose a high or ultra-high speed film for use on dimly lit shows and a slow or medium speed film for use on brighter shows. In fact, some decision of this sort must be made, but the choice cannot be automatic, mainly because film speed and *image quality* are profoundly interrelated.

Earlier I mentioned that the chemical reaction upon which photography is based depends on the way light affects crystals of silver bromide. When sufficient light energy strikes one of these crystals, a change occurs that compels the silver and the bromine to separate in the presence of certain chemicals called *developers*. The bromine, along with unaltered silver bromide, is then rinsed away by additional chemicals, leaving behind a permanent image comprised of metallic silver. (Silver bromide is incorporated in all films because of this unique property. Color films have three or more layers of silver bromide, each of which is chemically coupled to different organic dyes during further processing steps.) The issue of image quality arises because the *size* of the silver bromide crystals and the *sensitivity* of the film are directly related.

Statistically, bigger crystals have more chance of being struck with a photographically significant amount of light, while smaller crystals have less chance. Sensitive films, therefore, are made up of larger crystals than slower films. However, these same crystals, or *grains*, are also the mechanism for retaining image detail—lots of small grains will record more information than fewer large grains. Slow, fine-grain films can record very fine detail while fast, coarse-grained film cannot, and this is a crucial tradeoff.

The best match for a particular job is the film that is sufficiently sensitive to allow shutter speeds short enough to eliminate, or at least minimize, camera shake and subject motion, while still permitting a level of image resolution suitable to the purpose for which the photos are intended.

Within the broad spectrum of photographic applications, available light theater photography generally demands films of high to ultra-high speed. Before 1980, the automatic choices would almost always have been the venerable Kodak Tri-X (ISO 400) for black and white and Kodak Ektachrome EPT (ISO 160) for color slides, but nowadays film technology has literally exploded, and the variety of films for available light photography is very wide. More on this, and on the relationships among color, direction, specularity, and also film type, later.

Format

Format refers to actual film size—for example, 35mm is the width of the film employed in small format cameras. Image size for these machines is almost universally 24mm × 36mm. Medium format cameras use roll film that is approximately 70mm wide. Image size varies in medium format: 45mm × 60mm, 60mm × 60mm, 60mm × 70mm, and 60mm × 90mm are all common. Large format cameras use film in individual sheets 4" × 5" or larger.

Excellent photography requires the skillful balancing of many variables, and the careful selection of a particular format is certainly a major element in a successful technical strategy. If the number of grains per image determines image quality, then it stands to reason that the larger the film size, the better the picture. That is why many commercial photographs are made with medium or large format cameras. Unfortunately for photographic perfectionists, the disadvantages of large format cameras—such as bulk, weight, and slow speed of operation—make them poor choices for available light photography. Small format cameras are compact as well as relatively fast,

simple, and cheap to operate—for these reasons and more, 35mm is the format of choice for most performing arts photography.

Later in the text, I will discuss what is required to squeeze the maximum quality from the postage-stamp 35mm negative.

Camera Configurations

A camera consists of a light-tight box designed to hold a lens and a piece of film in precise alignment. Various add-ons and modifications to this basic configuration are required for practical operation—perhaps the most necessary being some means for determining what the camera lens is looking at. Three methods exist for doing this: The first, and the oldest, requires the film to be interchanged with a piece of ground glass. When the glass is shaded by a dark cloth draped over the back of the camera, the image projected by the lens is visible, albeit upside down and reversed left to right. This method has been used since the invention of photography; indeed, today's large format camera still rely on it. The second method depends on a separate optical system, called a viewfinder, that is supposed to cover more or less the same field of view as the camera lens. Simple systems employ crude wire frames, while more sophisticated types use high-quality lenses and *coupled rangefinders* that permit precise focusing by way of optical triangulation. The third and most popular method is called the *single lens reflex* or *SLR* system. Here the image projected by the taking lens is intercepted by a mirror and bounced upward to a ground glass, which in turn is viewed by the photographer through a prism that presents an unreversed, right side up image through an eyepiece. In practical operation a hinged, spring-loaded mirror is coupled to the shutter button, so that at the instant a photograph is made, the mirror swings up and out of the way.

The first approach is precise and direct but very slow. A ground glass smaller than 4" × 5" is too small to use for extended periods without eyestrain, so the ground glass system is restricted to large format cameras. It is most suitable for studio still-life situations or when shooting landscapes or buildings outdoors. The second and third systems are best for fast work, particularly with people, and they have been adopted for medium and small format cameras. The SLR system is by far the most popular because it allows easy lens interchangeability plus an enormous range of accessories. Some optical finder cameras have been refined down through the years and still exist today—extremely sophisticated cameras such as the 35mm Leica M series sport built-in light meters, automatic indexing of bright-line

viewfinder frame lines for a wide variety of interchangeable lenses, and motor drives.

SLR Versus Rangefinder

Although common fifty years ago, today large format cameras and ground glass focusing are virtually unheard of in the theatrical environment. The vast majority of professional shooters prefer sleek small format or, to a lesser degree, medium format SLRs. There are, however, some very accomplished photographers who are extremely attached to rangefinder cameras—usually Leicas. Why is this so?

There are three very good reasons. The first is simply a matter of noise. In SLR cameras, a number of mechanical events must happen in sequence whenever a photo is taken. Once the shutter is pressed, the *diaphragm* (the irislike device that regulates light transmission through a lens) must close down to a predetermined setting, then the reflex mirror must swing up, then the shutter must open and close, then the mirror must drop back down, and then the diaphragm must reopen for maximum viewfinder brightness. All this makes quite a racket in contrast to a rangefinder camera, in which noise is generated only by the opening and closing of the shutter. The Leica people have engineered their machines to the point where the shutter makes just a barely audible click, easily tolerated by the most fastidious actor or musician.

Reason number two has to do with camera shake. Noise and vibration go hand in hand. Rangefinder cameras can be reliably hand held for longer shutter speeds than SLRs because there are fewer moving parts banging around. This is an advantage for low-light photography.

The third reason some photographers chose rangefinders over SLRs is more closely tied to the esthetics of picture making. Remember that the SLR mirror must be out of the way whenever the shutter is open. This means that for the instant the exposure is made, the viewfinder is blanked out. In other words, the photographer is denied a view of the exact image being recorded at the moment of exposure. Since optical range/viewfinders are independent of the taking lens, this interference cannot happen, so stalking the perfect moment is a much more precise operation.

I used rangefinder cameras for fifteen years but switched to SLRs because I found them faster to focus with forty-year-old eyes. However, my average film consumption rose about 50 percent as insurance against camera motion and as compensation for the uncertainty engendered by

the single lens reflex blackout syndrome. Happily, the proliferation of motor drives in recent years seems to have reduced performers' sensitivity to camera noise.

Auto-Everything

In today's microchip environment, we are offered all sorts of technical toys unheard of even ten years ago. Cameras are available that use computer technology to automate every function. Kodak's turn-of-the-century motto—*You push the button, we do the rest*—has taken on a new meaning.

Until recently, I resisted all electronic advances in camera design except built-in manually operated light meters and motorized film advance. This seemingly reactionary posture evolved from experience and experimentation. Certainly, the earliest varieties of autoexposure, autofocus, and autoflash cameras were crude because their internal algorithms and electro-mechanical actuators were designed to cope only with a relatively narrow range of photographic situations that might be encountered by typical amateur photographers. The low-light, fast-moving circumstances of stage photography were just too extreme and too dynamic for the early automatic cameras to deal with.

I have to admit that things have changed in the last few years. Autofocus technology has evolved to the point where some cameras can react faster than humans can, particularly in the *follow-focus mode* developed for the benefit of sports photographers. In addition, some sophisticated cameras can be user-programmed to accurately measure the tricky exposure circumstances encountered in the performing arts. The continuing revolution in film technology has widened the capabilities of computer-managed cameras as well.

All this means that photographers now have more technical choices. I still appreciate the simplicity and reliability of mechanical cameras, but this does not mean that a professional who understands and appreciates electronically managed devices cannot do first-quality performing arts photography.

My strong recommendation, however, is to master the basics of performing arts work using only the most basic tools, that is to say, a high quality, mainly mechanical camera system with user-adjustable exposure and focus settings. Once the nuances of exposure and focus control are mastered, some responsibility for technical decisions can be shifted to electronic devices when appropriate. I will concentrate

first on helping you achieve a practical understanding of the basics and leave a detailed discussion of modern cameras until later.

Lenses

A lens is the camera's window to the world. Various terms apply to the accuracy with which particular lenses render an image—sharpness, resolution, color fidelity, aberration, and so on—but we can assume that most modern optics are sufficiently well corrected for professional use. After optical performance, however, there are two other characteristics that distinguish the function of one lens from another: focal length and aperture.

Aperture refers to the light-gathering capability of a lens, which is determined mainly by its diameter. The aperture may be altered by the introduction of a diaphragm, which is a variable iris or opening. The size of the aperture is quantified in *f-stops*—which are defined as $f = fl/d$, where fl is the focal length and d is the diameter of the aperture. Because the f-stop is a reciprocal, the larger the opening, the smaller the number. An aperture of f1 is considered to be large, while f64 is small.

Focal length refers to the distance between a point at the optical center of a lens and the location of the image of a very distant object projected by the lens. It is photographically significant because, for a given format, the focal length is related to the angle of view (or angle of acceptance) of a particular lens. Wide-angle lenses have wide angles of acceptance and relatively short focal lengths, while telephotos have narrow angles of acceptance and relatively long focal lengths.

The proper selection and use of photographic lenses depends on an understanding of human vision, evolution's almost perfect response to the visible portion of the electromagnetic spectrum—almost perfect because as spectacular as the system might be, there are a couple of flaws: The lens is (for all practical purposes) of fixed focal length, and it is not interchangeable.

Nevertheless, the eye is a truly amazing creation. Its automatic diaphragm, the iris, changes the effective f-stop from about f5.6 in dim light to approximately f22 in bright light—response time is so short that corrections are made according to relative brightness of different objects within a scene, thus allowing us to cope with a tonal range much wider than film or photographic paper can accommodate. Also amazing is the fact that focusing is accomplished by actually changing the shape of the lens itself—a process that goes on continually and quite fast, yielding the illusion of almost infinite depth of field. Focus

corrections are made spontaneously as one's attention shifts among different objects within the field of view. Overall angle of acceptance is very nearly 180° around an area of high resolution of approximately 40°.

So-called normal lenses in photography are related to the concentrated area of ordinary vision in that they cover nearly the same angle of acceptance. Nevertheless, it is just a coincidence that the favored normal lens for the 35mm format and the human eye have nearly the same focal length, and these similar focal length lenses do not see the world in the same way. This is because the brain, like the computer that can generate a full color map of Jupiter from a few electronic clues, processes the data relayed along the optic nerve from the eye and then reconstructs an image (the image we see mentally) so that everything looks O.K. We are conditioned from childhood to expect the visual world to follow certain rules of perspective, and it is one of the brain's main functions to enforce these rules. That is why optical illusions are possible: The brain, attempting to keep things in some kind of order, may be tricked.

Our response to images produced by various focal length lenses in photographic practice is influenced by our physiology but also by our psychological way of seeing. Some lenses, like the moderate telephotos, tend to render the world in a way that is more immediately acceptable to our conditioned expectations. Other lenses, such as the extreme wide angle, are used to shock and surprise because the images they yield are so spectacularly different from what our brains expect to see. We use the range of optics to satisfy or tease our visual programming.

On a mechanical level, it is easy to think of a wide-angle lens as a device to cram more stuff into the frame without having to move back or a telephoto as a device for getting close to the subject without moving forward. Such considerations are significant, but various focal lengths offer more than just a different angle of view. In fact, they each offer a different point of view, esthetically speaking.

With short focal length lenses, compositional options may be fine tuned without a lot of fuss because they put one close enough to the subject to permit significant alterations in framing by repositioning the camera a foot or two up or down, left or right.

Unfortunately, wide lenses also introduce a kind of visual deviation called *perspective distortion* that is both a curse and a blessing. The term refers, in part, to the difference between the brain's and the camera's responses to the optical phenomena of nature. The eye actually sees parallel vertical lines of a building converging, just as the camera does. The eye sees nearby small objects as large and faraway large objects as

small, just as the camera does. But unlike a camera, the brain wants to see verticals that do not converge and it knows from experience that a chair is smaller than a door. By projecting the light reflected from three-dimensional objects onto a two-dimensional surface and then presenting the flat image out of context, we challenge our optical preconditioning. In real-life situations, the brain tries to correct apparent visual anomalies and, up to a point, succeeds, while a photograph can only look how it looks.

The perspective offered by very wide to ultra-wide lenses (17–28mm for 35mm cameras) can push visual tension right to the limits of tolerance. We tolerate certain kinds of strange-looking pictures, such as a fish-eye picture of the inside of a space capsule, for example. Sometimes wide-angle effects are even appreciated in dramatic views of buildings or natural panoramas. Nevertheless, people and familiar objects pictured close up by extreme wide-angle lenses will never look natural.

Moderate telephotos (85–135mm for 35mm cameras) are long enough to give subjects a fair deal visually, yet short enough to hand hold fairly reliably. Lenses of 180mm or beyond, however, introduce another problem of perspective. To encompass a given object, we must move farther and farther away, and the scene visible in the finder starts to bunch up so that foreground and background seem to grow out of one plane. Short focal lengths tend to emphasize the objects close to the camera, while the greater working distances encountered with long lenses tend to flatten subject contours, resulting in images with noticeable lack of depth—thus *compression* of natural perspective begins to dominate in a way that is opposite and complementary to the *expansion* of perspective yielded by short lenses.

Aside from esthetic considerations, there are many circumstances when the simple factor of image magnification alone is the basis for choosing a long lens. If mechanical barriers (like an orchestra pit!) separate photographer and subject, telephotos will pull in a decent image size. The degree of magnification is directly proportional to the increase in focal length. Thus, at the same camera-to-subject distance, a 200mm lens yields an image four times the size a 50mm lens gives.

Two other variables must be considered when selecting lenses of different focal lengths. First, depth of field—the range of acceptable sharpness in front of and behind the point of perfect focus—is a function of aperture size, which in turn is a function of focal length. The longer the focal length, the shallower the depth of field at a given f-stop, all else being equal. With the wide apertures typical of low-light performing arts work, this may be a matter of inches or even fractions of inches. The second limiting factor is related to magnification—as

image size increases, so does the significance of focusing error and camera movement.

Keeping Still

Of all the skills that a performing arts photographer must master, the ability to stay still—photographically still—is the most basic. The main identifier of high quality images is sharpness—a colloquial term that encompasses the more technical concept of image resolution. Before optics, film quality, and focus, the absence of camera motion is critical to the production of usable images.

Keeping still is a mechanical problem common to all low-light-level photography in which shutter speeds often exceed the ordinary limits of what can be hand held. In some circumstances, it is possible to simply secure the camera to a tripod—this is the technique of choice for shooting architecture at night or for large format landscape photography, for example. Of course, buildings and mountains—unlike stage performers—do not move. Some special tricks are required to deal with both low light and moving subjects at once. Sometimes tripods are appropriate and sometimes they are not—I will discuss the proper use of mechanical supports shortly, but first some hints on how to hold a camera still all by yourself.

The first requirement is good physical health since a healthy body is a steady body. Performing arts work requires the maintenance of a calm state of readiness for surprisingly long periods—hours at a time in standby mode and often many minutes at a time with the camera carefully positioned in anticipation of individual photographs. The operating word here is stamina, which is a combination of endurance and strength. Abstinence from coffee and cigarettes helps both concentration and steadiness, as does the practice of a mental relaxation technique like yoga or meditation.

Really careful workers are fully conscious of the smallest movement or vibration, and this awareness even extends to breath and heartbeat. A high level of aerobic fitness encourages slow, deep breathing and a low resting heart rate, which together permit the body to stay quite still when required. My advice, therefore, is to avoid stimulants like nicotine and caffeine, to work out aerobically two or three times a week, and to follow a regular regimen of mental relaxation.

The actual technique of hand holding a camera is fairly straightforward. Here is a simple but useful formula to determine the slowest shutter speed that can be hand held without special concern: Take the

nearest reciprocal of the focal length of the lens you happen to be using. For example, a lens of 135mm focal length can be reliably hand held at 1/125sec, while a 28mm lens can be reliably hand held at 1/25sec. This approach takes into account the magnification of camera movement that occurs as focal length increases. Shutter speeds determined by the formula will need to be modified up or down according to the physical capabilities of the photographer. In addition, a motor drive contributes to steadiness by eliminating the jostling that inevitably accompanies the action of the film advance lever and by allowing the camera to remain in shooting position between shots. Autofocus cameras are easier to keep still because they can maintain sharp focus without constant mechanical adjustment by the photographer.

More care must be taken when working at shutter speeds longer than those determined by the formula. Here are a few hints that will help extend one's range:

First, try to develop a repertoire of steady shooting postures. When shooting at eye level, stand with your spine straight and your feet spread about shoulder-width apart. Don't clamp your elbows tightly to your body because all muscular tension results in vibration—instead allow your arms to rest against your rib cage by their own weight. Similarly, when bending or crouching, find postures in which steadiness is achieved through the geometrical arrangement of arms and legs rather than by muscle control alone. For example, for low-angle shooting, it is better to kneel or sit squarely on the floor rather than squat precariously on the balls of your feet.

Second, prepare the way for a rock-steady exposure by watching your breath just before pushing the shutter button. It is best to hold your breath briefly at this point—not a convulsive muscular lock, just a relaxed, momentary suspension.

Third, to initiate the exposure, it is preferable to gently squeeeeeze—rather than jab—the shutter button. Remember also that if posture and breathing are properly controlled, nothing should change during the actual exposure.

To recap, the desirable condition for low-light/long-exposure photography is a state of relaxed readiness, supported by a comfortable, steady posture and slow, easy breathing. The actual exposure is preceded by a gentle suspension of the breath followed by a gentle squeeze of the shutter button. Steadiness and concentration are easier to maintain if you use a motor drive to advance the film. Autofocus helps as well.

Twenty years ago, I successfully shot hand held exposures as long as 1/2 second using rangefinder cameras and the methods described above, but nowadays I find that 1/30sec is a more realistic limit with

reflex cameras. Rangefinder cameras are inherently less vibration-prone since they do not employ a moving mirror—1/15sec or even 1/8sec is quite usable with such cameras, assuming fairly short focal length lenses (50mm or less) and a photographer in good physical shape.

Whenever exposure times get too long to be manageable by the methods described above, some sort of mechanical support for the camera is the only alternative. Photographers usually resist the use of such aids because they restrict the quick selection of different points of view. The following information is organized according to ascending degree of restriction.

The first strategy is to take advantage of whatever structures are at hand. When shooting from the edges of a theater auditorium, for example, one can use walls and doorways for support. It is important to lean in such a way that extra muscular effort is not required—*lounging* might be the proper term. Keep your feet slightly apart and lean so that the wall becomes the third leg of a tripod of which the other two legs are yours. Choose a position far enough away from the wall so that your own body weight keeps you firmly in place, but not so far that it becomes necessary to struggle to stay comfortably upright. You can put a shoulder to the wall and achieve this effect, or else lean backwards and let your back be the point of contact. When you are supported in this way, the usefulness of the techniques described earlier can be extended for long sessions.

The same approach works in the center of the theater, with some modifications. Sometimes it is possible to lean right on the edge of a theater stage, using one's chest and elbows to form a temporary tripod. When sitting in a seat, settle comfortably against the backrest, or else lean forward with arms and/or elbows on the back of the seat in front of you. Always keep in mind that the effectiveness of all these techniques depends on selecting postures that reduce rather than increase muscular tension.

There are many mechanical devices that can be used to steady a camera when other approaches prove unsuitable: a tripod, a monopod, specialty clamps and stands, a gyroscopic stabilizer. Although they all work, I resist using these devices unless absolutely necessary because I would rather shoot several extra frames around each image—one or two of which will likely be critically sharp—rather than restrict my freedom of motion.

Subject motion is as significant a factor in low-light work as camera motion. Once all camera-related conditions are well controlled, the choice of the precise moment at which to make a photograph takes over as the critical factor—exposure *timing* is more important than

exposure *time*. Every dramatic gesture evolves through motion to a moment of stillness, after which the configuration either repeats or dissolves. The mindful photographer will track a gesture as it develops and then trip the shutter just at that moment of stillness. In this way, exposure times as long as 1/4 or 1/2sec—which might be necessary to record sufficient information—can become technically useful. The same technique enhances results with shorter exposure times.

An Indispensable Accessory

Performing arts photography requires very little in the way of equipment, save one or two decent cameras and a selection of quality lenses. Nevertheless, one accessory is mandatory: a lens shade. Actually, several different lens shades must be acquired because each focal length lens should have its own. Happily, shades are simple, inexpensive devices. Here is why they are so important.

Image-forming light is that light which is radiated by the subject, gathered by the lens, and projected onto the film while non-image-forming light, or *flare*, is extraneous radiation. After camera motion, flare is the most significant agent of image degradation. In performing arts work, flare occurs when some very bright source—like a lighting instrument—is located within the field of view of the lens but outside the image area. All lenses actually see more than what is required to fill the image area defined by the film, so sometimes the light from a bright source can be projected onto internal parts of the camera or lens and, after bouncing around inside the camera or lens body, end up on the film as ghostly spots or streaks. Less obvious manifestations cause a reduction in contrast and an apparent loss of sharpness.

A shade, a specially sized matte black tube that is attached to the front of the lens, largely eliminates these problems by preventing extraneous light from striking the front element. Since every different lens has a different angle of view, each requires a different shape or length of shade. It is a worthwhile investment of both time and money to obtain shades specifically designed to work with each lens you own.

3 Theatrical Lighting

The Qualities of Light

A photograph begins when light, organized by a lens, induces a pattern of physical changes in millions of silver bromide crystals (the *emulsion*) spread on a scrap of plastic film. After chemical development, the pattern becomes a permanent two-dimensional representation of some aspect of the real world.

Light is both a subtle and an energetic messenger. We are, at once, stimulated and limited by its four basic attributes: intensity, color, direction, and specularity. How these characteristics contribute to the power of photographic imagery will be reexamined from a theatrical point of view in Chapter 3, but for now, here are some preliminary definitions:

Intensity is a quantitative measure of light energy. The question—just how much light?—is answered with a measurement provided by a light meter. *Color* refers to the wavelength of visible light, the position on the visible spectrum of a particular source. This, too, can be measured, but usually we depend on simple observation that tells us the light source is either natural daylight or manmade incandescent, fluorescent, mercury vapor, sodium vapor, and the like. *Direction* has to do with the relative positions of the camera, the subject, and the light source that illuminates the subject. *Specularity* is a made-up word used by photographers that refers to the relative sizes of the subject and the source of light. If the subject is significantly larger than the light that illuminates it, the source is said to be highly specular—this kind of light is characterized by very clearly defined

Figure 3 - 1. Sweet light can be found in the oddest places! This intense portrait of actor J. P. Linton was hot hand held, out-doors under available light in the back lane behind the Manitoba Theater Center. [Leica camera, 90mm lens, Ilford FP4 film, f2 at 1/15 sec.]

shadows. If the subject is significantly smaller than the light that illuminates it, the source is said to be nonspecular, or diffuse—this kind of light is characterized by very fuzzy, indistinct shadows.

Total photographic control demands that the photographer have complete freedom to alter all the characteristics of light so as to realize his or her exact esthetic and technical purposes.

Artificial Light

Clouds, weather, air pollution, and the time of day or year all influence the way the outer world looks to us at any given moment. This is because these factors and many more modify some or all of light's photographically significant qualities. Nature's palette derives from variations of sunlight.

Indoors, we are accustomed to a plethora of artificial sources. Almost all manufactured lighting has one thing in common, however: No real effort is made to mimic natural conditions. We accept this situation for what it is and allow artificial light, the visible heritage of the continuing industrial revolution, to illuminate our nondaylight hours as it will.

In the performing arts, one particular light source—the incandescent lamp—has been chosen to be the main working tool of the lighting designer. This humble device, substantially the same glowing tungsten filament invented by Edison a century ago, is the active element inside millions of theatrical lighting instruments in regular use around the world. It is true that a couple of other technologies, namely the carbon arc used for high-intensity spotlights and the super-bright xenon discharge tube used to complement daylight outdoors, are also part of the lighting designer's arsenal, but almost universally one finds dozens, if not hundreds, of incandescent fixtures above every performing arts stage.

Why is this so? The answer begins with a study of the professional purpose—the raison d'être—of the lighting designer: to evoke or enhance a series of emotional responses in the audience that will reinforce whatever is being presented on stage, a sophisticated trick possible only because human beings are by nature extraordinarily sensitive to light's myriad manifestations.

Let's revisit the four qualities of light. Consider intensity, the characteristic that I earlier described as easy to quantify with measuring instruments. The emotional effects associated with light of different intensities are not so easy to measure, but they are certainly easy to identify, partly because they are deeply embedded in language. What does the phrase *as different as day and night* call to mind, if not the intricate array of primal responses, present in all living organisms, to the earth's ancient, daily changeover between light and dark? There are many more examples—*light hearted, the dark continent, an illuminated being, a thousand points of light*. The language of light is very rich, and most, if not all, of the states or feelings implied by such talk are part of everybody's personal experience.

Intensity speaks of the relative presence or absence of light, but the connotations of color are more subtle and harder to pin down emotionally. But here again, we can use familiar conventions of the English language to suggest some of the implications. What is *warm light*? What is *cool light*? What is a *white light experience*? Who is *red, green,* or just plain *yellow*? Who is *black-hearted*? What is the difference between *purple prose* and a *purple haze*? Why do *red, white, and blue* go together? Why don't *brown shoes* make it? What is so classy about a *black tie* affair?

The direction of light might not, at first, seem to be an emotional issue, but anyone who makes a living creating images—be it a painter, a sculptor, a photographer, a cinematographer, or a theater director— knows that it truly is. What is the difference between a silhouette and an ordinary portrait? Why do movie monsters seem to prefer rooms where what light there is always seems to come from floor level? Does it matter whether the sun sinks slowly in the west? Why is a studio loft illuminated by *north light* so highly prized? Could Hollywood westerns exist without a gunfight beneath the height of the noonday sun? *Chiaroscuro*, defined in the *Oxford English Dictionary* as *the style of pictorial art in which only light and shade are represented* was favored by both Italian and Dutch Old Masters—the disposition of light and shade in any picture is determined predominantly by the orientation of the light source relative to the subject.

Specularity is a word that can't be found in the dictionary, but it has achieved common currency in photographic circles. The extremes of the specular spectrum are easily summarized by the terms *hard* and *soft*. Hard light is highly specular—a light source that is very small relative to the subject it is illuminating generates very clearly defined dark shadows and very quick (some might say severe) light-to-dark gradients at the edges of surface forms and textural details. Soft light is nonspecular—a light source that is very large relative to the subject generates fuzzy, diffuse shadows and gradual light-to-dark gradients. Let me apply a linguistic analogy one last time: An escaping convict looks truly worried only when *pinned by the [highly specular] glare of a searchlight,* while a beautiful leading lady can look *truly radiant* only when caressed by the nonspecular glow of a sunset reflected off picturesque clouds or gently undulating ocean waves.

In short, what you see is what you feel. And since lighting designers make their livings by creating visual moods, the incandescent lamp is universally preferred because it generates light in a manner that can be easily manipulated.

The brightness of an incandescent source can be finely adjusted by precisely controlling the electrical voltage applied to it with electronic devices called *dimmers*. Unlike gas discharge or fluorescent lamps, incandescents radiate a relatively *linear color spectrum* without deep spikes or valleys. Since all colors are present in more or less natural proportion, any color may be enhanced or attenuated with filters—and there are thousands of different filters manufactured for the purpose of creating color effects on stage. Incandescent lamps are physically small relative to the amount of light they put out, so the instruments used in the theater can be compact and lightweight as well. This means that the requirement to provide light from any angle can be conveniently fulfilled by attaching light fixtures to all sorts of supports, stands, adjustable booms, overhead grids, and the like.

Many techniques have been developed for changing the relative size of tungsten sources. Simply bouncing the light off a reflector is the simplest way to achieve a nonspecular effect—the larger the reflector, the larger the apparent size of the source. Focussable instruments that incorporate carefully manufactured parabolic reflectors, adjustable lenses, diffusers, and patterned masks allow very precise control wherever a variety of specular effects are needed.

As useful as they are, incandescent lamps have disadvantages. To begin with, they are inefficient. Only about 15 or 20 percent of the electrical energy they require actually produces light—the rest is dissipated in the form of heat, enough heat to constitute a very real fire hazard if special precautions in their use and in the design of fixtures, filters, and reflectors are not observed. The wasted electricity costs money—a big theatrical production can use up to $1,000 an hour in electricity to run the lights and the air-conditioning/ventilating equipment they necessitate. This cost is one of the reasons that performing arts groups must keep photo calls short. Tungsten lamps are somewhat fragile—normal life expectancy is, on average, 50 to 100 hours, and if they are jarred sharply while operating, they can burn out prematurely. One final problem is replacement cost, which ranges from $25 to $150 per unit.

The Lighting Designer's Repertoire

A good photographer has to know what the lighting designer is doing (or trying to do!)—not a small achievement, since each designer and each performing art venue has requirements and practices that are unique. We can generalize, however, by saying that stage lighting is

divided into two broad categories: Category A is subtle, natural, and generally light handed (forgive the pun), while category B eschews the subtle in favor of the bizarre or the unexpected.

Such distinctions are possible because we all have built-in visual programming that establishes a set of expectations, and these expectations can be manipulated because certain lighting effects are common in nature while others are not. Our instinctive visual baseline can be said to be bright sunlight or sunlight diffused by clouds. The corollary of that fact says that multiple shadows are not natural because sunlight (or moonlight, for that matter) always comes from one direction, although the direction changes according to the season and the time of day.

Category A lighting plays with our visual expectations in a sensitive, gently provocative way. For example, slanting yellowish or pinkish light evokes sunset if brightness levels are falling or sunrise if levels are rising. Category B takes the haphazard, edgy quality of raw artificial light and amplifies it dramatically to achieve an artistic purpose. Here, undulating red light with flashes of green and purple might evoke the fires of hell for a heavy metal band or for a production of Gounod's *Faust*. Both approaches require sharp-eyed photographers—on the one hand, changes are delicate but significant, while on the other hand, changes are significant but unexpected.

Technical Characteristics of Stage Lighting

I have described in very general terms how lighting designers create various emotional effects, but there are three aspects of stage lighting that must be well understood by anyone who wants to photograph the performing arts professionally—brightness, color temperature, and contrast.

Brightness, or luminosity, is the photographer's way of describing light intensity. The general rule is: The brighter the light falling on the subject, the easier it is to record a photographic image. Modern film, cameras, and processing techniques make it possible to take pictures whenever there is enough light to see—unfortunately, this does not mean that all photographs, regardless of the conditions under which they were made, can look the same. Plentiful light will allow photographs of incredible accuracy, but a scarcity of light inevitably yields crude photographs—what Kodak calls *surveillance quality*. Very dark productions are sometimes outside the present photo-technical envelope.

The human eye/brain combination is amazingly tolerant—normal color perception can be maintained under a surprising variety of conditions. We always know that grass is green, the sky is blue, cows are brown. Yet weather, the time of day, and many other factors—like air pollution, to name just one—all change the color of the sunlight that reaches us. That is why a sunrise/sunset is pink or yellow, for example. We don't think about it, but our brains are always adjusting for natural (and unnatural) variations in color.

Color has been scientifically quantified by the Kelvin Color Temperature scale, which assigns a number (denoted in degrees) to every color in the visible spectrum. A warm-toned sunset might be 1,500K (K for Kelvin), while cool midday light up high in the Himalaya Mountains might be 10,000K. Average daylight, for photographic purposes, is considered 5,500K. Standard theatrical lamps radiate a warmer light than standard daylight at 3,200K.

Photographic film lacks the compensatory ability that our brains give us, so color film is manufactured to be daylight balanced (5,500K) or tungsten balanced (3,200K). Fortunately for photographers, the color variations introduced by lighting designers are usually within the tolerance of today's tungsten balanced color films—I will have more to say about this topic later.

Contrast is a critical variable that is independent of both brightness and color, but it is ultimately much more significant than either. The term is used to describe the range of luminosities—the range of brightnesses—within a given scene. A single highly specular light source striking a three-dimensional subject at a severe angle yields a very high contrast result—bright highlights with inky black shadows. The same subject illuminated with a broad, nonspecular source has a much more compressed contrast range where highlight and shadow luminosities are much closer together in value.

Brightness range is a technical concern because film cannot respond the same way as the human eye/brain combination. Biological vision accommodates variations in brightness by automatically varying the iris opening of the eye as it focuses on various parts of a scene. A dynamic composite image is constructed by the brain, which can encompass a brightness range of 100,000 to 1. Film is a much less forgiving recording mechanism, limited by definite upper and lower thresholds. Black-and-white or color negative films will accommodate a brightness range of six f-stops, or 128 to 1. Color transparency film will accommodate only three f-stops, or a brightness range of 32 to 1.

The technique of matching real-life circumstances with the capabilities of photographic film is called exposure control—a subject that will be very thoroughly explored later in the book. For now, it is enough just to note that the theatrical lighting designer is profoundly concerned with the capabilities of human vision but almost totally oblivious to the capabilities of photographic film.

A Unique Tool

Generally speaking, still photographers, particularly careful studio workers, are accustomed to elaborate lighting setups. In fact, the stage may be regarded as a giant studio in which the intricacies of lighting are controlled by the lighting designer. As discussed above, almost all the tools and techniques designers employ are familiar to photographers, even though they are often exaggerated in terms of what is required for film. There is, however, one particular characteristic of stage lighting that is virtually unknown outside the theatrical environment—*movement.*

In nature, light usually moves rather slowly. In fact, the most significant movement is the twenty-four-hour progression of the sun from dawn to dusk to dawn: This movement is itself altered in very small increments by the procession of the earth through the seasons. Sometimes light moves fast in nature: Lightning appears in different locations instantaneously and unexpectedly. Reflections off moving water certainly move, as do the shadows of objects buffeted by the wind, but only in the theater do we find dazzling follow spots, dancing laser beams, flash pots, synchronized explosions, and lights that fluctuate, pulsate, or oscillate in intensity, direction, or color according to artistic whim.

However dramatically powerful its many forms might be on stage, moving light is almost impossible to capture in a still photograph. Frozen motion, multiple and stroboscopic images, or various degrees of blur may hint at particular effects—or elements of particular effects—but no photograph can ever substitute for the real thing. That's why it's called *live theater,* after all.

From a performing arts photographer's point of view, moving light is, at best, a headache—and at worst, a disaster. Those who hire photographers to record their productions must be diplomatically reminded that all visual media are not equal.

Throughout this book I will describe several practical ways to cope with the diverse fruits of lighting designers' imaginations—but let me

say right now that no amount of study can substitute for experience and experimentation. This book is intended to be an inspirational field guide rather than a listing of rigid instructions.

Film and Television Lighting

In my experience, lighting for theatrical drama is divided pretty equally between category A and category B—that is to say that half the time a natural look is intended and half the time a totally contrived environment is the ultimate goal. This balance shifts strongly toward the simulation of realistic conditions in film and television.

There is a philosophical reason for such a shift. All drama depends on a condition called *the suspension of disbelief*. This requires that the audience discard their day-to-day notions of reality and become deeply involved in the action unfolding on the stage or screen. Patrons of live theater automatically accept the traditional conventions: The story is told from only one physical location—under the proscenium arch—with a minimum of props and a limited, often symbolic or metaphorical simulation of the natural world. The opposite is usually true for film production, where every effort is made to simulate real life.

In live theater, absolutely everything technical must be hidden from the view of the audience in order to sustain suspension of disbelief. This means that all lighting equipment must be high above the stage or in the wings. Since theatrical lighting instruments are highly specular sources, moving them far away from the stage and positioning them at steep angles relative to the performers automatically creates contrast problems. For nonspecular effects, many instruments must be used together, and this introduces multiple shadows—another impediment to the establishment of quasirealistic conditions. On the other hand, film and video production proceed without an audience and the restrictions on lighting techniques that an audience imposes.

On set, the only limitation is that lights be located outside the field of view of the camera, so a wide variety of instruments can be used, and they can be positioned very close to the performers. It is no coincidence, in fact, that many accomplished cinematographers are former still photographers—many of the most effective cinematographic lighting techniques evolved in sophisticated still photography studios.

Since film and video are reproduction oriented, that is to say the final product is to be displayed or reproduced on a screen, their

lighting parameters are by necessity more compatible with photography than those of live theater. This means that technical conditions during filming must be adequate to permit the recording of full-tonal-range images. Consequently, overall levels do not change as dramatically as on stage—the darkest scenes in a film or video will be lit more brightly than they would be for the stage, and the brightest scenes will be less brightly lit than a stage production. Typical contrast levels are lower, and special effects are more moderate as well.

All this does not mean that still photography of video or film productions is trouble free. The permissible technical conditions for film are more extreme than for photography, and video is even more tolerant than film. There are at least three reasons why this is so. First, on a simple mechanical level, fleeting moving images will never be viewed as critically as still photographs.

Second, film and video capture all those lighting effects that depend on movement—effects that are more or less invisible to still photography. And finally, cinematographers and videographers rely on *postproduction controls*, many of which are electronic in nature, to insure that extremes of lighting and special effects are accurately reproduced.

Supplementary Photographic Lighting

Photographers are permitted a measure of control over stage lighting conditions whenever performing arts institutions require very high quality images for particular promotional purposes. There are several degrees of control, depending on available time and money.

The most basic approach is consultation with the lighting designer and the lighting technicians. Just raising the overall light level for a few minutes is normally an uncomplicated task that makes photography a lot easier. When the technical people are cooperative, difficult cues can even be modified light by light at the dimmer board in a way that retains the mood of the scene while enhancing the photographic quality of the light. This approach can be extended in some circumstances with the rigging of additional lighting by theater staff at the request of the photographer, but this is pretty rare.

When the theatrical lighting is problematic and cannot be modified, some additional photographic lighting must be supplied. Most still photographers will never encounter a situation in which they must light an entire stage. Usually only small areas of the set, peopled with a small number of performers, are to be featured. On the stage, it is

easier and much more practical to supplement existing light with some reflectors or fill-flash (balanced to the ambient color temperature with a daylight-to-tungsten color correcting filter), rather than to construct an elaborate array of photographic lighting. I generally work with the camera on a tripod and a fairly powerful portable flash projected through a small soft box on a bracket that raises it twelve inches or so above the camera—this arrangement allows me to work quickly, to preserve the existing lighting ambiance, and to lighten shadows as required. In my experience, actors are capable of holding still for a second or two after a little good-natured coaching, so powerful supplementary light is not required even for slower fine-grained film.

4 Exposure and Print Control

Exposure Control

The technical and esthetic elements of performing arts photography are strongly interrelated. The design of an image depends to a large degree on the choice of optics, while the choice of optics will inevitably be limited by the particular venue, and so on. Nevertheless, everything depends on a few light-sensitive molecules receiving sufficient photochemical stimulation to record a permanent image. *Exposure control* is the method by which this condition may be consistently achieved.

Measuring Light

The duration and intensity of the exposure is mainly a function of the intensity of the light that falls on and is reflected by the subject. Making this determination requires a *light meter*, a device consisting of a *photocell* (a sensor that changes electrically in proportion to the amount of light striking its surface) and a mechanical needle indicator or an electronic readout. There are four configurations: *reflected*, *incident*, *spot*, and *behind-the-lens*.

A reflected light meter measures the light coming toward the camera from an object or scene. A simple lens or baffle in front of the sensor establishes the *angle of acceptance*, usually 15° to 30°. Some meters have an optical viewfinder, but most do not, so it is necessary to guess what the meter is looking at.

An incident light meter measures the overall level of illumination independent of the reflectivity of the subject. Instead of a baffle or lens, the photocell is mounted behind a small diffuser, usually a translucent plastic dome. A reading is taken from the subject position with the dome pointing at the camera.

The spotmeter is a highly specialized reflected light meter that uses a lens and viewfinder arrangement to permit very accurate measurements of the light coming off tiny areas of the subject. Generally, spot meters provide a viewfinder image with a 10° angle of acceptance surrounding a 1° spot of sensitivity.

Like the spotmeter, a behind-the-lens (BTL) meter is a specialized version of the reflected light meter, but in this case the sensing element and readout are built into a camera. The photocell (or cells) read the light gathered by the taking lens off the ground-glass viewing screen, through minute perforations in the reflex mirror, or from the film surface itself. The BTL approach is wonderfully useful because all factors affecting the intensity of the light reaching the film, such as filters and lens transmittance, are automatically taken into account.

The spotmeter, which permits extreme metering accuracy at a distance, is the preferred instrument for critical performing arts work. However, whenever it is possible to work right up on stage or within a film set, an incident meter is preferred. For general purposes, the BTL meter is considered the most convenient and consequently is very widely used.

A Gray World

Refinements in technology give us a broad choice of equipment, yet all light meters have a common characteristic—they don't think like humans. Some manufacturers and many photographers pretend this is not the case, but they are deluding themselves, microprocessors notwithstanding. Even fancy BTL matrix meters enhanced with computer technology cannot guarantee an appropriate exposure every time. This decision must ultimately be the sole responsibility of the photographer.

Exposure control means that if every other aspect of the photographic process is known, exposure alone will determine the density of the final tone on the print. In other words, if a particular film is exposed to a certain amount of light, developed for a certain amount of time at a certain temperature, and then photographically printed

under controlled conditions, a tone of predictable density will result. For calibration purposes, the photographic industry uses a middle gray tone—18 percent gray—as a standard for testing.

If an accurate reflected light meter is pointed at an 18 percent gray card, then the indicated exposure will end up as a print that looks exactly like the gray card. The designers of reflected light meters assume the whole world is one big gray card. The underlying logic is that all the various tones in a typical scene will average out to the equivalent of 18 percent gray. Unfortunately for performing arts work, such an approach is not sufficiently reliable.

Consider a performer wearing a white shirt and a black suit illuminated by a bright spotlight. A reflected light meter pointed at this scene from a camera position ten feet away might indicate f11 at 1/125sec for ISO 1,000 film. If a closer reading is made from the shirt, the reading might be f22 at 1/250sec. Another reading made from a shadow area on the dark suit might indicate f4 at 1/60sec. A comparison of the two close-up readings indicates a span of eight f-stops: Negative films cannot record detail beyond six f-stops, and printing papers cannot reproduce a range of tones beyond 100:1 under the very best viewing conditions. This means the shadow side of the suit will drop off the dark end of the spectrum and print jet black, while the spotlighted white of the shirt will shoot over the top of the reproducible tonal scale and consequently print bald white. Some skill is required to reconcile the eye/brain response to the film/paper response. Since the eye and brain working together can tolerate a brightness range of almost 100,000:1, what we see in real life and what we see in a photograph will not necessarily coincide. Reflected light meters should not, therefore, be considered *exposure meters* but rather *brightness* meters. Individual readings taken from small parts of the subject indicate specific intensities of light, but no single reading can automatically be assumed to be a perfect exposure. Instead, one must determine the *relative brightness* of the significant tones in order to know whether or not the tonal scale of the subject corresponds to the tonal range of the film. If the two are desperately out of alignment, a decision has to be made about which tones in the subject are to be sacrificed to the shortcomings of the medium.

Awareness of the relationship between subject contrast and the appearance of the final photograph is a basic requirement for practical exposure control, although it is also necessary to keep in mind the quality of the light, the f-stop required for adequate depth of field, and the desired relationship between shutter speed and subject motion.

Why Processing Is Necessary

The heart of photographic technology is a subtle chemical event that begins when light strikes crystals of silver bromide coated on a plastic film base. If the light was projected by a camera lens, invisible molecular changes in the crystals form a pattern called a *latent image*. The latent image becomes visible when development separates the silver from the bromine. Fixing the image dissolves away unexposed, and consequently undeveloped, crystals. What remains behind is a relatively permanent image made of metallic silver.

Color films and papers depend on the same mechanism but in a more complex configuration. Additional chemical manipulations link special dyes to layers of light-sensitive material that become the magenta, cyan, and yellow components. The final image in color material is composed entirely of organic dyes—that is why it is less stable than its black and white antecedent.

Why I Have a Darkroom

Photography requires an understanding of dozens of variables. To do it right, it is necessary to exercise control over all aspects of the technology, but this is difficult if the last few operations are surrendered to others. Creative control is not the only commodity that is lost—commercial processing takes much more time than doing it oneself.

There is something else worth considering—a darkroom can be a much-valued refuge from the often frantic intensity of the performing arts milieu. Under the amber glow of the safelights, the distractions of the outer world fade and are replaced by simpler satisfactions. Even after more than twenty years in the profession, I am still amazed by the magical transformation of film and paper into real images.

Darkroom Procedures

The darkroom is divided into *wet* and *dry* areas. Wet-side procedures include mixing solutions, washing equipment and containers, plus all the chemical steps of processing. Dry-side procedures are slide mounting, film sleeving, print trimming and mounting, as well as loading exposed film into reels or hangars for development. The enlarger and all the operations associated with it require dry conditions. Conventional practice says that the wet and dry areas should be several

feet apart or even in different rooms so that liquids or chemical powders cannot contaminate dry-side materials.

Kodak publishes several excellent pamphlets on darkroom construction and use that are well worth reading. My book, *How to Start and Run a Successful Photography Business*, Images Press, New York (1992), contains detailed information on efficient darkroom practices for both black-and-white and color processing.

The Black-and-White Negative

Anyone who regularly makes b&w prints must have a really thorough understanding of what constitutes a good b&w negative because bad negatives are extremely difficult to print. That which is not present in the negative to begin with cannot be added in the darkroom.

A negative is too thin when shadow areas appear clear and devoid of any detail. A negative is too heavy when highlight areas are completely black, or *blocked up*; it should be possible to read newsprint viewed through the darkest part of the negative. A normal negative will print easily on a #2 (so-called normal contrast) paper.

The contrast of photographic paper is a built-in characteristic determined at the time of manufacture, while the density of an image on photographic paper is primarily a function of exposure. This is not the case with film, where both exposure and development work together to establish the density and contrast. Film can record a range of brightness of greater than 128:1. Black-and-white negative film will record texture over a range of five or six f-stops, or about 64:1, and a subject brightness range of 512:1 or greater. Black-and-white printing papers, however, produce a reflection density or brightness range of about only 100:1. (Since the response of neither the film nor the paper is linear, there will be considerable compression in both the shadows and the highlights with some subjects.) If the subject brightness range exceeds the nominal 128:1 capability of the film, it is said to be a *high-contrast* subject. If the subject brightness range is substantially less than 128:1, it is referred to as *low contrast*. An incident light meter measures the brightness of light falling on a scene and recommends an exposure to put an average subject, like an 18 percent gray card, right in the middle of the useful density range on the negative. A reflected light meter would give the same reading under the same light provided that the reading was taken with the meter pointed directly at the 18 percent gray card.

If exposure of the film is always based on an average reading, and if development and printing are normal, prints made from both

high-contrast and low-contrast negatives look unnatural. Within certain limits, the contrast range of such negatives may be expanded or contracted by selecting a different grade of paper, but outside these limits the remedy for both excessive and insufficient contrast is based on manipulation of the relationships among exposure, development, and density.

When film development is extended, density continues to build up; however, the density of the highlight areas builds up faster than the density in the shadow areas. This allows contrast to be controlled by special processing. According to the motto of zone system aficionados: *Expose for the shadows, develop for the highlights.* In other words, a high-contrast subject may be compressed by overexposure and underdevelopment, while a low-contrast subject may be expanded by underexposure and overdevelopment. Ansel Adams's books *The Negative* and *The Print* tell the whole story.

A Good Black-and-White Print

How does one know when a print is good? The design of the image is paramount, but technically speaking, a good print is one that may be properly reproduced in a newspaper, magazine, or poster—a wide range of tones with significant details visible in both highlight and shadow areas is the most important factor. Of course, the print must be sharp and free of defects like fingerprints, dust spots, and scratches, as well.

The Technique of Printmaking in Brief

The chemistry of black-and-white print processing is basically the same as for black-and-white film processing, although the hardware is quite different. Developer and fixer are set out in trays rather than tanks. Unlike film, which is processed in absolute darkness and never touched while wet, prints are moved from tray to tray by hand under the surprisingly bright illumination of red or orange safelights.

To begin the printmaking process, a negative is selected from a file, inserted in a negative carrier, dusted with compressed air, and then placed in the enlarger, which projects an image of the negative on to an easel that has been preadjusted to the correct size. A piece of light-sensitive enlarging paper is inserted into the easel and exposed for some appropriate time, usually five to thirty seconds. The paper is

immersed with tongs into the developer and agitated to insure uniform development. Because the whole operation is done by safelight, it is possible to actually see the image gradually appear on the blank paper. This takes about two minutes, and then the paper is transferred to a *stopbath*, a dilute solution of acetic acid that immediately halts the process of development. The print is moved to a tray of fixer after thirty seconds of continuous agitation in the stopbath. After the print has spent a short time in the fixer, the white lights may be turned on, and the print can be evaluated. If it is satisfactory, the paper is then washed and dried. It takes hardly any more time to make a print than it does to read this short description.

Finding an appropriate contrast and exposure when printing involves trial and error testing, using small pieces of photographic paper (*test strips*) for economy. Usually two or three tries will yield a usable exposure.

Easily printed negatives are mainly the product of controlled shooting conditions, but in performing arts work, shooting conditions can be controlled only rarely. This means that performing arts photographers must rely on good printing techniques to produce results of consistent technical quality. If a brightly lit highlight is lacking in detail, it can be darkened, or *burned in*, by giving extra exposure in that location. I use masks fashioned out of cardboard for burning in very tiny or irregularly shaped areas. Most often I can quickly arrange my hands into a suitable shape.

Reducing local density is called *dodging*. A test print will reveal those areas that need *holding back*, or lightening. One's own hands or cardboard tools are used to prevent light from striking those parts of the print, such as deep shadows or dark clothing, that appear too dark. Care must be taken not to go too far—sufficient density should remain to preserve realistic modulation in tone in areas that would otherwise look unnaturally heavy and featureless.

Characteristics of Color Films

Two very different families of film are available for color photography: one for color slides and one for color negatives. Each type requires different chemistry for processing and different materials and procedures for printing. I process both types of film in my own darkroom, although fully 95 percent of my work is shot on color negative films and I print from negative films exclusively. A brief explanation of the functional and esthetic distinctions between negative and transparency films will clarify my choices.

Modern color materials are vastly superior to the films available even a short while ago. There is, however, a prejudice in the nonphotographic printing trade that says transparencies are superior to prints from negatives. This was true ten years ago, but now a color transparency has only a marginal edge. In fact, color negative is a tremendously flexible medium. It has a much wider exposure latitude than reversal films. Color balance, density, and cropping are easily controlled in the darkroom. There is, however, a psychological advantage to transparencies. Because they are viewed by transmitted rather than reflected light, transparencies do appear richer than an otherwise identical print. Nevertheless, the unavoidable fact is that when a transparency is reproduced on paper, whether photographically or photo-mechanically, its brightness range is reduced; it becomes a print like any other.

In most circumstances a color negative and a color transparency record exactly the same degree of detail. In other words, the *resolution* (detail-recording ability) of a negative and of a transparency can be identical. A print made from either medium loses some detail by virtue of the fact that a print is one generation away from the original image. A well-made original transparency, however, may be reproduced directly, which of course eliminates any losses associated with the enlarging process.

In the old days I shot performing arts assignments with two identical cameras, one loaded with black-and-white Kodak Tri-X and the other loaded with tungsten-balanced Ektachrome. Nowadays I shoot exclusively with Kodak Ektapress 400 or 1600, from which I make black-and-white prints on Kodak Panalure (now available in three contrast grades) and color prints on Kodak RA (rapid access) color paper. When color transparencies are required, I send the negatives out to a lab or else make them myself on Kodak Type 4111 color print film.

Color Printing the Simple Way

Low-tech solutions might appear tacky to those people who have succumbed to microprocessor fever, but I prefer a simple and direct approach whenever possible. The logic that justifies black-and-white printing in trays applies equally well to color work. Moreover, there is a powerful technical advantage to trays over machines that is unique to color processing for the low-volume lab.

In b&w printing, the main variables that must be attended to are contrast and density. When making enlargements in color, these fac-

Color Plate 1.
Jim Compton, who covers
native affairs for the CBC,
was photographed in front
of a diorama of a prairie
scene at the Manitoba
Museum of Man and
Nature. An electronic flash
was modified with a green
filter to match the available
fluorescent light. [Hassel-
blad camera, 100mm lens,
Kodak VPS film.]

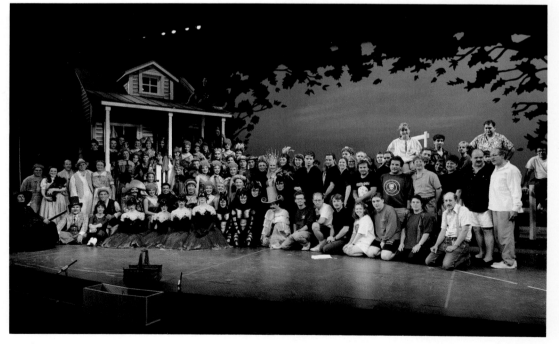

Color Plate 2. The cast and crew of Winnipeg's Rainbow Stage summer theater on the set of the
The Wizard of Oz. A large company is typical of joint amateur/professional productions.
[Hasselblad camera, 60mm lens, Kodak VPL film, f16 @ 1 sec.]

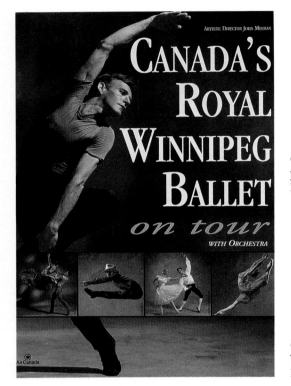

Color Plate 3. A Royal Winnipeg Ballet poster featuring the photography of Paul Martens.

Color Plate 4. Dancers from the Royal Winnipeg Ballet photographed by Paul Martens.

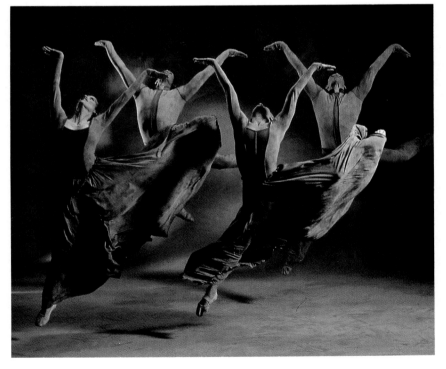

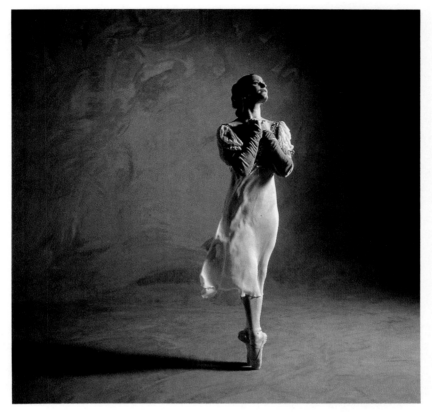

Color Plate 5. Ballerina from the Royal Winnipeg Ballet photographed by Paul Martens.

Color Plates 6 and 7. Two different images of a scene from the Prairie Theater Exchange production of *Dog and Crow* directed by Michael Springate. The top photo is my favorite. It conveys the awful intensity of the fight between characters even though it is blurry due to subject motion, but movement adds drama and power. The bottom is more static but sharper, and better suited for newspaper reproduction. [Nikon F3 camera, 200mm lens, Kodak Ektapress 400 film.]

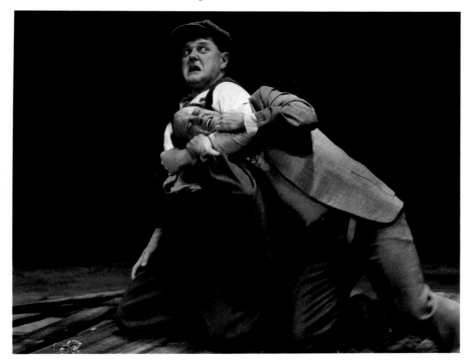

Color Plate 8. *Chartered Accountant* magazine commissioned this photo to accompany an article about accountants with unusual hobbies. This happy fellow spends his spare time playing in a band that specializes in fifties and sixties hits. An unfinished gyp rock wall served as a funky background. [Hasselblad camera, 100mm lens, Kodak Ektrachrome EPP film.]

Color Plate 9. A postcard for *Night Lines*, an FM Radio show featuring alternative music.

Color Plate 10. This elegant studio shot was created for a high-budget Manitoba government brochure intended to lure high-tech industry to the province. The image incorporates elements symbolic of the performing arts. The text describes the rich cultural life available for discerning newcomers. [Hasselblad camera, 100mm lens, Kodak Ektachrome EPP film.]

Color Plate 11. My studio photograph was used on the cover of *Opera Canada Magazine*, which featured a story about The Manitoba Opera Association.

Color Plate 12. A program cover for The Manitoba Opera Association.

Color Plate 13. A guest conductor/composer with the Winnipeg Symphony Orchestra, photographed by Paul Martens.

Plays about the beginning of the modern world.

Festival
Shaw
1992

APRIL 21 *to* NOVEMBER 1
NIAGARA-ON-THE-LAKE
ONTARIO, CANADA

CHRISTOPHER NEWTON
ARTISTIC DIRECTOR

Color Plate 14. A picture from the Shaw Festival brochure photographed by David Cooper.

tors remain important, but they are significant only after the correct color balance has been achieved. With my tray method, a test can be processed and evaluated in under three minutes, and a satisfactory final print can usually be achieved after a couple of tests. With feedback this fast, the exact state of the chemistry at any given time is unimportant. Changes gross enough to significantly alter the appearance of a print simply don't occur in ten or twelve minutes. In one stroke this method reduces processing time by 80 percent and completely eliminates the need for chemical monitoring. These economies also apply to batch processing of multiple color prints, which is very useful for the performing arts market.

Safelight

Aside from the dissimilarity in chemistry and materials, there are two other significant differences between color and b&w printing: The latter takes place at room temperature (68°F) under the light of bright safelights, while the former is intended to be processed at high temperature (95°F) in total darkness. These technical restrictions for color work would seem to make tray processing awkward, to say the least. Nevertheless, I have been able to work out a straightforward technique that makes color printing almost as easy as black and white.

After some experimentation, I discovered that very dim safelight will not affect color paper, so I equipped my b&w safelights with a light dimmer. Nominal brightness must be reduced by about 75 percent to set the safelight levels low enough to prevent fogging yet high enough to allow safe maneuvering around the enlarger and printing sink.

Temperature Control

Some simple technology is required to keep color processing solutions at the right temperature. I made a long shallow tray out of half-inch thick plastic. At forty-eight inches long, sixteen inches wide, and five inches deep, the sink within a sink accommodates three ordinary plastic 11" × 14" trays placed two inches apart. The trays sit snugly on the upper edge of the larger tray with a two-inch gap at the bottom. Hot tempered water is circulated through this space by a 750-watt Calumet Temperature Regulator connected through vinyl tubing to pipe fittings tapped into the side of the larger tray.

The first 11" × 14" tray holds six liters of Kodak RA (Rapid Access) Color Developer, the next tray holds an equal amount of the same acetic acid stopbath used for b&w processing, while the third tray is filled with Kodak RA Bleach/Fix (sometimes called blix). RA papers are developed at 95° for 45 seconds, followed by 30 seconds in the stopbath, followed in turn by 45 seconds in the bleach/fix.

The Calumet heater costs over $500. If this is too steep for your budget, a low-cost alternative is hot water right out of the tap—the *thermal inertia* of the chemicals and the water bath is sufficient to allow things to remain fairly steady with only occasional manual adjustment.

New Variables

Color printing is more complicated than black and white because color balance must be controlled along with density and contrast. Unlike black-and-white processing, which allows for a tremendous degree of control over negative contrast, the contrast of all color films is predetermined when they are manufactured. Fortunately, Kodak offers Ektacolor RA papers in three contrast ranges: *Portra* is lowest, *Supra* is normal, *Ultra* is highest. These papers are powerful new tools for performing arts photographers because we struggle constantly with unpredictable lighting conditions.

5 Efficient Techniques in Detail

My own experiences and the experiences of other photographers have convinced me that what follows will prove practical and useful to anyone interested in shooting performing arts rehearsals and performances. Many of the techniques described for particular venues can apply—with slight modification—to several others. Photo calls and studio work will be addressed in Chapter 6.

Theater

Rehearsal Protocols

The typical theater consists of a tungsten-lit stage at the front of an auditorium, and the typical theater assignment puts the photographer in a seat fairly close to the stage to watch a dress rehearsal a few days before opening night.

All the people involved in the production—actors, director, designers, technical staff, theater administration—will be stressed to some degree, depending on how well or poorly the production has come together. It is usually inappropriate to press for gossip about the true state of affairs, however, so information must be gathered in subtler ways.

Arrive at the theater early—that way you can greet familiar performers and theater staff, be introduced to the new faces, and chat with the director, stage manager, lighting designer, and the public relations folks who will shortly put your photos to work. None of these

people should be pursued or badgered, of course, but it is necessary to seek out whoever hired you and find out what he or she wants you to watch for. Sometimes the client is the P.R. officer, sometimes it is the artistic director, and sometimes it might be an outside promoter or producer if the production is to tour after a local run. Part of the responsibility of the photographer is to determine what is photographically possible, however, so observe the rehearsal carefully and remember to point out where the client's expectations might clash with technical reality.

Of course, the main reason for watching a run-through is to get a preview of the action and lighting. I bring along a spotmeter and take several readings during the course of the show so I will know what type of film to use and what exposure adjustments will be necessary. I also make note of where events happen on stage so that I can properly position myself, ready with the proper lenses, for all photographically significant scenes. It is important to get a sense of which dramatic moments might be disturbed by camera noise or movement around the stage, as well. Usually I don't bother anyone during intermission, but when the rehearsal is over I make it a point to find out from both the stage manager and the paying client whether or not a set photo is required and exactly when the rehearsal to be photographed is to begin.

There are always two starting times in theater: 7:30 PM *call* and 8:00 PM *curtain* mean that everyone associated with the show must be present and available in the theater by 7:30 PM in preparation for the performance, which will begin—come hell or high water—at 8:00 PM. Start times for paid performances never change, but rehearsal times shift all over the place, even moments before a scheduled run. It is a good idea to establish a reliable method of contacting stage management, if only to avoid unproductive waiting during unexpected delays.

Regardless of who is paying and who will use the photographs, at shooting time it is the artistic director alone to whom the performing arts photographer must defer about where and when to photograph. Total responsibility for the show resides with the director until opening night, when the whole thing is handed over to the stage manager. Until that time, and particularly during the final dress rehearsals, it is the director who decides what freedom of movement the photographer will enjoy.

Some directors are very professional and accommodating and will make sure the photographer and the players are introduced and aware of mutual goals—others are overbearing, fretful, petulant, distracted,

or worse, simply uninterested. My goal is always to insure that the actors and the director will let me move about freely in the first or second row in front of the stage: This allows for the use of moderately wide and normal focal length lenses that permit a variety of interesting views from many angles. The alternative, to be trapped in a seat farther back in the house, makes for a more restful but much more boring shoot.

Toward that end—decent working conditions—I try to create an understanding between myself and the director, whatever his or her temperament might be, by delicately restating the significance of the production photos. In touchy situations I try to negotiate a graduated series of restrictions rather than immediately accept an imposed exile. By persuading the director to agree to a few minutes of close-up shooting, followed by a quick pantomime consultation using hand signals or significant facial expressions, I get to demonstrate my tactful working methods and possibly earn my freedom for the balance of the rehearsal. If this doesn't work, I immediately withdraw to a less conspicuous shooting position as gracefully and as quietly as possible.

In many repertory theaters, the director for each show is different: They are hired by the theater's artistic director, who is, of course, a full-time staff member. Photographers are usually hired by the communications or public relations director, also a full-time staff member. Therefore, assuming a good long-term relationship between photographer and theater, an intransigent director puts himself or herself in conflict with two other important staff people besides the photographer. Consequently, there is some diplomatic recourse if the photographer is unduly hindered by the director's prohibitions.

Technical Preparations

Having witnessed a rehearsal and haggled for access, I start to assemble the appropriate gear and supplies. The first consideration is always film, and film selection depends on the end use of the photos, the lighting conditions of the show, and the intensity of movement of the performers on stage.

Available light stage photography is a balancing act between image resolution and the photographer's freedom. In the best of all possible worlds, every image made with a hand held camera would be grainless and sharply rendered, but in real life one must struggle to achieve acceptable results, although I must admit that recent advances in film technology have lifted a number of odious restrictions.

Early on in my fanatical pursuit of image quality, I felt it necessary to shoot with two sets of matched Leica rangefinder cameras and lenses—one set for black and white and one set for color transparencies. Color negative films are now so good that I have been able to abandon this tiring practice. At present my film choice dilemma is limited to deciding between Kodak Ektapress 400 and Ektapress 1600, from either of which I can make high-quality black-and-white prints, color prints, and color slides as required. I prefer to shoot with the slower speed material, but if my rehearsal spotmetering indicates that exposures will exceed 1/15sec with Ektapress 400, I reluctantly opt for the faster film.

The rapid incursion of electronic imaging technology into what was only recently the exclusive realm of silver-halide-based photography is making work easier for theater photographers. This is illustrated by the fact that the biggest newspaper in my city, the *Winnipeg Free Press,* recently built a new multimillion-dollar production facility without including the once mandatory conventional darkroom. Instead they have a machine for processing color negative film and electronic scanning devices for transferring images into digital data. The data files are then entered into computers that allow the photographers to electronically enhance and crop the images and make conversions to b&w if necessary. The digitized images are then transferred via modem directly to the composing room for electronic prepress assembly with the editorial material. The happy corollary of all this is that local performing arts groups no longer have to provide color slides or black-and-white prints for newspaper use—decent color prints are readily accepted.

I mentioned earlier that most performers and theater staff have been habituated to the noise of motor-driven single lens reflex cameras. Until very recently, my basic shooting tools were a motorized Nikon F3 and Nikkor lenses ranging in focal length from 20mm to 300mm. I never used zooms—although undeniably convenient for fast work in relatively bright light conditions, early variable-focus optics could not match the performance of prime lenses at the wide apertures dictated by available light work. Things have changed, and I have recently switched to autofocus cameras. An 80–200mm f2.8 zoom is my most-used lens. Computer-governed matrix metering has replaced my spotmeter in many instances. If a set photo is requested, I either load a 35mm camera with fine-grain Kodak Ektar 25 or I bring along some Kodak Vericolor II Type L, a Hasselblad with a 40mm wide-angle lens, and a tripod.

Shooting Technique

As I mentioned earlier, I prefer to work as close to the stage as possible, and if all the negotiations go well, I normally shoot from the space between the first row of seats and the stage.

I unpack my camera case and position my equipment and film on the seats in the first row so that everything can be quickly accessed during the run. I carry a penlight flashlight, its beam diminished with a few layers of masking tape over the bulb, in case I have to locate or adjust equipment in the dark.

Although I carry two camera bodies to the job, I shoot with only one—the second is a spare in case of mechanical breakdown. (I have never actually experienced a breakdown, but being prepared doesn't hurt.) Some photographers prefer to work simultaneously with two or even three bodies equipped with different lenses. I feel differently. Watching a dress rehearsal allows me to plan what lenses I want to use when, so I trade the intermittent effort of mounting and dismounting lenses with the constant inconvenience of having to juggle extra hardware dangling from my neck.

Behind-the-lens metering systems are undeniably convenient. Most such systems are center weighted, which means that meter sensitivity is concentrated mostly on the central 25 percent of the frame. Set the ASA dial to one-half the rated film speed and measure (in manual mode) with the central area of the frame positioned on a bright facial highlight. In difficult lighting situations, or for those rare occasions when I shoot only transparency film, I use my spotmeter, also set to one-half the film's rated ASA, to measure directly off a facial highlight, such as a cheekbone or forehead. I always use the face as a benchmark tonality for exposure control because natural-looking results depend on pleasing skin tones.

My experience has shown me that color negative films normally have enough latitude to record sufficient set and costume detail if typical Caucasian faces are exposed as described. Dark skin or very heavy makeup requires one stop extra exposure. Under most conditions, advanced BTL multisegment matrix meters will set accurate exposures in *program mode*, although under difficult circumstances perfectionists may want to double check the computer choice by shifting to spot mode.

Part of what I look for during the preview of the show is light-level fluctuations within and between individual scenes. When shooting, I try hard to follow any changes in brightness with appropriate changes in exposure settings. *I change exposure settings only when the light*

changes. The goal is to end up with negatives so consistent they can all be printed with close to the same enlarger settings.

Frame-to-frame consistency is virtually impossible to maintain using autoexposure systems. The contrast range in theatrical lighting is so extreme that slight changes in the posture or position of the actors trick autoexposure cameras into overreacting. Since facial highlights are almost always the brightest elements on stage, when an actor turns his or her head or simply moves around on stage, an autoexposure camera thinks that the overall light level has shifted and adjusts exposure accordingly. The inevitable result is a set of negatives in which each frame is differently exposed. Proof sheets will look patchy and unprofessional, and a lot of time will be wasted in the darkroom during printing because of the extra testing required.

When selecting an appropriate exposure setting, I choose the fastest shutter speed that still permits an aperture small enough to yield whatever depth of field is most appropriate to the shot. When shooting only one actor or several actors positioned the same distance away from the camera, I opt for a faster shutter speed rather than a smaller aperture. When two or more actors positioned at different distances from the camera are equally important, I will opt for a smaller aperture and take my chances with longer shutter speeds—I make the same compromise when elements of the set must also appear relatively sharp. When I am forced to use shutter speeds longer than 1/30sec I make at least two extra exposures per image as insurance against camera shake. Because of the increased possibility of focusing error, I make a couple of additional exposures per shot whenever I am forced to use a very wide aperture.

I find that for typical stage conditions my average exposure with Ektapress 400 varies plus or minus two stops around 1/30sec at f4. This seems to be about the standard for TV and film production as well.

Making the Pictures

During rehearsal I find that it is necessary to shoot more or less constantly in order to end up with the twelve to eighteen excellent photographs considered the minimum for promoting a show. That is not to say that the rest of the images are worthless, just that very few photographs qualify after the technical, political, and esthetic evaluations they must endure at the hands of the director, the theater management, the public relations people, and the performers. I usually go through six to ten 36-exposure rolls during two hours of shooting—maybe double that for a fast-paced or extra-low-light show.

I choose moments to shoot using four specific criteria. First, I look for images that have been specifically requested by the client or anyone else who has a professional interest in the production. Second, I make an effort to insure that each moment recorded is a faithful representation of the artistic intentions of the show. Third, I select moments that satisfy my personal esthetic standards. And finally, I decide if it is technically possible to capture an acceptable image given the technical situation at hand.

The last point is very important—there is nothing worse than offering a client a bunch of fuzzy or underexposed pictures of an otherwise breathtaking composition. When I discover that one or more critical shots cannot be made hand held during the run, I speak up: If the client feels strongly enough about the difficult images, a posed photo call will be arranged. Don't be shy about invoking this option, since photographers are not personally responsible for the limitations of the medium.

Taking a good picture is an act of *visual stalking* that is most effectively undertaken from a state of focussed concentration. The actual image making proceeds under the rules described in the section in Chapter 2 called *Keeping Still*. You will find that after some practice, the process of keeping still encompasses the mind as well as the body.

A wonderful bonus of performing arts work is the fact that all the events to be photographed have been designed and refined by the artistic sensibilities of others. The work of photography, then, is to carefully observe—and carefully select from—the consciously contrived configurations unfolding on stage. Three elements control the look of the photographs: timing, point of view (POV), and lenses.

Timing refers to the determination of the exact fraction of a second at which the shutter is activated. This choice is facilitated by keeping still—a relaxed state of readiness insures that when the right instant comes, you will be ready.

POV is strongly influenced by lens selection—where the camera must be located relative to the subject is a function of focal length because different focal length lenses offer different fields of view. I prefer to work at close range because the mechanical POV can be altered significantly by small shifts of posture or position. This flexibility means that I have a wider range of esthetic choices compared to what I would have if forced to work at a distance. The shorter the focal length, the wider the view. With shorter lenses, more of the background will be visible behind subjects located in the middle and near foreground.

Working close to the stage with a 35mm moderate wide-angle lens will cover a nearby actor from head to toe, or two or three actors from

the waist up. Close-ups require a 50mm lens or even a 100mm. Most of the time I alternate about equally between the 35mm and the 50mm. When a lot of the action occurs well away from the edge of the stage, I find that the 100mm sees more and more use, supplemented by a 200mm for tight close-ups. Using a long lens like the 200mm at slow shutter speeds is tricky, so I often lean with my elbows on the stage to steady the camera.

One drawback of working right next to a raised stage is that the mechanical point of view is located below the performers. When I was younger and more limber I used to stand with my sneaker-clad feet on the armrests of the seats in order to achieve a higher shooting angle. Nowadays I simply keep track of the way actors' heads and limbs are positioned in order to avoid pictures dominated by nostrils or an undignified view of a male or female crotch.

Shooting Etiquette

Two aspects of photographic work are potentially disruptive to theatrical events. The first is the physical presence of the photographer and the second is the noise of the camera. Ameliorating the offense of just being there has already been addressed: In most situations all that is required are good manners and a diplomatic negotiating style. Camera noise is a different matter altogether.

Some plays are generally noisy and some are generally quiet, but every play has both quiet and noisy moments. Unrestrained shooting is almost always safe when actors are speaking loudly or shouting and when they are moving about vigorously. On the other hand, very soft or even normal speech might be rudely interrupted by the clunk and whir of a motorized SLR. A partial mechanical remedy is the selection of a well-mannered rangefinder camera, such as one of the Leica M series, but no machine is completely silent. Here are three tips on how to work without destroying the mood of quiet moments on stage.

First, don't interrupt. Everybody in the theater knows that photographs are being taken, but suspension of disbelief, even in a rehearsal situation, induces forgetfulness during certain moments. Don't disturb those moments with the camera. Wait until the tender word, phrase, or gesture is completed before snapping the picture. Photographically significant configurations associated with very intense moments on stage usually linger for at least a second or two after a dramatic peak, so the opportunity to make compelling images will not vanish on account of a little restraint.

Second, trade distance for intimacy. Good actors become their characters when they work, and during very intimate scenes they can

be embarrassed or disoriented by any stranger who intrudes on that privacy magically established at the edge of the stage. The first rule goes a surprising distance towards making camera noise tolerable, but crowding a quiet scene can cancel that advantage. It is much more effective to move a little farther away and use a slightly longer lens, even though the natural urge is to get close. Your tactfulness will be appreciated.

Finally, pay attention to what the people working on stage are telling you—the photographer—directly. Since the rhythm of shooting closely tracks the rise and fall of dramatic tension, it is likely that the shutter will have to go off close to difficult or passionate moments for the performers. Keep an eye on the actors so that you will know if (or when) you are disturbing them. Generally speaking, well-prepared professionals will not lose concentration when a photographer is at work, provided they have had advance warning. Regardless, a rehearsal is a rehearsal because the work of preparation is not yet complete, so the potential exists for anyone on stage to momentarily lose his or her place and become flustered or angry. And whether it is justified or not, a photographer is always an easy scapegoat. Occasionally a particularly agitated actor will interrupt a rehearsal to demand that the offending photographer be hauled away. Such an upsetting event can be avoided. If a player is missing lines, dropping out of character, or making little gestures that indicate irritation, it is time to back off. In most cases a nod of acknowledgment followed by a few moments' respite from photographic scrutiny will allow an overextended thespian to regain his or her composure.

Working Farther Back

Difficulties arise whenever an easily distracted cast member or a protective director insists that the first or second row be abandoned as a shooting position. A new technical strategy must be adopted when working farther back because longer lenses are harder to manage and because the range of vantage points becomes limited.

Since the width of the house increases in a fanlike way away from the stage, simple geometry dictates that it is necessary to travel relatively greater horizontal distances in order to get a variety of views of the action. An interesting POV that might be achieved in three or four steps at the first row requires a twenty-yard hike at the back of the house—this trick must be accomplished silently and in the dark. In addition, the inverse focal length law requires faster shutter speeds for telephoto lenses or else a very, very steady hand.

My first instinct is to switch to a faster film in order to avoid the restrictions imposed by mechanical supports like tripods or monopods, but this is an option for bright productions only. Anyone lacking the stalking skills of a panther, therefore, will end up shooting from a seat somewhere in the house with the camera on a tripod.

Five considerations make stationary shooting at a distance more appealing than it might first appear. First, less running around means the work is less tiring. Second, since control over mechanical point of view is eliminated, one is able to better concentrate on timing and the selection of appropriate lenses. Third, being located farther away from the stage reduces the potential distractions of camera noise and physical activity, so freedom to shoot during quieter scenes increases. Fourth, with cameras firmly anchored, lots of extra exposures as insurance against camera shake are no longer so necessary. And finally, since the floor of the typical theater auditorium rises away from the stage, the compositional problems associated with a low-level perspective are eliminated.

Opera, Musical Theater, and Dance

Special Hardware

The basic techniques of live theater photography apply equally to opera, musical theater, and dance, particularly when they occur on conventional stages with the orchestra, band, or pianist sequestered out of sight in the wings. The presence of an orchestra pit, however, institutionalizes long-distance shooting. Nevertheless, the necessity of shooting farther back is not so awful for these venues because, as indicated in the preceding section, working from a seat in the house allows for a more contemplative approach.

Calmness is certainly an asset where there is a lot going on. Song-and-dance events—regardless of how elevated the program might be—often involve large casts and big sets as well as artistic, dance, musical, and technical directors. Movement is always complicated and sometimes very quick. New variables like intermittently open-mouths and the requirement to capture choreographically correct images make photography more difficult: It's just as well we get to do it sitting down.

Operatic melodrama often requires especially low light levels, and this fact, combined with the necessity of using telephoto lenses to reach over the orchestra pit, makes mechanical support a must. The Mani-

toba Opera Association can afford only one dress rehearsal. Because of the budget considerations, reduced-price tickets for this rehearsal are offered to students and seniors. The presence of an audience means I am restricted to a single shooting location. To make the work easier, I built a stand that attaches to the seats at the Manitoba Centennial Concert Hall, the home of the MOA.

The stand consists of a horizontally oriented 1" × 3" × 36" hollow aluminum bar supported by four retractable legs scavenged from a couple of old tripods. I use two three-inch C-clamps to secure the two back legs to the metal frame of the Concert Hall seats and then adjust the front legs to a convenient working height. I attach two tripod heads to the stand and adjust the horizontal and vertical locks so that there is sufficient friction to keep two cameras in position when unattended, but not so much friction as to prevent me from moving the cameras smoothly with only a small amount of effort. With this setup I am able to reliably operate at shutter speeds as long as several seconds.

I normally set up four rows back from the pit and midway between the center and the extreme edge of the house. I choose this location to avoid the head and arms of the orchestra conductor—visible from time to time in the center of the pit—and to spare the orchestra members direct exposure to the constant clicking of my shutters. From this spot I can pull in waist-up images of individual performers at center stage with a 300mm telephoto lens. The 300mm stays on one of the cameras during the whole rehearsal, since close-ups are the main requirement for the newspapers, for lobby enlargements, and for performers' portfolios. The other camera is used with 35mm, 50mm, 105mm, and 200mm lenses as required. Exposure is determined with the BTL meters and confirmed with a spotmeter when the lighting gets complicated.

Opera, musical theater, and ballet have an aspect of structure in common besides music—the chorus. The chorus is an assemblage of singers or dancers who work more or less in unison to support and enhance the main action. It is common to use photographs that show off the whole cast to promote large-scale works. When full company action shots are requested ahead of time, I set up my motorized Hasselblad—equipped with a 60mm or 40mm wide-angle lens—on a tripod nearby. The camera is aimed to cover the entire stage and loaded with either Agfa 1000 or Konica 3200 color negative film. I focus before the show begins and then tape the focusing ring in place. I trigger the shutter with a long cable release and adjust aperture and shutter speed settings from time to time, but otherwise the camera remains unattended.

Motion

Motion is pretty well invisible to the still camera, so a successful photographic documentation of these activities is an exercise in artful implication.

Shooting dance, or any sort of stylized movement such as theatrical swordplay, inevitably uses up a lot of film. Although motion-induced blur is undeniably attractive in some pictures, it doesn't reproduce very well. Most photos of choreographed events are expected to be sharp renderings of interesting postures, but in low-light conditions such images are elusive, to say the least. Shooting many images is the only guarantee that a few will be useful.

The odds can be improved by careful application of the rules about keeping still listed in Chapter 2, especially the one about the cyclic nature of gesture that says *every dramatic gesture evolves through motion to a moment of stillness, after which the configuration either repeats or dissolves.* This is true for fast as well as slow movement, but the moments of stillness are much shorter in duration in the former case; therefore one must be prepared to do some anticipatory guesswork and to accept a higher *shooting ratio*, the proportion of wasted shots to useful shots. Happily, dance by its nature is very repetitive, so there are usually several opportunities to capture most of the postures. Please refer to Chapter 6 for detailed advice on shooting dancers under studio conditions or while on stage during formal photo calls.

Having captured sharp pictures does not guarantee that they will be automatically acceptable because there are many levels of technical scrutiny beyond the photographic—the choreographer, the musical director, the fight master, and the performers themselves all have a say in what representations of their work can be released to the public. The ability to anticipate the reactions of these professionals at the moment of shooting requires a lot of experience—that's why many successful dance photographers are themselves dancers.

Shooting really complex movement is very demanding work, and simply watching a run-through beforehand is often not enough preparation. Preliminary consultation definitely helps, as does studying photos previously published in posters, advertising, and dance publications. The most direct approach is to do some practicing yourself: Most performing arts institutions are willing to allow photography at earlier stages in the rehearsal process provided the performers and artistic staff agree to it—if you work discretely and are willing to provide a few prints in exchange, this will not be a problem.

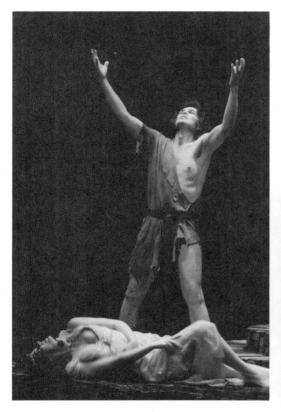

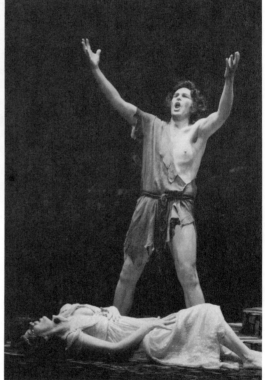

Figures 5 - 1a, 5 - 1b. These two images were made just a second or two apart at a Manitoba Opera Association dress rehearsal of *Salome*. Her passion and sensuality writhing at the feet of Jokanan (John the Baptist) captured in the right photo, caused quite a stir when it appeared in *Opera Canada*—many consider opera a fairly conservative genre. The right photo, demonstrates the open-mouth syndrome of opera. I prefer the closed-mouth version in the left photo. [Nikon F3 camera, 300mm lens, Kodak Ektapress 1600 film.]

The Open-Mouth Syndrome

Speaking and singing require the mouth to be open, but still photographs can easily render an open-mouth as awkward or undignified. Part of a performing arts photographer's job is to preserve a certain visual grace. Each and every type of production demands a different

level of restraint—ribald operatic farce will photograph differently than an exquisite contemporary dance. Good taste is the determining factor.

There are four subtle techniques for dealing with visual awkwardness. First, follow your instincts: If someone who isn't supposed to looks foolish on stage, resist taking a picture. Next, watch for graceful alternatives to dramatic moments that happen to be photographically clumsy—in opera, for example, duets where lovers stare balefully into each others' eyes while their mouths are gaping can appear pretty darn silly in a photograph, so wait a second for the more conventional embrace that will inevitably follow. Third, make a distinction between theatrical and photographic perfection because perfect moments on stage do not always make perfect photographs. In opera and musical theater, for example, the grand climactic gesture often translates as caricature in a still. Shoot sequences around such gestures and you will find that sometimes photographs made a second or two before or after the peak can retain the heroic mood while avoiding parody. Fourth, don't be shy about discarding negatives that are technically good but stylistically inappropriate.

Classical Music

Working Conditions

Classical musicians are difficult to photograph not only because their medium is not a visual one but also because their postures and gestures are by tradition severely limited. A very few new-wave classical performers like the extravagantly eccentric Cockney violinist Nigel Kennedy have brought some photogenic excitement to the concert stage, but most performers still appear in formal dress and don't move around much. What action they offer tends to be quick and jerky or very small and mild—both difficult conditions to translate to film effectively.

The blocking of classical presentations is not conducive to still photography either. The most photographable personality—the conductor—faces away from the audience while the rest of the players are seated in a big lump of chairs, music stands, and confusingly complex instruments. Soloists are more visible up at the front of the stage, but the orchestral clutter behind them is tough to handle tastefully. On top of all this add the fact that a dress rehearsal for an orchestra means that the session takes place on the concert stage rather than a practice hall, but not that everybody is dressed up like they would be for a real performance.

With up to a hundred or more performers involved, most orchestras cannot afford to mount a single-purpose photo call, so when promotional pictures are required everyone is compelled by pressure from management and by contractual obligation to don formal attire during a regular rehearsal. The photographer is typically given the freedom to work from whatever vantage points are necessary—this means shooting from the house, the wings, and, with a few provisos, on the stage itself. In my experience, however, budget restrictions limit shooting time severely. In addition, the performers are often uncooperative because no one really likes to work in fancy dress, particularly when the lights—and the temperature—are raised solely for the benefit of the photographer.

Shooting Strategies

There are some specialized technical considerations that have to do with musical instruments and their use—fingering, the manner in which the instrument is supported, and so on—that will be carefully evaluated by the musicians and the musical director, but beyond that, most of the information offered in the preceding sections on live theater, opera, musicals, and dance is applicable. In fact, shooting a symphonic performance from in front of the stage or from somewhere in the house is technically less demanding than shooting a play or an opera because for all intents and purposes nobody changes position and the lighting never varies. The main challenge in this work is esthetic in nature, namely, how to make interesting images of a somewhat stilted situation.

One strategy is to view the instruments as design elements around which to configure some of your shots. How do the musicians relate to and interact with their tools? Groups of players with similar instruments might offer some interesting repetitive patterns, or else some instruments and players can be used as frames, possibly rendered out of focus, with which to focus attention on other instruments and players. A second artistic point of departure might be faces—good musicians bring tremendous concentration and emotional power to their work, and this is often dramatically visible in facial expressions. Extreme close-ups can be another esthetic hook—the instruments themselves, as well as musicians' hands and fingers, are wonderfully animated forms that can take on almost mystical attributes when magnified photographically.

Naturally, the full realization of some of these themes is impossible without moving closer to the subjects, but shooting from the wings or from within the orchestra itself adds at least two complications.

The first problem is technical and has to do with lighting. Since stage lighting is intended to illuminate the stage rather than the audience, the majority of lighting instruments are directed away from a photographer working from the house, but on stage or in the wings this is definitely not the case. The flare sometimes caused by the inclusion of bright light sources within or slightly outside a photograph is unpredictable —sometimes dramatic and sometimes disastrous—so always use lens shades and always take alternate views from different angles for insurance.

The second problem has partly to do with shorter working distances. Shooting on stage means that certain individuals will be featured—or perceived to be featured—in important photos. There are lots of big egos in the symphonic world, so some hard feelings are inevitable. In a similar vein, it is difficult to know when small cliques or individuals oppose or support management, the conductor, or the musicians' union, yet these political undercurrents all figure in how receptive people are to being photographed or to accommodating a photographer who might literally be treading on their toes. The best policy is to keep an eye out for malcontents, and stay well away from them.

One final note: As I mentioned, it is likely you will be working among the musicians during an actual rehearsal. All players in a symphony orchestra depend to a large degree on the conductor to stay in time with everyone else, and nobody wants to screw up in front of his or her peers. Since it is very likely that you will obscure somebody's view of the conductor some time during your shoot, it is only prudent to prepare for this possibility by talking to management, the conductor, and a representative of the musicians' union beforehand.

Smaller Groups

Everything that I have described for large orchestras applies to trios, quartets, chamber orchestras, and the like, although smaller groups are less complicated politically and consequently more accommodating photographically.

Where I work, only the Winnipeg Symphony Orchestra can afford the 2,200 seat Centennial Concert Hall, so other classical ensembles use several smaller, more intimate halls around the city: I believe this to be typical of most medium-size communities. More modest venues mean more and easier access but also lighting and decor that are less sophisticated. Still, as a rule the smaller the stage the more helpful the technical staff, and I am always happy to trade additional photographic difficulties for a cooperative atmosphere. In addition, since

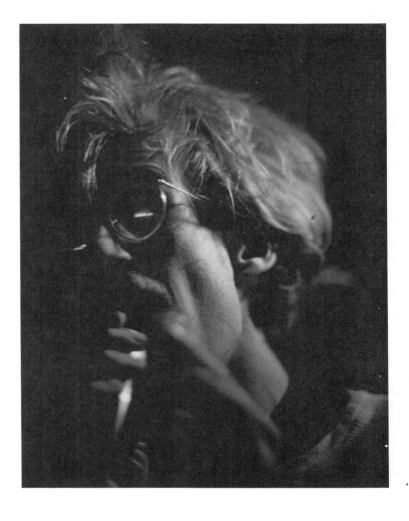

Figure 5 - 2. Rock 'n' roll singer during a performance. Lighting was provided by electronic flash units mounted on the band's own light stands. [Leica camera, 135mm lens, Kodak Tri-X film, f2.8.]

the rental costs are significantly lower, more time will be available for photography. The use of supplementary photographic lighting can be a practical alternative to available light work in small halls, as well.

Popular Music

I have found that popular musicians are easier to photograph than classical musicians because they are more animated physically and because their performances are staged and lit more imaginatively. Except for huge traveling juggernauts mounted by the biggest popular stars, the atmosphere around popular music is less formal and restrictive than that of the classical world, so photographers are more welcome.

The problem of when to shoot persists across the culture gap, since rehearsals in the highly electrified popular scene are necessarily technically oriented, and the costumes that will be worn in performance are not required. Interestingly, the various contemporary manifestations of what used to be called rock 'n' roll are so circuslike that the presence of a photographer directly in front of or even on the stage during a real performance is often perfectly acceptable to both the players and the audience. High-energy shows rely heavily on complicated lighting involving all sorts of motorized spots and other special effects, so avoiding unwanted flare is a major effort.

On occasion I add my own studio-type flash units to the piles of stage lighting and amplification equipment. Elaborate setups might include side lights and/or back lights, possibly filtered with gels. In such cases, I always shoot about half my pictures with fairly slow shutter speeds—perhaps 1/30sec to 1/4sec—to capture some action-related blur and some ambient color. I fire at will during the show—the constant popping of the strobes just adds to the pandemonium.

What to photograph—and in what style—are the two big questions. In popular culture there are fewer traditional guidelines and a great demand for shockingly original imagery. Oddly, a useful approach is to study the work of others—have your clients gather together a collection of ads, posters, or record cover art that they find appealing, and use the material as the starting point for a discussion on how you will work with them. (This idea is useful with classical artists as well, but the range of imagery will be much more conservative.)

As the style of the performers changes toward the less extravagant, so must the working style of the photographer. Very serious folk music manifests itself on stage in much the same way as classical music. One must be responsive to the sensitivities and expectations of the performers.

Outdoor and Street Performances

When the proscenium is the sky, temperaments mellow. For the still photographer, this means better working conditions—not only are performers usually more accommodating, but light levels are very comfortable as well.

Accessibility is determined by the size of the outdoor enterprise. Small events do not normally involve complicated security arrangements, so shooting in front of and/or behind the stage is not a problem. Large outdoor events are controlled more like large indoor events, and consequently arrangements must be made for the necessary permissions and passes a few days before the show.

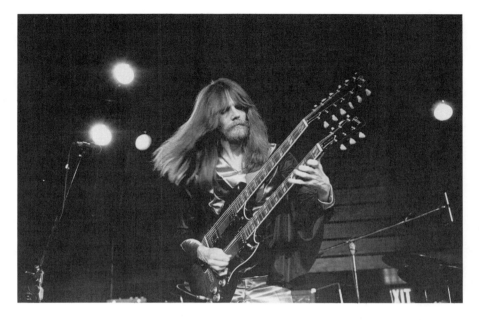

Figures 5 - 3a–b. The photo at the top of this page is rocker John Hannah in performance. The photo was taken using available light. [Leica camera, 50mm lens, Kodak Tri-X film, f4 at 1/30 sec.] The other black-and-white photos here and on the next page typify the sixties—a basement band lit here with direct electronic flash mounted off camera in various positions. Two of these kids are professional musicians today; one is a corporate lawyer. [Minolta SR2 camera, 28mm lens, Kodak Plus-X film.]

Figure 5 - 4. Outdoor available light promotional portrait of folksinger/composer Jim Donahue. [Leica camera, 35mm lens, Ilford FP4 film.]

One technical challenge that is unique to outside performing arts photography is color balance. All but the most modest events will incorporate some sort of stage lighting, but conventional practice does not take into account the difference in color temperature between daylight and incandescent illumination. Film or video lights are as a matter of course altered with blue gels or dichroic tungsten-to-daylight conversion filters to preserve a natural look, but for the live stage such provisions are rare. One reason for this might be that a difference in color balance helps sustain a kind of visual distinction between the stage and the rest of the world. In any case, still photographers must make some adjustment, by appropriate filtration on the camera, by appropriate filtration at the printing stage, or by selecting a tungsten-balanced film and hoping for the best.

Figure 5 - 5. A grab shot of street musicians and friends. The picture was made with available light on a bridge over the Seine River in Paris. It illustrates the value of working quickly. A variety of camera positions yielded strikingly different views in just a couple minutes of shooting. [Minolta SR2, 28mm lens, Ilford FP4 film.]

The exact technical response is tricky to determine, since the degree of correction changes according to the weather and the time of day. At midday the light on a fully exposed stage will be predominantly daylight, during late afternoon and evening the light will be a hard-to-quantify mixture of daylight and tungsten, while after sundown the light will be 100 percent artificial. In addition to all this, canopies or tents affect ambient color temperature according to the nature of the materials from which they are made.

My earlier recommendation to use color negative films holds true for outdoor stage photography as well. It is very difficult to keep up with changing color balance during a shoot, but the use of color negative technology moves the correction-making into the darkroom—a more contemplative arena.

Amateur Productions

For me, the most appealing aspect of amateur productions is the exuberance of the participants. They do it for love and they do it for fun—photography just adds to the excitement.

Although some highly evolved amateur organizations are indistinguishable from professional institutions, most are far more informal. This does not mean that photographic standards can be significantly lower, but it does mean that there is often a reasonable tolerance for error—a tolerance that is brutally absent when big dollars are at stake. Photographers, particularly those just beginning a career in performing arts work, can take advantage of this tolerance in a positive way by discussing beforehand the possibility of one or even more reshoots in case of technical problems. Most groups will not object to the extended presence of an enthusiastic photographer, provided their rehearsal regimen is not inordinately upset and they don't have to pay for wasted materials.

The big challenge associated with many amateur productions is low light—well-funded groups perform on conventional stages, but everyone else is relegated to school auditoriums, church halls, or the second stages of big theaters. Since modern materials make it possible to photograph virtually anything that you can see, you can always come away from even the most dimly lit show with some sort of photograph. The first and the easiest approach, therefore, is to load up with super-fast film—Konica makes a 3200 ISO color negative material—and fire away at the widest available aperture. Results will be grainy but often quite acceptable, especially if those who have asked for the photographs are shown comparable samples beforehand.

Figure 5 - 6. Not all drama takes place in established institutions. This portrait of a university student who performed in an amateur production of a Greek tradegy was shot during an evening dress rehearsal. Illumination was bounced electronic flash. [Leica camera, 90 mm lens, Ilford FP4 film.]

There are two inexpensive technical fixes that circumvent poor existing light, and both of them depend on the willingness of the group to sacrifice a measure of theatrical verisimilitude for an improvement in the technical quality of the production photos.

The first no-cost solution is simply to shoot a run-through using whatever existing light is available but with all colored filters removed and all dimmers set to full—this will result in at least an average two-stop increase in brightness that will usually permit the switch to a 1000 ISO, or even a 400 ISO film.

The addition of some supplementary light is a second, slightly more complicated alternative. A couple of medium-power battery-operated

slave-triggered electronic flash units, fixed in place with clamps or stands two or three feet above eye level at each side of the stage, will illuminate a thirty by twenty foot area well enough to use 400 ISO material at an aperture of about f4. The ultra-short duration of the flash will eliminate all subject and camera motion so that the performers, their costumes, and the set will be rendered very clearly.

With either of these methods, the only thing missing will be the ambiance of the existing stage lighting, but in the second instance this can be partially reincorporated by the use of longer shutter speeds for some of the shots. Both of these methods work well for those professional assignments where the existing light is not only low, but so simple that no one will object if it goes away.

Film and TV Production

Special Considerations

Moving pictures are created differently than live theater, so the techniques for successful still photography must be different as well. To start with, the time required to do the work will be much longer because all film and video, except for documentary recording and broadcasting of live performances, is shot in an extended, repeating sequence of set-up and rehearsal, followed by takes with the camera rolling. Such a disjointed schedule compels the photographer and everybody else on the set to work in fits and starts. This gives rise to impatience in some people, but more importantly, it disguises the plot, so some research, such as reading the screenplay or talking to the person in charge of continuity, is required to make pictures that are contextually relevant.

The exact working procedure must be negotiated with each production company. Sometimes a tactful photographer will be permitted to shoot unfettered during the rehearsal periods, in which case it is necessary to be sufficiently unobtrusive so as not to interrupt the performers or the many technical people. Shooting during a take happens very infrequently, but when it is requested, a flexible, sound-absorbent camera shroud, known as a *blimp*, is absolutely essential.

It is fairly common to be allowed some time with the performers just before a scene is to be dismantled after a final take, in which case very fast work is required because the whole crew will be on hold waiting for the still photography to finish. Different productions allow different degrees of access to performers for setting up shots off the set.

Technical and Esthetic Considerations

As discussed in Chapter 3, film and video lighting can be more sophisticated than theater lighting because lighting instruments that do not have to be hidden from an audience can be very large and positioned closer to the performers. In practice this usually results in softer, more natural lighting effects that look very pleasing in still photos.

For a couple of reasons, brightness levels are more consistent in film and video production than they are in stage production. First of all, shorter subject-to-light-source distances mean that lower-power lamps have more punch—this is easy to understand if you recall the inverse square law that says intensity falls off by the reciprocal of the square of the distance between source and subject. Second, both film and video are recording media that require minimum light levels very similar to those required by still photography in order to capture richly textured images—extremes of light during filming are avoided whenever possible, and technically challenging visual effects may be added or enhanced in post-production. All this, of course, makes life easier for the still photographer. Under typical conditions good results are achievable with 400 ISO materials, and under extreme conditions virtually anything that can be filmed can be photographed relatively effortlessly with 1600 ISO material.

Another bonus for still photographers arises from the similarity of optical esthetics among still, movie, and video cameras. In fact, cinematography operates under the same rules of scale and lens performance as still photography—what the cinematographer sees through his or her Cinemascope camera, the still photographer can see through his or her single lens reflex. Assuming production politics are favorable, this visual affinity permits and encourages some wonderful photography. Remember also that the lighting designer is working to support the vision of the director and the cinematographer/videographer so a complete appreciation of movie-making requires an appreciation of the lighting setup for each scene, as well.

The mechanical work of making films or videos proceeds outdoors in much the same way as indoors, although the visual tapestry expands dramatically. Even so, those scenes involving people that are sufficiently important to be documented photographically are lit and shot on a manageable scale—the process of production in such instances reduces the sun to the status of just another lighting instrument to be modified by diffusers, reflectors, and filters, while the landscape becomes just an element of the set. Whenever production values actually

Figure 5 - 7. Winnipeg CBC-TV evening news anchors Sandra Lewis and Mike McCourt photographed on location in one of the station's control rooms. Shot for a newspaper ad, this photo required a combination of electronic flash (diffused by a large softbox) and a one-second shutter speed at f8 to register the various video monitors. [Hasselblad camera, 60mm lens, Kodak VPS film.]

do shift to emphasize or exploit the truly grand view—whether inspired by a natural or a manmade vista—the still photographer must switch gears as well. Like a jewelry photographer who is asked to photograph a building, one must learn to think big. I don't mean to say still photos must be rigid reproductions of what the film or video cameras are looking at—just that it makes creative sense to synchronize visual perspectives, if only for the sake of a stylistic accord between the images that will be used to promote the production and the images that will actually appear on the screen.

In order to discover some of the interesting possibilities hinted at above, it is necessary to become a student of the cinematic gestalt and keep in mind that individual scenes often make little visual sense except from the point of view of the film or video camera. At a casual glance, a crowded set presents the confusing complexity of a misaligned hologram, but—like a hologram—when studied from exactly the right angle, it all comes together in exquisite harmony. Try to visualize what the cinematographer or videographer is working to create. Happily, this process becomes more and more exciting to experience according to the level of sophistication of the filmmakers.

6 Formal Photo Call and Studio Techniques

In this chapter I deal with studio work and formal photo calls together because they share a common characteristic—in each instance the photographer acquires a measure of control over what unfolds before the camera and so becomes something more than just a highly skilled observer. The exact degree of control depends on the circumstances and the personalities involved, but whenever part of a performance is staged solely for photography, the role of the photographer is automatically elevated from that of a straightforward service provider to that of a professional collaborator. Along with the change in status come new responsibilities and opportunities—photographers who are unused to being the center of attention will need to acquire a few new skills. I will use live theater as an example, but most of what I have to say applies, with some modification, to all the other venues as well.

Formal Photo Calls

Throughout the previous chapters, I have used the term *photo call* to mean any rehearsal or performance during which noninvasive documentary photography takes place. To my mind, however, a *formal photo call* is a special-purpose event consisting of fixed poses or short excerpts that are presented on stage specifically and exclusively for photographic purposes. In other words, at a formal photo call the still camera is the only important witness.

The above definition encompasses several configurations, but perhaps the most common are those formal photo calls typically scheduled

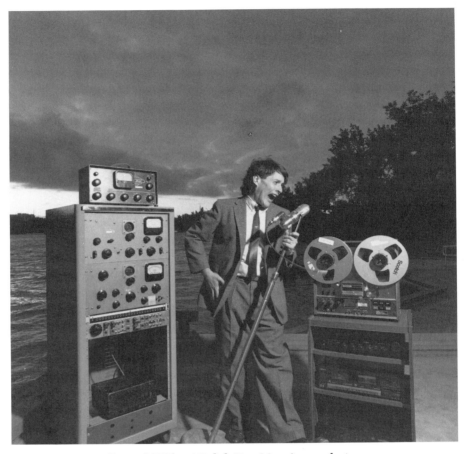

Figure 6 - 1. Radio and TV host Ralph Ben Murgi was photo-
graphed for a postcard promotion for the Canadian Broadcasting
Corporation radio network. The picture was made on a riverside
dock with direct electronic flash illumination set a level about
2 stops above the ambient daylight for dramatic effect. Vintage
radio equipment was supplied by the CBC.

just before or just after a regular dress rehearsal or performance.
Because of budget constraints, such events are usually no longer than
thirty to sixty minutes in length and may or may not be fraught with
tension, depending on the state of mind of the performers, the director,
the stage manager, the technical crew, and the photographer. The
tension level is a wild card simply because the civilizing influence of
an audience and the structure of a start-to-finish run-through are
absent. Indeed, everyone is compelled to appear early or stay late

Figures 6 - 2a, 6 - 2b. This pair of photos of actor Roland Hewglitt in Shakespearean garb illustrate the effect of diffusion. Single overhead light source. The photo on the right has been softened with a cross-star filter—note lower contrast and diffraction effect on reflective highlights. [Hasselblad camera, 100mm lens, Kodak Tri-X film.]

because of contractual obligations, and attitudes toward this sort of duty vary according to individual temperaments and the conviviality of the company as a whole—and these variables depend in turn on the state of perfection of the work being presented. The interplay of the participants' attitudes is important because quality pictures require cooperation and concentration, neither of which can long co-exist with animosity.

An understanding of what I call *formal photo call management* begins with an appreciation of the following fact: In an ordinary photo call the attention of the photographer is focused on the players, while

in a formal photo call the attention of the players is focussed on the photographer. In the first case the responsibility of the photographer is to be unobtrusive and alert, while in the second case the photographer is expected to be front and center and in charge—a daunting prospect without some experience, or at least some good advice.

The goal of most formal photo calls is to generate twelve to twenty-four key images, so the first measure of control is who gets to pick the shots. Arguments or highly vocal diplomatic discussions about what to shoot should never occur during the actual session—it wastes time and irritates everyone. It is more efficient to discuss the shot list ahead of time with the communications/public relations people as well as with the artistic director and the stage manager. Consultations of this kind are important because there are several technical and political factors that come before purely photographic concerns. For example, a complicated stage set might be too awkward to alter in the short time allowed, so some images might have to be shot in a way that disguises the missing elements—this requires the permission of the director, who is responsible for maintaining the artistic consistency of the production, as well as the cooperation of the stage manager, who is responsible for informing the performers and instructing the stage-hands. A second and related consideration is the order in which the shots are taken. At the end of a performance the sets and costumes will be different from the way they were at the *top* (beginning) of the show. Because the show must be *struck* (dismantled) and reassembled for the next performance, the logical chronology for an end-of-show formal photo call is to start with the last scenes first and work backwards to the beginning: It is easy to see why cooperation and concentration are indispensable commodities. There are, in truth, a lot of significant variables. Elaborate makeup, difficult costumes, or special lighting effects must also figure in the planning.

Control at the planning stage starts with your intelligent input into the discussion. Because there are so many things to juggle, theater staff all too easily lose track of photographic imperatives, so speak up: Tell them clearly what is and what is not technically and esthetically possible and desirable, if only to insure reasonable client expectations on the big day. Remember, reasonable expectations are expectations that can be fulfilled with reasonable effort. By being honest, you will have paved the way for a harmonious shoot.

After the shot list has been established and the members of the company have been informed of their responsibilities, one final consultation will complete the preparations. Because a formal photo call exists only for the camera, the lighting designer and the lighting technician in charge of the dimmer board are expected to cooperate

to make the shoot a technical success—a meeting can occur either a few days or a few minutes before the photo call, depending on the skills of the theater staff, the sophistication of the lighting hardware, and the complexity of the show. Naturally, if the photographer and the lighting people have worked together before, less planning time will be needed.

Most conflicts at this point arise from the lighting designer's understandable desire to preserve the integrity of his or her work. This worry can be mitigated by emphasizing the fact that in most cases the only alteration necessary is to raise the overall light level —the color filtration as well as the position and focus of individual lighting instruments can remain the same. Designers relax once they realize that a higher *absolute* level permits the camera to more accurately record the important *relative* levels. The one shift in relative levels that is occasionally required—brightening the back wall of the set—actually works to maintain the look of most shows in the final photographs.

The photo call itself can be a very politically complex event, since the customary pecking order will be temporarily upset. Actors who normally have the stage to themselves are no longer alone. Instead, they find themselves nose-to-nose with a photographer who is likely acting very much like an artistic director, albeit a mild-mannered one. The artistic director becomes something of a nervous voyeur, anxiously enduring the photographer's rearrangement of blocking and gesture. Hovering nearby will be the stage manager with a stopwatch—photo calls are expensive and overtime is an impossibility. The public relations department will be represented by one or more serious-looking beings clutching photocopied shot lists. Actors waiting for their turn to be photographed will be impatiently hanging about the wings and the house.

Some of these events are circuslike, with catcalls and lewd jokes and goofy antics on and around the stage. Others are very serious and silent and methodical. Sometimes the photographer is regarded as a machinelike extension of the camera—someone to take instructions and perform as directed. Other times the photographer is expected to be a policeman, somebody to take command.

The most direct route to a working understanding is to figure out who is supposed to be in charge and then try to figure out what his or her attitude is. If the artistic director is present, everyone will, ultimately, defer to his or her wishes. However, the director can be a wimp or a firecracker and just as easily interested in first-class photos as not. In the absence of the director, the stage manager and the public relations/communications person share authority—with the last word going to the stage manager. In either case, if a photographer is left to

his or her own devices to control the situation, it will be because of an unprofessional lack of support. When the photo call is over, however, it will be the photographer who will bear the professional consequences of bad pictures.

Maximizing one's prospects is an exercise in diplomacy. The way people behave at the preliminary planning meetings can offer some insight into how they will behave on stage and under pressure, but not necessarily. Keep in mind that even with established companies, directors, lighting designers, and performers may change for every new show and that first time out with a new contingent of professionals will be a revelation in group dynamics. Nevertheless, the photographer has surprising influence over the tone of the enterprise. The goal is to achieve concentration—yours and everyone else's—on the task at hand; consequently, the effective practice of diplomacy begins with self-control and, once that is achieved, extends to crowd control.

By self-control I mean that mental housekeeping that permits one to maintain equilibrium while skillfully circumnavigating abrasive personalities. To do this, it is necessary to come to the work well prepared technically, to keep in mind that you are paid to be there, and to treat everyone in the same way you would like to be treated yourself.

Crowd control is slightly more difficult. The first and most important step is to establish early that the performers are to take their instructions from only one person. Actors, by definition, follow detailed instructions very well, but their concentration is quickly diffused when they hear several voices coming at them all at once. Unless the director is extremely authoritarian, it is most efficient for the photographer—the person who knows what looks good from the camera position—to direct the actors through the poses or short excerpts that are to be photographed. Such control can be established ahead of time by negotiating a chain of command whereby the stage manager assembles the required bodies and props, which are then turned over to the photographer, who organizes them in consultation with the director and the P.R. people, as required. When things go smoothly, last-minute consultations about what the shot should look like take place quietly and discreetly and, one hopes, out of earshot of the performers. Once the nature of each shot is established, the photographer, with the permission and support of the director et al., delivers the appropriate instructions.

A combination of firmness, politeness, and gently conspiratorial cajoling usually keeps everyone on track, yet complete formal photo call management must extend well beyond the realm of politics and diplomacy. A measure of intimacy is required between photographer

and performer, especially right around those moments when photographs are to be made. Just as a successful play depends on the suspension of disbelief on the part of the audience, a successful formal photo call depends on the suspension of disbelief on the part of the performers. This is easier to understand if you remember that a photo call is related to a performance in the same way that a performance is related to real life: The participants' full engagement in the proceedings depends on their ability to transcend an array of mundane distractions. The skillful photographer will assist performers in their struggle to create believable snippets of emotion on demand. The main tool in this endeavor is a respectful attitude. One must remember that what performers do is difficult and that any patronizing or manipulative impulse will be instantly obvious—those who make a living from their ability to mimic the full range of human behavior are highly sensitized to artifice.

This sensitivity has, over a very long time, resulted in an elaborate, almost Victorian ritual of politeness among working theater professionals. Certainly formalities are regularly abandoned during intervals of humor, or anger, or frustration, or great exuberance, but those critical, brief seconds of interaction between photographer and performer are most productive if the conventions are observed. The word that best describes the proper language and deportment is *courtly*. Explain, rather than demand. Encourage rather than complain. If you must interrupt a speech or a scene in progress, do so gingerly, even mildly. When performers deliver what you need, say "Thank you"— every time.

The flip side of what an outsider might consider to be obsequiousness is the quite legitimate expectation that professional respect should and will be reciprocated. When performers lose their focus and behave badly, the only response is to tactfully but implacably insist on their complete attention—after all, they are required to concentrate for only a very brief period of time.

Studio Techniques

A Rationale

Professional photography exists to serve specific communications-related purposes—a visual problem is defined by the needs of particular clients, an appropriate arsenal of techniques and equipment is assembled, and the required photos are created. The question arises: If the purpose of documentary-style photography is to extract an archival

record, to provide up-to-date imagery for publicity and promotion, and to generate photographs for lobby displays and artists' portfolios, what more could a studio session possibly produce? The answer, of course, is pictures to order.

Chapter 2 began with the following sentence: "There are two fundamental approaches to photography: The first is a straight-forward documentation of things as they appear, while the second involves active manipulation of subject and lighting to achieve a preconceived result." The phrase *active manipulation of subject and lighting* sums up studio work very succinctly. Special theatrical images that must by themselves illuminate a poster, a billboard, a bus card, a magazine ad, or the cover of a souvenir program must be first imagined, then designed, and finally constructed. Some performing arts shooting approaches a level of sophistication equal to that of the most elaborate commercial photography.

Basically, studios exist for one reason—*creative control*. Documenting a performance or rehearsal, however sensitive or inspired such an exercise might be, is fundamentally derivative of the creative efforts of other professionals, while photographs made on one's own turf are for the most part original inventions.

The dramatic potential inherent in a totally controlled environment endows the studio with a quasimystical ambiance different only in scale from that of a theater stage or a movie set. The diminished scale is appropriate for the medium, however, since the very best still photographs, particularly the specialized portraiture specific to the performing arts, are reductionist masterpieces, authentic emotional landscapes captured in miniature. The tangible visual elements of performing arts events—costumes, props, set components, even the performers themselves—can be distilled by studio technique into two-dimensional imagery that is not necessarily representative but instead vividly symbolic. Not all studio work is exotic or difficult, but unlike stage photography, studio work can be an elegant advertisement for the imagination and creativity of the photographer.

The Technological Palette

As I suggested, sophisticated studio-based performing arts photography and sophisticated studio-based commercial photography have much in common—similar lighting techniques apply in each case, and many other options such as format, film type, and lens selection are handled similarly, as well. Literally dozens of comprehensive manuals dealing with commercial photography are available and well worth reading, but unfortunately for us, the majority of them make only

passing references to performing arts applications. The following discussion is offered to address that deficiency.

Introduction to Studio Lighting

Creative control cannot exist without technical control. In the studio such control must encompass every conceivable mechanical, optical, or chemical variable simply because each of them influences how photographs look. Nevertheless, it is universally agreed that the most important variable is light.

In Chapter 3 I said that the job of the theatrical lighting designer is "to evoke or enhance a series of emotional responses in the audience that will reinforce whatever is being presented on stage." Well, the still photographer working in a controlled environment must perform the same function, except the audience is whoever happens to view the finished photograph, and the stage is the studio.

We have already examined the four photographically significant qualities of light—intensity, color, direction, and specularity—and how nature and lighting designers deploy them in wonderful variety outdoors and on stage. Nowadays an amazingly wide spectrum of specialized photographic tools is available, permitting accomplished studio photographers an unprecedented degree of control, as well. In fact, modern light-modifying equipment is so accessible that lighting style, rather than lighting paraphernalia, is the factor that ultimately distinguishes one photographer from another.

Photography's 150-year history has witnessed a variety of fashions in lighting. Styles have tracked changes in picture-making technology at the same time as they paralleled the broader tastes of entire cultures. Early portraiture, for example, was lit by large skylights because there were no artificial alternatives to sunlight—consequently, human subjects appeared rigid and formal because they had to stay still for several minutes while whatever light was available built up sufficient density on insensitive emulsions.

Later on, with the advent of gas and then incandescent fixtures in combination with more sensitive films, portraiture became an elaborate exercise in which multiple specular sources were carefully balanced to build up a more stylized look. The glamour portraits produced in the forties by Hollywood's George Hurrel are perhaps the most highly evolved examples of this heroic style. Later still, in the sixties and seventies, electronic flash and fast films ushered in a period of experimentation as photographers, liberated by technical advances, began to capture life on the run.

The eighties could be called the "decade of the softbox," during which a combination of powerful electronic flash and large artificial windows reprised the natural effect of studio skylights but without restrictions on subject or camera motion. Recently, equipment manufacturers have added accessories like honeycomb grids and focusing fresnels that allow flash systems to mimic the effects of traditional theatrical instruments—now ersatz hot lights are often used to emulate Hurrel and his contemporaries. Actually, so many choices are currently realizable that no single stylistic convention predominates— a photographer builds whatever look best serves his or her personal purpose and the subject at hand.

Putting a Studio to Work

Conventional stage light employs literally dozens of specular sources arranged on tubular-steel grids high above the action. Audiences become used to frequent variations in intensity, extremes of contrast, brilliant back light, and awkward multiple shadows—they have no choice, since these characteristics are by-products of the physical constraints of typical venues. Happily, the expanded repertoire of lighting techniques available in the studio allows the presentation of performing arts imagery in a very appealing manner.

Flattering nonspecular lighting is much easier to achieve in the studio than on stage, since without an audience to consider, big umbrellas or softboxes can be positioned very close to the subject(s). In addition, there are at least three solid reasons beyond ease of use that make such an approach desirable.

To begin with, bright soft light works beautifully with slow, high-resolution films. Images made this way are richly textured, very clear, and remarkably different—even to ordinary folks—from the grainy, contrasty results often associated with documentary-style photography.

Second, soft light is more tolerant of changes in subject position. Specular light is by definition very directional over a narrow area of coverage, which means that a small change in the position of the subject will result in a significant change in the apparent lighting effect—it is mainly variations induced in this way that make documentary photography such a technical challenge. On the other hand, soft, nonspecular light covers a much broader area, so exact subject positioning is not as critical. For inanimate subjects none of this matters very much, but for human subjects it definitely does—because movement is natural to humans, soft light allows a measure of spontaneity that hard light does not.

Figure 6 - 3. This studio still life ended up as a poster for a play about the life of Albert Einstein. Props were constructed from photocopied images of Einstein at different ages culled from an encyclopedia—the images were rephotographed on high-contrast ortho film and then mounted to cardboard and taped upright on a seamless paper background on which a number of parallel lines had been scribed. A hard light above and behind the set provided the shadows in the foreground. [Hasselblad camera, 150mm lens, Kodak Plus-X film.]

And finally, soft light helps simplify visually complicated subjects. One of the most powerful techniques in still photography is—for lack of a better word—*editorial* in nature. By this I mean the selection or emphasis of significant details and the de-emphasis or elimination of extraneous details, a practice that enhances both graphic and emotional impact. This process is particularly important for theatrical

subjects because they tend to be encumbered with larger-than-life accessories: Details of costume, makeup, and hair style are often exaggerated so as to read more clearly from the stage. Hard light makes complicated subjects even more complicated by amplifying tonal variations, by adding dense shadows, and by creating bright reflections whenever shiny objects are included within the frame. The forgiving embrace of soft light does exactly the opposite.

I don't mean to imply that carefully managed hard light is not of value, although it is true that many of the stunning visual effects achieved by skillful lighting designers elude the camera, mainly because they are created for the eye rather than for film. Even so, the same effects, slightly attenuated, can be spectacular in a photograph. My advice is to use part of your documentary shooting time to study the lighting designer's art and then import the most exciting tricks into the studio.

Make theatrical-style lighting more useful by observing the following guidelines: First, avoid tungsten-incandescent fixtures in the studio. Such lights are extremely inefficient because they convert fully 80 percent of the electrical energy they consume into heat, and much of that heat is reflected or projected onto the subject by the same lenses and reflectors that direct the light energy—hence the less-than-affectionate nickname *hot lights*. Incandescents are common in theater because they are continuous, easy-to-dim sources, not because they are convenient to handle. Fortunately, flash tubes are small enough to be perfectly satisfactory specular sources and efficient enough to provide adequate light levels, minus the extreme heat. Professional electronic flash units incorporate modest-sized *modeling lamps* (75 to 150 watts) that avoid unpleasant temperatures but still allow lighting effects to be effortlessly previewed. Sophisticated systems such as Speedotron, Balcar, or Elinchrome offer a variety of light-modifying tools sufficient to duplicate the performance of any conventional theatrical instrument.

Next, learn to apply theatrical lighting techniques moderately. If soft light is a visual embrace, hard light is an optical chisel. The trick of transporting a lighting designer's sculptural cleverness from the stage into the studio is *contrast control*. Keep in mind that photographic film and paper cannot accommodate the same range of light levels as the eye and the brain. To visually duplicate a particular effect involves matching the brightnesses, positions, colors, and relative sizes of the lights in the original setup. To photographically duplicate a particular effect involves matching the positions, colors, and relative sizes of the lights while subtly altering relative brightnesses so the

range of luminosities of the subject can be properly accommodated by the film. Generally this means maintaining highlight-to-shadow ratios of no greater than 4:1.

Basic Lighting Tools for the Studio

A modest but professionally oriented complement of lighting equipment is required to reliably produce the results described above. I recommend an electronic flash outfit that includes at least three flash heads—one for a main light, one for a background light, and one for a hair/rim light. Power is not a major concern in portraiture—commercial flash generators come rated up to 4800ws (*watt seconds*), but smaller units in the 800 to 1000ws range are certainly adequate.

More important than power is *recycle time*—the time, usually expressed in seconds, that the unit takes to recharge between flashes. Portraiture is very much concerned with spontaneity, which means there are periods in a session when the ability to shoot fast is critical. One or two seconds is not too long to wait between exposures, but ten or twelve seconds most certainly is. Fast recycle times require high current draws, in the fifteen-to-twenty ampere range, so flash units must be supplied with separate power outlets of adequate capacity.

To achieve a variety of soft and hard light effects, the flash heads will have to be fitted with light-modifying accessories. For soft effects these can be as simple as a large white reflector card, but commercial-quality umbrella or softbox reflectors are preferable because of their relative ease of use. The larger the reflector or umbrella or softbox, the softer the light. I have several softboxes, ranging in size from 4ft × 6ft to 1ft × 2ft. Honeycomb grids or barn doors mounted directly on the flash heads can be used to manage hard-light effects—black cardboard or tinfoil will do in a pinch.

Sturdy stands will be required to position the lights. A *boom* is an extremely useful tool for exact placement of main and hair/rim lights. A boom is a pole that mounts more or less horizontally on top of a light stand—the most useful variety has two small hand cranks at one end that can be used to precisely control the up/down, left/right orientation of any lighting instrument mounted on the other end.

Fill light can be controlled or modified by passive reflectors, made of foamcore board or reflective fabric stretched on a PVC or metal frame. (Frames for reflectors can be cheaply constructed using plastic plumbing pipe or electrical conduit pipe and some white nylon.) You will also need some black cardboard for use as *flags*, which are used to block or reduce extraneous light and to control flare.

Figure 6 - 4. Camera-ready velox print—an advertisement for a
financial firm that appeared in several performing arts companies'
programs. Photo was made with four tungsten spotlights and
smoke-machine-generated fog. Some retouching was required.
My client was Tom Powell Design Studio. [Toyo G 4" × 5" view
camera, 150mm lens, Kodak VPL film, printed on Kodak Panalure
paper, f22 at 5 sec.]

Figure 6 - 5. Bernie Micheleski's instituional/cultural ad for Great-West Life Insurance Company.

Also useful are a few different types of diffusion filters. These can be a set of commercial filters, such as the Hasselblad Softar series, or low-tech substitutes such as bits of pantyhose, window screen, or Saran wrap.

Working With a Designer

Contemporary technical freedoms notwithstanding, there are limits to style that cannot be circumvented by clever application of hardware: In the studio, photographs are created rather than constructed, so

Figure 6 - 6. The original layout for Tom Powell Design's generic cultural ad produced for James Richardson and Sons. See Figure 6 - 4 for the final version.

imagination must transcend technology. Photographers blessed with an intuitive, spontaneous design sense are naturally well suited to posing performers and arranging theatrical still-life setups in appealing ways. More pragmatic types can acquire an appreciation of good composition by studying the work of accomplished photographers, past and present.

My own abilities lie somewhere between those of an artist and those of an artisan—I appreciate visual art, and I enjoy using techno-

logical toys to make it. I am not, however, one of those amazing virtuosos who can conjure up exciting visual concepts on short notice; consequently, I am very pleased to work with individuals who often can: Whenever a photograph is intended to be a critically important ingredient of an advertising campaign, a promotional poster, or a fund-raising brochure, I prefer to work with a graphic designer. Some performing arts clients, lacking cash or experience, try to produce promotional material without the benefit of design input from professionals. I always counsel against this practice, since it invariably leads to unrealistic expectations and wasted effort.

Graphic artists or graphic designers are to the printed page what an architect is to a building. They are fluent in a sophisticated two-dimensional idiom that consists of color, typeface, illustration, layout, and paper. To a designer, a photograph is simply one of several components in a construct that is intended to be greater than the sum of its parts. Such photographs are postulated at the design stage, illustrated with a thumbnail sketch or tested with a quick Polaroid shot at the planning stage, and finally brought to life as a cooperative effort during a studio shoot. The photographer's own nature and working style determine exactly when his or her involvement in the process begins.

When I work with designers, I try to think of myself as a problem solver and a facilitator. It is exciting to experience the creativity of others and to participate in the realization of their two-dimensional fantasies. The only difficult part is helping them understand the technical limitations of the medium and the constraints imposed by modest budgets. We in North America are inundated daily with excellent high-budget photography in national and international magazines, on packages, and on billboards and posters. As a result, all of us have extremely high visual standards: Designers, by nature and by training, are pushing for the cutting edge, but they or their clients cannot always afford to pay the real-life costs such as those incurred in finding or fabricating special props, costumes, or studio sets.

The best way to keep designer-clients' expectations well grounded in a manageable reality is to invite them to participate in a process of *pre-visualization*. The famous nature photographer Ansel Adams invented the word to describe the intellectual elements of the *zone system*, his ultra-sophisticated method of exposure control—now use of the term has expanded to describe the technique of mentally previewing all aspects of creating a photographic image. This is a powerful tool, akin to psychologically internalizing the target in a Zen archery exercise, but most clients are unable to do it. Happily, graphic designers and artists

are well used to thinking about imagery—at least in terms of typefaces and layout and illustration—so pre-visualizing a photograph is only a modest stretch. I have found that working together in this way promotes a very harmonious and productive professional relationship.

7 People Skills for Performing Arts Work

Egos, Artists, and Diplomacy

In the foregoing discussion, I described some of the many tools and technical procedures required to produce credible photographs of performing arts events. In so doing I included some advice about how to manage the complicated relationships that arise during the communal creative act of mounting a sophisticated production for the stage or screen. The word that best describes this nontechnical set of skills is *diplomacy*. Diplomatic relations are, of course, political in nature. (The *Merriam-Webster Dictionary* describes politics as, in part, *competition between groups or individuals for power and leadership,* so the allusion is appropriate.) The interpersonal machinations one must deal with as a photographer are not unlike those faced by a freshman ambassador to the United Nations.

Some performers in very large cities are able to avoid constant travel by doing a variety of jobs in addition to performing, but the great majority of those involved with the performing arts are necessarily transients, unable to live close to where they work. Many arts-oriented administrative jobs are longer term than acting jobs, although such positions often last only two or three years. The basic fact of life in the performing arts is constant change—days, weeks, or months of uncertainty separated by four-to-six-week intervals of intimacy and hard labor. Add to this the fact that the performing arts, by their very nature, are highly visible. In fact, criticism—often brutally frank, if not savage—is an institutionalized aspect of the whole business.

Only politics and the performing arts guarantee participants soul-wrenching public dissection on a regular basis.

The flip side of all this is adulation. Audiences attend performing arts events for a variety of reasons, but generally people are looking for stimulating emotional, intellectual, even spiritual experiences. When performers really deliver, they are instantly rewarded with applause, praise, love, gifts, fame, and—from time to time—money. Administrators, technical people, and photographers share in the rewards to some degree, particularly when budgets are large and audiences reliable.

Both survival and success in this topsy-turvy world tend to encourage the development of strong, if not distended, egos in all the players, whether they toil on stage or behind the scenes. There are many kind and reasonable people in the performing arts-related professions, but only saints can endure the relentlessly fluctuating pressures of pleasure and pain and still maintain equanimity. Most of us recognize that the ego is a defense against emotional assault and that rituals of politeness are required so that strong egos can interact productively. Perhaps jet-set photographers like Richard Avedon or Lord Snowden can demand and receive cooperation whenever they want it, but most photographers of the performing arts occupy modest positions on the political totem pole and so must rely on diplomacy and tact.

The rest of this chapter is intended to offer a little insight into the organization and politics of that aspect of the performing arts world that extends beyond the stage.

The Role of Photography in Marketing the Performing Arts

Entertainment, however elevated it might be, is a commodity. Government subsidies and grants from benevolent corporations or individuals notwithstanding, ticket sales drive the performing arts economy.

Studies and surveys have shown that the most effective method of selling dance, theater, and live music is direct mail, followed by newspaper advertising, followed by television and radio. Nowadays posters are more valued for their intrinsic value as visual art or as collectables, rather than selling tools—they just don't reach enough people.

The technology of mass communication is usually put to use to communicate information or light entertainment, but something more must be transmitted in the special case of performing arts marketing. Potential customers must be enticed by a kind of emotional foreplay,

by hints and glimpses of a spectrum of pleasures, both cerebral and sensual. To do this effectively and tastefully requires a fairly specialized approach.

Sometimes it is only necessary to remind patrons of the power of well-known classics like Shakespeare, or Beethoven, or "Guys and Dolls," or Johnny Cash and to provide details like dates and venue and ticket prices, but when new works or unfamiliar performers are to be featured, a measure of patron education is required. The short list of useful advertising mechanisms provided above indicates that visual imagery must logically play an important role in the process—hence the need for good photography.

Photography is at once a subtle and a powerful tool. Since performing arts photography portrays human figures and faces, infinitely graduated shades of meaning and emotion may be presented. Farce and tragedy and comedy and love—every imaginable passion and enterprise—can be evoked. Sometimes the emotional data is so condensed that a single photograph becomes an icon, an instantly recognizable symbol: Consider Yousuf Karsh's rear-view portrait of the aged Pablo Cassals practicing his cello. Other photos are sublimely tantalizing, or exotic, or exuberant, or even mocking and sharply satirical.

The emotional and informational range of photographs is so wide that those who use photographs regard selection and cropping as very serious undertakings. The process is further complicated by the fact that photographs, like the performing arts themselves, convey information on many levels at once. This intellectual richness makes excellent bedfellows of photography and the performing arts, but it is also responsible for many arguments around exactly which photographs will be used and exactly how they will be used: Performers are concerned about how good they look, choreographers are concerned over technical perfection, artistic directors want to conceal enough aspects of plot to sustain suspense and drama, marketing people want simple, emotionally charged pictures that will reproduce well, and so on.

Politics and Personalities

Public Relations People

In almost every instance, the client—the person who hires, fires, and authorizes payment of the invoices submitted by the performing arts photographer—is a public relations or communications professional. If a production were a house, these people would be real estate agents.

Because their main job is to sell tickets, they are usually in charge of advertising. They also manage relations with the media, mediate disputes with disgruntled patrons, and dispense complimentary tickets. Choosing a photographer, organizing photo calls, and selecting and distributing publicity stills is obviously only part of the job description.

The responsibilities listed above cannot be fulfilled in a vacuum. P.R. people must deal with constant pressure from above. Artistic directors, theater managers, and board members are notoriously curious and sometimes very demanding about advertising, promotion, and media relations. Colleagues and associates—designers of all kinds, stage managers, technical producers, as well as stage hands and their union representatives—will help or hinder the work according to their dispositions, the nature of the production, and the interpersonal skills of the public relations/communications specialist. Actors and other performers add another potential measure of grief: Because working relationships in the performing arts are much more intense and intimate than those in the typical office environment, displeasure manifested by even a very minor player can sometimes taint the most finely tuned promotional effort.

The background, the personality, and the manner in which they obtained their post all help to determine the working style and the effectiveness of communications types. My guess is that about half of them are exclusively marketing oriented. Such people often come to performing arts promotion from advertising or sales positions in business and industry—they seek out the work because it seems exotic compared to what they were doing before, or they are sought out because they have been very successful selling other products. They need to know something about what they are flogging, of course, but they are not necessarily passionately involved in the artistic aspects.

The balance of public relations people, at least in my experience, are drawn from within the performing arts community. For example, an ambitious actor might find after a few years on the boards that his or her interpersonal skills are more highly developed or of greater interest than his or her skills as a performer. Such a person might volunteer to lead public tours of the theater facility, to do local interviews for TV or radio, or to assist in community outreach or fund-raising activities. Sharp-eyed managers are always on the lookout for intelligent and personable support people, so capable individuals with a bit of flair are often offered junior responsibilities in the public relations department. The bottom rung involves sealing envelopes and running program corrections over to the printer, but once even a part-time presence is established, administrative skills tend to accumulate rapidly.

The two types of P.R. people interact with photographers somewhat differently. Those without a theatrical background are understandably less aware and consequently less interested in the subtleties of the work, while those with theatrical backgrounds are sometimes too interested. Those who come from nontheatrical backgrounds are usually unaware of the technical limitations of performing arts photography and consequently suffer from unreasonable expectations, while those in the business and already habituated to good work can be overly controlling and view photographers as warm-blooded tools. Mainly, however, the biggest difference is vocabulary.

Public relations jobs seem to have an average life of two to four years in the performing arts institutions with which I am familiar. The potential for insider/outsider tension exists whenever someone new takes over. Photographers can make life easier for themselves by simply talking on a regular basis to the professional communicators with whom they must work.

Administrators

No professional performing arts institution of significant size exists without a managerial structure similar to that of any purely commercial corporation. The basic elements of business—namely, accounting, forecasting and budgeting, dealing with regulatory agencies, and more—must be attended to appropriately for a theater or dance troupe or symphony to survive, particularly in today's austere climate. Those individuals who are charged with fulfilling such responsibilities need not necessarily have artistic souls, but the degree to which they can empathize with those who do determines, to a surprising degree, the congeniality of a performing arts workplace.

Since photographers are usually political lightweights who exist in a shadow reality located outside and between the artistic and administrative camps, managerial style can make life either a lot more or a lot less difficult. Consider the following observation: In business there are basically two types of people—those who wish to profit at the expense of the other guy, and those who try to insure that success is a cooperative affair in which all participants benefit at once. Since everyone in the performing arts is sensitive about something, there is endless opportunity for conflict, but skillful managers are capable of simultaneously mediating disputes and supporting individuals while steering a course that strengthens the whole institution. Compassionate and intelligent administrators are capable of bringing photographers in out of the cold.

Fund-Raisers

Many performing arts companies are strictly commercial, so success or failure depends on marketing and good management alone. Lots of other companies, especially in Canada and Europe, are subsidized or sponsored in some measure by governments charged with the responsibility of preserving worthy enterprises of an intellectual and cultural nature. Such enterprises have a certain lofty cachet with the public, and so direct solicitation of money for ongoing expenses and for special projects is an accepted element of their financial operations. Fund-raisers are professionals or highly motivated volunteers who rely on an array of techniques—usually a relatively tasteful hybrid of Madison Avenue hype and high-minded begging—to bring in much-needed dollars. As both a public service and a way of guaranteeing the survival of valued clients, I donate my professional skills for a few fund-raising projects each year. I sometimes ask that my out-of-pocket expenses be covered, depending on the scope of the project.

Artistic Directors

Artistic directors in the theater, directors in film, choreographers in dance, and producers in TV are not just artists. They are political animals who must relentlessly sweet-talk, inspire, fight, cajole, wheedle, and otherwise outrageously manipulate people in order to fashion a public vehicle for their creative vision. Life for many of these people is precarious because they, like photographers, are only as good as their last assignment.

My twenty-year tenure with the Manitoba Theater Center encompassed the coming and going of several different artistic directors. Their careers with the company lasted three years on average, and each followed a similar pattern: One year of honeymoon-type sweetness and light, one year of working experimentation and political wrangling, and one year of success, dissatisfaction, or outright war, followed by a resignation or a dismissal. The actual time involved in each of these stages expanded or contracted somewhat in individual cases, but the substance and format remained the same.

New artistic directors are typically hired to bail out or revitalize a faltering institution. Usually the incoming director has acquired some credibility during a successful stint at another theater. The expectation is that such success—defined in this business as good ticket sales, good reviews, and no operating deficit—will be repeated. The first year is harmonious while the director learns the political ropes and makes a study of what needs to be changed and how to go about doing the

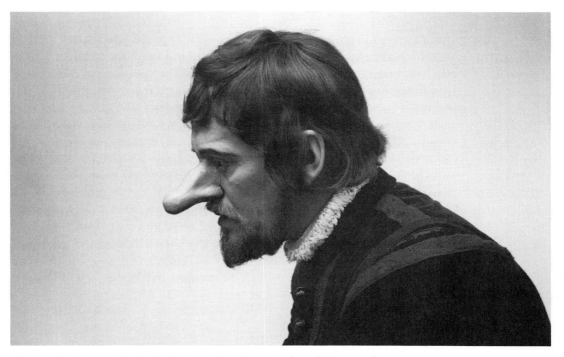

Figure 7 - 1. Actor/artistic director Len Cariou played Cyrano de Bergerac during his tenure at the Manitoba Theater Center. He wanted to see the effect of a variety of noses and wigs from different points of view. This portrait in costume was made against a light-colored wall at the theater with a flash bounced from the ceiling. [Leica camera, 35mm lens, Ilford FP4 film.]

changing. First-year choices for productions are usually conservative and reliable. Year two is the make-or-break year as the *artiste*, now more certain of his or her power within the organization, starts to take risks and exert some personal pressure. By year three the honeymoon is over. If the director is a moneymaker—popular with the public, the politicos, and the critics—then life is sweet, at least until next season. More often than not, however, nits are picked and molehills are turned into mountains as the cry of *off-with-his-or-her-head!* sounds anew in the boardroom, the balcony, or the entertainment pages of the local papers. Artistic directors know very well that people are really hard to please.

The foregoing scenario gives only a hint of the uncertainty that can haunt artistic directors through their entire careers. One sobering thought—photographers are just one of literally dozens of potentially difficult professionals that these people must deal with.

Writers

Surprisingly, writers occupy a position quite akin to that of photographers in the performing arts world in that they both produce works that are appropriated by others and put to use in ways that may not coincide with the intentions of the original creator. Politically and mechanically, writers are often excluded from the process of mounting a particular play or film—their work is considered to be a kind of emotional armature around which a larger artifact is constructed by the artistic director and the company of actors and technicians. Photographers, like writers, are often constrained to be observers rather than active participants. What they both do is acknowledged to be important, but definitely separate from stagecraft. And finally, writers, like photographers, are chronically underpaid in all but the most extravagant performing arts venues. Perhaps because of all these similarities, I find writers easy to talk to. I often solicit their insights about productions we might both be involved with.

Set and Costume Designers

These people are largely responsible for the look of a production. Both roles can be assumed by one individual—a condition that typically results in a very consistent visual/esthetic statement on stage. Some performing arts companies have resident designers, but mostly different people are imported specially for each show. Once a particular show is scheduled, long-distance consultations between the artistic director and the resident production staff and technical crew might be carried on for a period of several weeks before the designer(s) arrive at the theater, usually a month or so before opening night.

Since most of the important technical information will have been received well ahead of time, upon arrival designers tend to assume a role similar to that of a general contractor on a construction project. That is to say that many other individuals—needleworkers, carpenters, scenic painters, and prop makers—are actually responsible for the physical work, while designers are responsible for quality control and deadlines and insuring that the artistic director is satisfied.

Much of the budget of any large or complicated show, even one with a noncelebrity cast, must be devoted to the set and costumes. In addition, production costs are pushed even higher by demanding celebrities who expect that their working surroundings will be as sophisticated as their reputations. All this means that designers, typically free-spirited and free-spending types, are squared off against theater managers and comptrollers who must control the purse

strings. Directors—by profession advocates of artistic freedom and, by necessity, reluctant financial pragmatists—are caught in the middle. This dilemma has ballooned to truly epic proportions in the feature film, popular music, and network television industries.

Once again, it is easy to understand the approach/avoidance conflict that arises whenever a photographer appears on the scene. Frictions reach their apex just before opening—just at the point when theatrical photography must happen. The possibility for discord is in fact increased by the appearance of a photographer, since the photographic needs of designers are considered secondary to those of the communications people: Set and costume photos are the first to be eliminated from photo call schedules whenever deadlines are tight.

Prop Makers

These craftspeople are skilled artisans and scavengers who are highly valued for their impeccable taste. They work directly under the set designer, and they must find or fabricate the many objects and artifacts required to establish a believable ambiance on stage or on set. Unless truly rare or extremely valuable items are required, the props department is usually a pretty relaxed place. Photographic requirements are limited to simple documentation plus the occasional printed photographs or slides to be used as set elements.

Lighting and Sound Directors and Designers

The work these people do helps establish or reinforce dramatic atmosphere. Of course, sound and light are less tangible than cloth and wood and paint, so preproduction preparations are, of necessity, somewhat limited. By this I mean that relatively more work must be done on stage with performers present—a tech-run is a rehearsal dedicated entirely to coordinating sound and light with the physical movements of the performers on stage.

Any sophisticated performing arts production demands a synthesis of literally hundreds of interrelated elements. The recent advent of digital computer control has automated many manual procedures at the same time as it has radically elevated the creative potential of audio and lighting technology. Complicated productions will have several tech-runs during which the responsible professionals and their support crews work intensely with the artistic director to synchronize and fine tune hundreds of subtle and not-so-subtle effects.

Three factors combine to keep light and sound professionals under pressure. First, technological change is relentless. Because information

IN RETROSPECT CON'T

MTC is...'world class theatre...''

REG SKENE, WINNIPEG FREE PRESS
DECEMBER 13, 1983

GREASE/1981

MIDSUMMER NIGHT'S DREAM/1978

DEATH OF A SALESMAN/1979

ROYAL HUNT OF THE SUN/1978
THE DINING ROOM/1984

Typesetting: Xact Digicreatronics Inc.
Color Separations: Great Western Graphics
Printing: Public Press

Photography: Gerry Kopelow
Design: Tetrad Design Group Inc.

Figure 7 - 2. An inside page from a brochure intended to drum
up season ticket sales for the Manitoba Theater Center.

is so broadly disseminated, technical people are at once tempted and
frustrated by a rapidly expanding cornucopia of tools. Second, direc-
tors are passionately interested in maintaining reputations at the
esthetic cutting edge: They all want to experiment with the newest
toys. The final factor is related to the Peter Principle, which says
workers tend to rise in an organization until they reach their level of
incompetence. What I mean here is simply that technology and tech-
nical people do not necessarily increase in sophistication at the same
rate. Many theater professionals are left to their own devices to main-
tain or upgrade their skills. Having worked for many years with a
conventional manually operated dimmer board, for example, does not
automatically qualify someone to manage a computer-based system,
yet a surprising number of people are expected to do just that. Learning
on the job can be a frightful experience when the job involves brutal
deadlines—this explains, in part, why twenty-four-hour work days are
so common in the theater and why some lighting designers are disin-
clined to alter existing light cues to accommodate a photographer.

Hair, Wig, and Makeup Specialists

No sophisticated production can rely on performers by themselves to take care of all the details of appearance. Period pieces are especially difficult to manage. Hair, wig, and makeup specialists are involved early on in the rehearsal process to consult with the costume designer and the artistic director—if the budget does not permit professionals to be present all through the run, performers are carefully coached about how to take proper care of their faces and their coiffures long before opening night.

A common mistake photographers make is to underestimate the importance of these people and their work—since they attend to very intimate details one on one, hair and makeup artists can influence the mood and morale of an entire company. Since they literally have the ear of every member of the cast, they can quite effectively bad-mouth a photographer who might omit to record at least a few clear close-up views of their handiwork. Sometimes particularly accomplished or fastidious artists will commission detailed special-purpose portraits for portfolio purposes. In addition, many commercial photographic assignments require hair and makeup people in attendance, so good relations at the theater can lead to a mutually beneficial relationship on the outside.

The Technical Crew

By the time a production is ready for photography, the technical crew—encompassing sound and light technicians, as well as carpenters, scenic artists, and stagehands—should have mastered their respective functions so well as to have become more or less invisible. This does not mean that they should be overlooked or unappreciated. The exact opposite is true, since the jobs these people perform, however unobtrusively, effectively animate every performing arts event. Should they happen to be highly visible during a dress rehearsal or even a technical run-through, it is a sure sign that the show is significantly behind schedule.

Above and beyond their indispensable contribution towards assembling a great-looking and smooth-running show, the technical crew is charged with the safety of whoever works on or around the stage. This is a serious responsibility. I have witnessed a fire on stage—a papiér-maché candelabra ignited in an actor's hand—and I have seen a performer slightly injured by a falling light fixture: Both these events were frightening, but they would have been much worse had not competent stagehands reacted immediately and precisely.

Still photography almost always means extra work for crew members, since it is they who must zoom about backstage, on the overhead catwalks, or in the carpentry or paint shops, quickly rearranging things according to the instructions of the various designers and directors and public relations people who have an interest in the photo call. All theater contracts specify that union members (and virtually all the technical people working in larger halls are unionized) must facilitate photo calls and other promotional undertakings to some degree, but it is just human nature to consider such activities as somehow superfluous to the more important task of mounting the show.

It is also prudent to remember that while artistic directors, designers, P.R. staff, and even general managers come and go, stagehands and other unionized technical staff tend to work the same venues for many, many years. As a result of such long experience, some individuals can become valued dispensers of advice and support and theatrical lore.

Unfortunately, inadvertent slights can lead to long-term problems. Early on in my career I enraged the rather thin-skinned stage manager at the Manitoba Centennial Concert Hall, home to the Winnipeg Symphony and the Manitoba Opera Association (as well as countless big-profile touring shows), by neglecting to clean up the packaging from fifteen or twenty rolls of film after a long photo session. Until his retirement twelve years later, the persistent fellow noisily badgered me about the incident every time I had to work in his hall, about once every other month. Photographers can promote good relations by being patient and considerate and tidy—of course, a few appropriate complimentary photographs will always be appreciated.

Seniority and the Silver Screen

So far, this chapter has concentrated on those companies concerned with creating productions to be performed before a live audience, and, as we have seen, they are quite complicated in structure. Nevertheless, theater, dance, and musical institutions look positively Spartan compared to the labyrinthine organizations required to crank out feature films. What follows is a brief sketch of the artistic and technical hierarchy of the movies.

Traditionally, the *producer* is in charge of all noncreative aspects of filmmaking, but because producers are the ones who find and control the money required to finance the whole undertaking, they carry a lot of clout. In these days of hyperinflated budgets, producers wield so much power that they regularly demand input in casting and editing.

The *executive in charge of production* makes certain that the interests of the studio or production company are safeguarded on the set.

Executive producers are concerned only with money and usually remain uninvolved in the actual filming process, but sometimes they will be summoned by a panicky studio or production company if the predetermined production budget is being exceeded by an extravagant director. Producers are supported by various *assistant* or *associate producers*. The *line producer* or *production manager* actually runs the day-to-day operations of the production in the studio or on location.

The *screenplay*, also referred to as the *script*, contains the movie's plot, or story, in dialogue form. A screenplay is the creation of a *screenwriter*—or a group of screenwriters—but it is the responsibility of the *director* to make the script come alive. As in the theater, movie directors oversee the entire creative process. For some films, the director and the producer might be the same person. Directors can be screenwriters as well, but usually they are concerned with adding instructions for camera angles, lighting, and a myriad other technical/esthetic details: This results in a *shooting script* in which scenes are divided into shots and arranged in a not necessarily chronological shooting schedule.

On the set, the director is always at the center of the action—virtually an absolute dictator, benevolent or otherwise. Directors work one on one with the performers and the *director of photography*, although some authority will be delegated to *assistant directors*. The *first A.D.* is responsible for maintaining a smooth-running operation on the main set, while the *second A.D.* is in charge of shooting footage of less important scenes or scenes that don't involve performers.

The director of photography is responsible for *framing* (or composition)—what the camera sees. In harmony with the intentions of the director, the D.O.P. supervises the technical and esthetic components of lighting. On large productions, the director of photography does not actually manage the camera—that task is delegated to the *camera operator*, who is in turn assisted by the *focus puller*. The *supervising editor* works with the director to sequence and assemble the film. Usually the editor will make a preliminary assembly, or rough cut, which will then be carefully refined in collaboration with the director. The *assistant editor* is responsible for all the mechanical tasks associated with the editing process, including processing, inspection, and transportation, but it is the *apprentice editor* who does the actual physical work.

Many others contribute to the overall look and feel of a film, but the most influential is the *production designer*. Like the set and costume designers in theater, the P.D. has considerable power, particularly on

period film projects or sci-fi epics. Under the production designer are the *art director* and staff, the *construction coordinator* and *carpenters*, as well as the *set decorator* and the *properties* (props) staff.

The *sound designer* has control over all audio elements of a movie, including recording the performers, incidental music, sound effects, and whatever ambient noises might be required to maintain authenticity. *Sound effects editors* and *Foley editors* specialize in creating and incorporating special audio effects—audio atmospherics—in the final cut. The actual tape-recording is done by the *sound mixer* or *sound recordist*. Microphones are handled by the *boom operator*, a kind of professional contortionist who must remain for long periods in uncomfortable postures so that the microphone can be close to the performers but out of view of the camera.

The *chief lighting technician*, or *gaffer*, directs the installation of all the lighting hardware required to establish the effects specified by the director and the director of photography. The *best boy electric* supervises the lighting crew and electricians. The *grip*, or *key grip*, takes care of everything technical that is not electrical. Assisting the grip is the *best boy*, and several other grips assigned to specific tasks. For example, the *dolly grip* is the one who controls the motion of the wheeled cart that supports the camera during nonstatic shots. *Continuity* people insure that props, lighting, costume, hair—even actors' gestures—are logically connected and consistent from scene to scene. The *script supervisor* performs a similar task for the spoken words. The *location manager* finds (scouts) locations and arranges whatever supplies and technical support are necessary for shooting away from the studio. Catering is handled by *craft services*.

The *unit publicist* is in charge of publicity and promotion during production, while, last but not least, the *unit photographer* makes still photographs on set during filming.

Performers

I have purposely devoted the preceding pages in this chapter to describing the significant roles played by the many professionals who never set foot on a stage during an actual performance because I wanted to show how indispensable their services actually are. Having done that, it is time to discuss those professionals who live to perform.

There are only a few thousand stage and film artists who actually achieve what middle-class North Americans might consider to be fame and wealth. All the rest labor in relative obscurity for low pay. What drives these people? For many, it is a deep and abiding romanticism, an appreciation of the richness and eccentricity of the ancient traditions,

and the desire to entertain and to enlighten fellow humans. Just as many others are motivated by a compulsion, an unfulfilled adolescent need for admiration. There is no question that exhibitionism and vanity are significant factors.

As any behavioral psychologist will tell you, intermittent reinforcement is nearly irresistible—many ambitious performers struggle on, encouraged by a good review here and an enthusiastic ovation there, hoping against hope that the right part will propel them upward into the limelight of Hollywood or Broadway.

The talent—actors, dancers, musicians—are the raw materials from which artistic directors construct their elaborate esthetic monuments. When I photographed my first theatrical production, "Alice Through the Looking-Glass," at the Manitoba Theater Center in 1971, I was absolutely astounded by the actors in the green room (the traditional name for the actor's lounge) after the rehearsal. How well chosen they were, how perfectly cast! The performers off stage were just like the characters they played on stage. I was sharply jolted after shooting the next show, only a month later—some of the same players were involved, and they had seamlessly assumed new off-stage personalities that exactly matched their new on-stage characters. When you talk to an actor, you can never be certain exactly whom you are talking to.

It must be difficult to retain a notion of self while having to inhabit daily the personae of other beings—beings carefully crafted by powerful writers and relentlessly fastidious directors. After faithfully assuming and artfully rebroadcasting the counterfeit personae, it must be difficult to accept the brief but often outrageously outsized accolades or barbs from audiences and critics, only to return to a more modest existence hours or days later. I think the reality of this rather brutal psychic cycle accounts for the high rates of divorce, depression, and substance dependency among many otherwise accomplished performers.

Although I certainly value what performers do, I cringe at the thought of what they have to go through to do it. Few outside the performing arts industry are aware of how carefully controlled, how minutely orchestrated the behavior of performers on stage or in front of the camera must actually be. There is, of course some collaborative interaction, but in most cases it is a matter of following fanatically detailed instructions to the letter, or else. Some performers do achieve a true spiritual communion with the intentions of the director, the choreographer, the playwright, or the composer, but this condition is sufficiently rare as to maintain many performers in a state of constant tension and insecurity.

Add to all this the fact that performers spend much of their time not performing. In the film and TV industry the familiar lament is *Hurry up and wait!* So many technical details must be attended to between shots that the actors—however highly paid or highly strung they might be—are obliged to remain on emotional standby during a ten-, twelve-, or sixteen-hour day punctuated by, perhaps, sixty minutes of real work. Stage performers and touring artists must be available for two or three hours in the evening, but they are often left to their own devices for the rest of the day. Dancers and musicians are somewhat protected by the technical nature of their crafts—much time is devoted to practice and rehearsal of a general nature. Still, the working life of a dancer can be short—and musicians are sometimes victims of fickle popular fashion and increasingly sophisticated recording technology.

I don't mean to paint a grim portrait of performers as emotionally fragile egotists, but it is necessary to be aware of a few of the realities in order to understand why some of them are so damned touchy once in a while. I recommend that the occasional difficult person be approached with a compassionate, cooperative attitude. After all, performers are the raw material for all performing arts photographs, aren't they?

8 Photographic Needs of Individuals

Introduction

The following chapter is divided into several sections, each of which deals with the particular photographic needs of clearly defined groups of individuals working in the performing arts. The advice and suggestions offered in each section are not intended to be exclusive to any one category, however. Feel free to mix and match.

Actors

Of all the individuals who buy performing arts photographs, actors are by far the most enthusiastic. This is a consequence of the fact that, although they are masters of many voices, actors make a living largely by their appearance—and appearance changes amazingly from role to role. A record of these changes is required for both sentimental and professional reasons. On the one hand, a collection of good performance shots is reliable evidence of a productive and interesting working life, and on the other hand, the same collection is a reliable instrument for acquiring new work.

Actors need three types of photographs: performance/rehearsal photos, portraits in costume made offstage in a studio setting, and head shots, what ordinary beings would call portraits. The *8 × 10 glossy*—a black-and-white photographic enlargement eight inches by ten inches in size, with a shiny surface—is, by tradition, the universal format.

Figure 8 - 1. Portrait in costume made by bounce flash in the green room at the Manitoba Theater Center during the run of *Billy the Kid*. [Leica camera, 50mm lens, Kodak Tri-X film, slight diffusion.]

Some performing arts institutions are very helpful when it comes to connecting performers with production photos, while others are less accommodating. When relations are harmonious, someone from the P.R. or communications department will insure that proof sheets are tacked up on the bulletin board in the green room, that order forms are provided, that money is collected, and that the photos are delivered. In a wholesome environment, this type of courtesy is viewed as a morale booster for the cast and, as a consequence, healthy for the theater in the long run.

When selling photos to performers is regarded as crass commercialism by the administration, other, more direct arrangements must be made. Since it is the stage manager who is responsible for the production after opening night, he or she will have to agree to some sort of arrangement for the distribution of photos and the collection of cash. Once the S.M. is on your side, very often an actor or a member of the crew can be persuaded to take care of these matters in exchange for free photographs.

Not every performer can be flatteringly featured in production photos made on the run; consequently, portraits in costume are very much appreciated, particularly by supporting actors, members of an opera or ballet chorus, and amateurs. Since it is awkward, if not impossible, to shift valuable costumes from the theater to the studio, it is necessary to move the studio to the theater. Once again, the success of this enterprise depends on the cooperation of the stage manager. If everyone concerned is enthusiastic about the idea, a simple studiolike setup—involving a seamless paper or painted canvas backdrop and a couple of electronic flash lamps with suitable reflectors—can be created somewhere backstage or in a nearby rehearsal hall. Photographs of interested individuals can be made before, after, or during a performance shortly after opening night. Proofs can be posted and orders taken along with the regular production photos.

In order to recover the cost of the extra film, processing, and time, I charge about 50 percent more for such photos than I do for regular productions. Typical rates are $10 or $12 for production photos, $15–$18 for portraits in costume, and considerably less for multiple prints. Portraits in costume are very much in demand by the performers and the relatives of performers in sophisticated amateur productions, particularly those involving children. Interestingly, many celebrity performers want portraits in costume once they realize the level of quality that may be achieved under photographically controlled conditions: Make sure that a few good samples are posted together with the notice announcing the session.

Black-and-white head shots are the calling cards of the performing arts world. Virtually everyone needs one, and that includes lighting, costume, and set designers, directors, even stage managers, as well as performers of all kinds. Head shots are typically the first contact between a performer and a prospective employer. Many theaters display head shots of the cast and artistic staff in the lobby or box office for the duration of whatever show is currently on offer. A quality head shot will often be printed together with an interview in a newspaper or a magazine and will normally accompany biographical notes in the program.

Head shots must depict performers as intelligent, competent, physically and perhaps sexually attractive, energetic, engaging—in short, special. A tall order.

The basis of the work is conventional portraiture, which is usually, but not always, undertaken in a studio. Kodak publication #O-4, *Professional Portrait Techniques* ($23.95), available through any camera shop, will provide a solid technical foundation. Beyond that, it is necessary to synchronize with the needs and desires of the subject, while keeping in mind the styles and treatments currently in vogue within show-biz circles. At the beginning, one can learn what approaches are in favor by studying photographs in entertainment magazines and books and in theater lobbies. If you can negotiate access, the files of actors' representatives, booking agents, casting directors, and theater directors will contain hundreds of real-life samples. A request to examine such material is not so outlandish—all these people require good photographs of the performers with whom they work.

Although the head-and-shoulders portrait is still the favorite, the combined influence of contemporary documentary, editorial, and fashion photography has expanded expectations in some circles. Magazines like *Rolling Stone, Spin, People, Premier,* and others have created a market for what might be called *environmental portraiture*—strong full or half-figure pictures that place entertainment industry personalities within a particular context, be it home, work, or play.

As I mentioned, actors make a living largely by their looks, so most of them have a fairly clear notion of what they want to look like in a photograph. This is helpful, except when expectations exceed the potential. Under such circumstances it is important to take a realistic, but diplomatic, approach in a pre-session consultation.

A useful tactic for establishing exactly which style best suits a given individual is to ask for sample images that he or she happens to like

Figure 8 - 2. A young concert pianist photographed using a single bounced flash against a plain wall in a rehearsal studio. The geometry of the grand piano is used to frame the subject, who has been positioned to emphasize her capable hands and her steady gaze. [Leica camera, 35mm lens, Kodak Tri-X film.]

or dislike—these may be culled from appropriate publications, or from friends in the industry, and so on. A brief discussion around these images can reveal personal preferences as well as provide an opportunity to relate costs to specific esthetic choices. Fees for performing arts portraiture vary from a modest $50 for a quick studio session involving one roll of film, proofs, and a single 8 × 10 print, all the way to several hundred dollars for a definitive upscale image of a demanding celebrity shot at some exotic location.

Figure 8 - 3. This informal portrait of cellist Bryan Epperson was used together with the photo on the back cover in an institutional/corporate advertisement produced by Tom Powell Design. Lighting was a combination of available daylight and bounced electronic flash. [Hasselblad camera, 60mm lens, Kodak Tri-X film.]

One final caution—strangely, many performers are more comfortable in front of an audience of hundreds than an audience of one. Photographers must cultivate a soothing, supportive, and cheerful manner in order to excel in this work.

Musicians

Like actors, musicians require portraits, although the conventional head shot is less useful. Generally, musicians need to be pictured with their instruments. To do this well requires some knowledge of product photography, since musical instruments, many of which are complicated in shape and very shiny, present a number of technical challenges. Consider the difficulty of attaining pleasing highlight and shadow details for a brilliant white dress shirt, a black tuxedo, a burnished brass trumpet, and a smiling human face, all at once. A further complication: Musicians have a greater need for full-color photographs.

My advice is again to consult a Kodak publication, this time #O-10, *Professional Photographic Illustration* ($27.95), for useful advice. After reading up about the basic techniques, you will likely find it very productive to study the work of those masters of photography who serve the music industry. Just a few short years ago, one could easily find a very accessible and inspirational collection of specialized imagery at the local record store. The twelve-by-twelve-inch covers of vinyl long-playing records constituted a truly gigantic repository of imaginative music-related portraiture and illustrative photography, all of it listed alphabetically and cataloged by musical style. These instructive artifacts still exist in large numbers in private collections, in libraries, and in the discount bins. Today's cassette and compact disc covers, because they are so much smaller than LPs, are, by necessity, simpler. Even so, the pressure of the musical marketplace demands first-class design and execution for all packaging and point-of-sale advertising, so exciting photography of musicians and musical themes is still widely available, although somewhat attenuated in size and scope, wherever recordings are sold.

There is a very straightforward method for extracting useful technical information from the work of other photographers. In fact, I described it earlier in this book: Simply figure out as best you can the locations and relative sizes of the light sources that were used to make the photo in hand by noting the distribution and density of shadows and by taking a close look at reflections and highlights from shiny objects. Make a guess about the format, film choice, focal length of the taking lens, and point of view, as well. Some experimentation should lead to a reasonable duplication of the technique employed originally, which can then be modified to suit your own tastes and subjects.

Figure 8 - 4. Young blues singer in the recording studio. Photo made by available light. [Leica rangefinder camera, 35mm lens, Kodak Tri-X film.]

Singers

Although an element of glamour inevitably pervades all performing arts portraiture, pictures of singers and dancers are expected to radiate more than an average measure of this hard-to-define quality. While on stage, vocalists of all stylistic persuasions—from grand opera, through unrestrained rock 'n' roll, to super-cool jazz—undergo a sort of charismatic enhancement: To those in the audience, the complex emotions evoked by music and movement become inextricably linked to remembrances of the performers themselves. Memory, of course, is more closely related to moving pictures than still pictures. Glamour— defined by Merriam-Webster as *a romantic, exciting, alluring, and perhaps illusory personal attractiveness*—becomes a very desirable component in the professional images commissioned by performers simply because it suggests, perhaps subconsciously, the compelling ambiance of a live performance. Modest fortunes and immodest repu-

tations have been built exclusively on the ability to render show people as larger than life in a photograph.

We can look to the fashion industry for a few clues about star making. The bottom line here is defined by an attitude, which in turn is defined by clothes, accessories, hair, and makeup. Consider clothes as costume, accessories as props, and attitude as acting, and we are right back on familiar territory, although some coaching may be required—singers are typically so concerned about technical matters that issues of image are dealt with rather reluctantly. When budgets permit, hair, makeup, and clothing stylists are very helpful in setting an appropriate mood.

A number of photographic tricks are useful here. For example, hair and skin and certain fabrics (silk, for instance) appear more luminous when some diffusion is employed. When introduced over the taking lens, a diffuser creates a subtle halo effect around highlight areas—this generally looks better than diffusion at the enlarging stage, which softens by spreading the shadow areas. Diffusion de-emphasizes blemishes, wrinkles, coarse skin, and facial hair. Fashion and glamour photographers are very selective about the type and intensity of the diffusers they use: Some favor the commercial devices furnished by camera or filter manufacturers, while others swear by bits of nylon stocking, window screen, plastic wrap, or Vaseline on glass. Conventional practice permits a greater degree of diffusion for women than for men.

Lighting for larger-than-life portraiture tends toward the highly sculptural look favored by Hollywood in the forties. This is accomplished with lots of bright back light, in combination with a very carefully focussed specular main source and just enough soft fill to open up the shadows. Other approaches may be equally effective, depending on the subject's features. Young women with excellent skin and well-defined bone structure look good close up under high-key soft light. Many men and some women look romantically rugged when lit for a contrasty, chiaroscuro effect, with fairly hard side light.

Combining long lenses for natural perspective with wide apertures for very narrow depth of field contributes to an aura of uniqueness and personal power, but focus must be set very carefully on the eyes. Point of view and posture are important as well. Both men and women look flatteringly formidable from slightly above eye level, positioned with their backs quite straight, and a slight forward lean from the waist: As a starting point, a male subject might be instructed to support one foot on a box or short stool while placing a forearm across the raised thigh—a woman could be seated slightly sideways in a chair, with a little weight on one arm. A reminder: Upscale fashion magazines are handy sources of elegant, sophisticated poses for both sexes.

Dancers

Dancers are a challenge, since their photographic needs encompass all of those of actors, musicians, and singers, as well as an additional professional requirement to appear choreographically correct all the time. Since a dancer's instrument is a moving body, the expected level of perfection cannot be achieved in a small physical space, nor in a short period of time.

Shooting dancers is necessarily a collaborative affair, since the photographer must learn what is and what is not acceptable from a dancer's point of view, while the dancers must learn what is and what is not possible from a photographic point of view. A productive working relationship evolves out of talk, study, and patient effort. This is why so many successful dance photographers are either ardent dance aficionados or former dancers.

There are several magazines and many books dedicated to contemporary and classical dance. Anyone interested should spend some time at the library and find out what good dance photography looks like. Happily, the aspiring photographer with a long-term plan can start off modestly, perhaps by shooting a local community center dance class.

Experiment with fast films and available light as well as slower films and electronic flash. Lighting designers for dance invariably provide a wash of side light by using groups of focussed instruments configured as two or more vertical stacks located in the wings, just outside the view of the audience. Such an approach, supplemented with top light from lamps secured directly above the stage, greatly enhances the visual texture and three-dimensionality of the moving figures on the stage. Most photographers light a photo session for dancers with electronic flash in order to freeze motion: At least three flash heads, likely attached to large softboxes or umbrellas, are located to the right, to the left, and directly above the working space.

Once an understanding of the basics is attained, contact some very junior students at a professionally oriented school. Good results at this level will automatically attract attention from the school's artistic and public relations staff.

Build up a portfolio of work and show it around—advanced students and small professional troupes usually welcome photographers who will work for free or on speculation. When seeking access, however, one must keep firmly in mind that no serious dancer will bother with a photographer who only wants to satisfy some sort of personal artistic agenda: Dancers want photographs that clearly demonstrate their own technical and esthetic achievements.

One should approach larger professional companies only after acquiring a very solid foundation. Working dancers are busy people, with astoundingly heavy rehearsal and performance schedules. They have little time to waste, and neither do the people they work for.

Set, Costume, Lighting, and Wig Designers

In satisfying this group, what is most important is an appreciation of exactly how each of them contributes to the success of any given production—designers need photographs that highlight their work. For them, pictures serve as documentary records, as components in promotional portfolios, and as examples of particular effects to be emulated in future productions.

Set and costume designers look for similar types of rehearsal photos: Fairly wide views that clearly reproduce conditions on stage. Should there be several strikingly different scenes during a particular show, one or two shots of each will be required. Some set designers prefer pictures with the stage devoid of people, in which case a special photo call, or additional time tacked onto a conventional photo call, must be negotiated with the theater. The designers themselves will make the necessary arrangements, politics, budgets, and production schedule permitting. If a special-purpose shoot is possible, then it is preferable to switch to a medium-format camera on a tripod to preserve detail. I use a Hasselblad 6 × 6cm camera and Kodak Vericolor L Type II for such work. A 40mm extreme wide angle, which is equivalent to a 24mm lens on a 35mm camera, works best for set shots. With an aperture of f11, exposures vary from 1/15th of a second for very bright conditions to 15 seconds for very dim conditions. I find that performers can stay photographically still for perhaps one or two seconds, so extremely low light conditions automatically preclude people, unless some blur is acceptable.

Mentally visualizing three-dimensional objects is not an ability that everyone in theater possesses, so set designers are often called upon to build scale models of proposed sets. Before formal commitments are made, photographs of the models must be distributed to various concerned people, such as the chief carpenter, the scenic painter, the artistic director, the technical director, and perhaps the theater manager.

Photographs of architectural miniatures are generally made from a point of view that simulates what would be eye level in reality. This

puts the camera very close to and just level with (or very slightly above) the miniature stage. A normal or moderate wide-angle lens will yield a natural-looking impression. Since the camera must be level in order to preserve proper perspective (nonconverging vertical lines) a perspective control (PC) lens, such as those used by architectural photographers, is recommended for exact framing. Most photographic rental houses can supply a PC lens for just a few dollars per day. Remember also that depth of field is a function of magnification, so small apertures—f11 through f22—are de rigueur for maximum sharpness.

The simplest approach to lighting is to take the model outdoors on a sunny day. Carefully select an orientation that yields the most pleasing effect—a black background and foreground (cloth or seamless paper) aids in simulating a realistic look. Indoors, one or two tungsten photographic lamps should do the trick, but be careful not to overheat the subject: Most models are constructed from fragile, flammable materials.

Costume designers like to have full-figure photographs of the characters they dress. Rehearsal photos taken on the run do not always show performers from top to toe, so designers also have an interest in photos produced during offstage portrait-in-costume sessions. Since hair, which can be very dark in color or obscured by headgear, does not always record well during rehearsal photography, wig designers like portrait-in-costume head shots as well.

From time to time, all designers require photographs of renderings and technical drawings. Kodak publication #M-1, *Copying and Duplicating in Black and White and Color* ($34.95), will provide all the technical details, but here a few general guidelines:

In order to preserve rectilinearity and maximum sharpness, the camera must be positioned on a line perpendicular to the center of the item being copied. Lenses specially designed for close-up photography, such as the Micro-Nikkor series, work best, but ordinary lenses with extension tubes or auxiliary close-focus attachments will do in a pinch. The illumination must be even—position two photographic lamps equidistantly at a 45° angle on either side of the camera. Direct sunlight or open shade are also fine, but check carefully for reflections if the material to be copied is at all shiny or uneven. For low-contrast originals, chose a contrasty film, such as Kodak Vericolor HC. For high-contrast originals, use a lower-contrast film such as Kodak Vericolor L or Fuji Reala. Advise your clients that precise color fidelity cannot be guaranteed without testing—not all inks, paints, or dyes can be reproduced accurately on photographic materials.

Directors, Writers, and Related Professionals

These people need good head shots for inclusion in lobby displays and programs. Beyond that, they have no specific needs other than to acquire some regular rehearsal/performance photos for sentimental, documentary, and promotional purposes.

One additional note: Directors, writers-in-residence, assistant directors, and other members of the creative staff usually expect to have some input into decisions about what is photographed for promotional purposes and what is distributed to the press or displayed in the lobby or box office. In order to avoid problems during or after a photo call, it is a good idea for photographers to determine beforehand who has ultimate authority over such matters and discuss with them how best to handle specific requests from the other interested parties.

Multiple Printing Technique

Enterprising photographers can expect to sell lots of photographs of performing arts events. Profits are maximized, delivery times are reduced, and pricing can be competitive when printing is done in house rather than through a commercial lab. Income from selling prints often exceeds professional shooting fees for moderate or large productions. As discussed in Chapter 4, anyone interested will quickly find that color processing mythology is just that—mythology—and well within the capabilities of anyone with an interest in mastering the procedures.

I have found a very efficient way to produce large quantities of color prints in a very short time. The first step is to insure consistent exposure and film processing, so that all negatives from a particular session are similar in density. If this is the case, then all the negatives will print well at about the same exposure time at the enlarging stage. When I have a lot of prints to make, I start off by first testing and processing two or three negatives individually. (As described in Chapter 4, I use trays for color print processing.) After determining appropriate color balance and exposure times, I then expose ten or fifteen other negatives using the same settings—the exposed paper is stored in a paper safe. After all the exposures are made, I don clean, dry rubber gloves—I find thin latex gloves are best—and then I process all the prints together.

Here is the exact procedure: First set out the left-hand glove so it can be found easily in the dark, and then put on the right-hand glove. After the lights are extinguished, remove the exposed paper from the paper safe and put it face up on the counter beside the processing sink. With the ungloved left hand, remove one print from the pile and transfer it to the gloved right hand; then smoothly slide the print—still face up—into the color developer bath. This process continues until all prints are in the tray of developer. Once that is accomplished, as quickly as possible insert the left hand in the other glove—a slightly tricky procedure in the dark, but not impossible after a little practice— and then, using both hands, gently separate and agitate the prints, but be sure to keep them in the same order. After one minute and fifteen seconds, the pile of prints is flipped over and, one at a time, each sheet is inserted in the stopbath, taking care not to contaminate the developer solution with the stopbath. Agitate for thirty seconds, and then transfer the prints one at a time to the bleach/fix. The lights can be turned on after a minute or so of constant agitation. Using Kodak RA chemistry, the whole operation takes about six minutes. Wash and dry in the normal manner.

Processed prints can be examined by lifting one out of the bleach/fix with tongs and rinsing it briefly with running water. If exposure and film and print processing were truly consistent, very few prints out of a batch of fifteen will have to be re-exposed. It is possible to make up to sixty prints an hour using this method.

Burning in Names, Address Information, and Logos

Individual performers, small classical music ensembles, and others have a regular need for multiple photographs that include information or graphics. This is not difficult to do. The appropriate artwork or type can be photographed or contact printed on high-contrast black-and-white litho film, either by the photographer or at a typesetter. A simple mechanical arrangement can be devised from an ordinary easel and strips of opaque cardboard so that individual sheets of paper can be accurately positioned and exposed one at a time to the resulting high-contrast negative. Normally the graphic or type is to appear in a one- or two-inch strip along the bottom of the photograph—the rest of the paper should be completely masked off. After a sufficient number of sheets have been exposed, they are re-exposed with the appropriate conventional image, while taking care that the logo portion is masked off. Process as described in the preceding section.

Since there are many high-volume commercial processors who do this kind of work quite cheaply—as low as fifty cents per print in multiples of a hundred—profit margins for this kind of work are quite slim.

The Cast Picture

One type of image is an automatic bestseller in the world of performing arts photography—namely, the cast picture. After working together for several weeks, those involved in mounting a production develop very intense feelings for one another; consequently a company photo—which properly includes the artistic, design, and technical staff as well as the performers—is a highly valued remembrance.

Since public relations people are as often as not only vaguely concerned with company morale, it usually falls to the stage manager or the artistic director to request and organize the few minutes at the end of a rehearsal or a photo call that are required to photograph the entire ensemble. It is best to decide early whether or not a cast photo is to be made, because the entire company will have to be notified, and sufficient time on stage must be reserved. In fact, photographers interested in the extra business should diplomatically inquire about the possibility of a cast photo at least a day or two before a scheduled photo call—theater people become quite involved in the rehearsal process, and the reminder is often appreciated.

Just as for set photos, a medium-format camera is the tool of choice—individual faces must be clearly visible. Since most performers like to see the company photo in the context of the entire set, the same camera position and film type will often work for both cast and set pictures.

Some practical considerations must be attended to for a cast photo to work out well. First, talk about a suitable arrangement for the positioning of the group with the stage manager before the shoot. Discuss which scene offers the best setting, where people should be placed, if or how stage lighting will be altered, and whether or not costumes will be required. Arrange for risers, chairs, or stools as required.

It is also imperative to decide who will be in charge of directing the group—it is simply impossible to control a crowd of fifty or a hundred people when more than one person is shouting instructions at them. And *shouting* is the appropriate word. Crowd control is not an occupation for shy individuals. The idea is to be set up and waiting before the group appears, be clear and precise in delivering any posing

instructions, and finally be very quick taking the pictures. If people have to stay still for a longish exposure of a second or two, make sure they understand that goofing around will spoil the picture. It is not necessary to be severe—just cheerfully firm.

Here is a simple but helpful technique for arranging big groups: Tell everyone to position themselves so that they can each see the camera lens with *both eyes*. That way every face will be clearly visible in the final image.

9 Variations of Performing Arts Photography

Approaches to the Promotional Portrait

The successful portrait photographer will possess technical competence, a heightened sensitivity to the manifold hieroglyphics of the human face, and an honest empathy with his or her subjects. I believe that the aboriginal peoples of the world are correct in believing that portraiture is an intimate act that does, in fact, capture some aspect of the soul. In earlier times people were either less complicated or perhaps less protective of their inner selves—today photographers must work hard to achieve extraordinary results.

There are a number of techniques commonly used to encourage a portrait subject who balks before the camera. What might be called the *stream-of-consciousness* method requires photographers to accompany a barrage of motor-driven flash exposures—99 percent of which will be discarded—with loud music and nonstop conversation. The purpose of this presumably entertaining distraction is to diminish the significance of each individual click of the shutter, to lull the subject to a point of forgetfulness beyond self consciousness. The frenetic, machine-gun approach, inevitably featured whenever Hollywood includes a photographer as a character in a film, is so much a part of our cultural Gestalt that some clients feel cheated if they don't get the full treatment. Although wasteful of film, the technique works well enough with many individuals.

My own personal style, and the one that I recommend—if only as a starting point—is more sedate. Rather than dazzle the subject into a state of distraction, I prefer to enlist him or her as an accomplice, to

Figure 9 - 1a. This photo was taken while Rick McNair was the artistic director of the Manitoba Theater Center. He is dressed up to promote a fund-raiser for the theater—an evening of dining and mystery built around a "murder" that the $200-per-ticket patrons had to solve. I donated my services on this occasion. [Hasselblad camera, 150mm lens, Kodak T-Max 100 film.]

Figure 9 - 1b. This photo shows Rick in his incarnation as children's performer and storyteller. He is pictured here with his portable set— a tent—and a collection of props. A bare-bulb flash was placed inside the tent to give the silhouette effect. [Hasselblad camera, 100mm lens, Kodak GPF film.]

Figure 9 - 2. Not all performing arts photography takes place on the stage. Some cast member of the Manitoba Theater Center's production of *Billy the Kid* found appropriate props on a ranch a few miles outside Winnipeg. This image was used in a full-color newspaper advertisement and for a color mailer. [Hasselblad, 60mm lens, Kodak VPS film.]

create an environment defined by concentration rather than chaos. This is accomplished by first pointing out that except for a small handful of people who are true, unrepentant egotists, almost everyone is uncomfortable in front of the camera. Rather than deny this condition, I identify it openly, right at the start of each portrait session.

I regard subject reticence as a baseline, a starting point for a more intimate working relationship. By acknowledging discomfort as normal right off the bat, I avoid the cat-and-mouse games that photographers and their subjects sometimes get locked into. A more direct

approach begins with the question *What image or attitude do you want to project?* Most performing arts clients are professionally interested in answering this question clearly—they think a lot about how they look and, with a little encouragement, can express their thoughts in terms a photographer can understand. Sample photographs from magazines are helpful here. The process can begin even before you pick up the camera, and it continues throughout the session with brief consultations over test Polaroids. Some topics to be discussed: Which side of the face should be most prominently featured, what lighting style is most desirable, how much diffusion is appropriate, how the background should appear, which posture looks best, and the like.

Once technical matters are addressed, the real work begins. The human face is an emotional kaleidoscope, and the portraitist's job is first to notice and then to make a permanent record of certain desirable, albeit fleeting, facial expressions. Concentration is the main tool. Noticing means paying attention, and paying attention requires concentration. Facial expressions are easier to notice if the desired configuration sticks around for more than a fraction of a second at a time—a facial expression is the physical manifestation of a particular state of mind, and concentration on a particular state of mind makes it linger.

Concentration is called *visualization* when it is employed as a tool to evoke and maintain a particular mental image. The trick is to figure out what sort of mental image will call up a particular feeling that will, in turn, result in a desired facial expression. For example, if someone wishes to look strong yet vulnerable in a photograph, he or she might think of himself or herself in the act of comforting a frightened child. To look alert and affectionate, he or she could imagine a surprise meeting with an old friend in an unusual location. If it can be done in a spirit of trust and playfulness, selecting a mental image is something that a photographer and subject can do together. With a little gentle coaching, even very shy subjects will get the idea, although they will likely keep their mental images private.

The Art of the Promotional Poster

Three kinds of photographs are commonly employed in theatrical posters. The first type is an authentic rehearsal or performance shot made under stage lighting. The second type involves the recreation of an authentic dramatic scenario but under studio conditions. The third approach is to conventional production photography what nonrepresentational art is to photo realism: an impression, a mood, or an

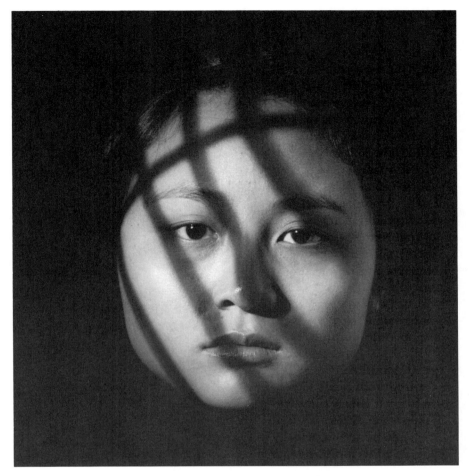

Figure 9 - 3. This photo was produced in the studio for a poster, newspaper ad, and program cover for *Enemy Graces*, a Prairie Theater Exchange production about the internment of Japanese Canadians during World War II. Steven Rosenberg, designer. [Hasselblad, 150mm lens, Kodak VPL film, bare-bulb tungsten light with 1/4" aluminum rod formed to cast the cell-like shadow.]

abstraction that is related to, but not a real element of, a particular production.

Approach number one has limited applications. Only repertory companies that prepare and present several plays simultaneously have the opportunity to harvest real production photos in time to incorporate them into promotional posters. Sometimes generic production photos from a previous production are used to promote a current show. This is not uncommon in opera, for example, where the repertoire

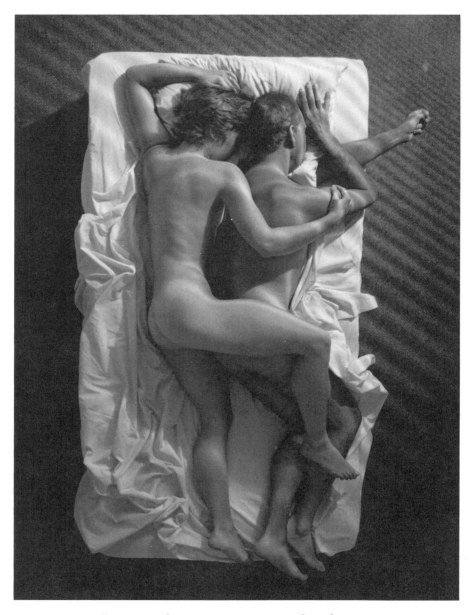

Figure 9 - 4. Illustration for poster, newspaper ad, and program cover for *Remembrances of You*, a Prairie Theater Exchange production. The image was cropped at the models' waistlines because of concerns about public reaction to nudity, but it was later used full frame on the cover of the script when it was published in book form. [Hasselblad camera, 100mm lens, Ilford FP4 film, flash lighting through horizontal-type blind for shadow effect.]

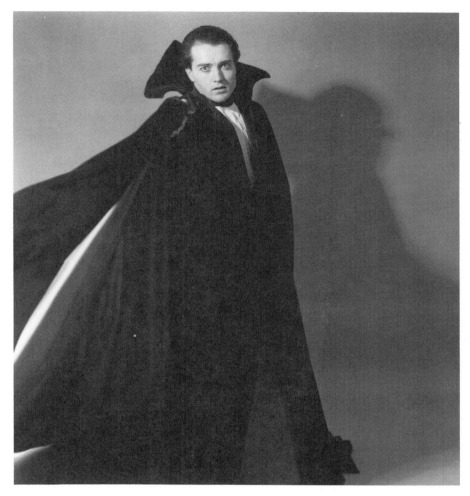

Figure 9 - 5. This image depicts the lead actor in a Manitoba Theater Center production of *Dracula*. This poster illustration was produced on location with a seamless paper background and one electronic flash head in a 10-inch reflector. [Hasselblad camera, 60mm lens, Kodak Plus-X film.]

is small and star performers have fairly long careers. Ballet companies retain some elements of their repertoire for many years, as well. Classical musicians with solo careers will often have shots of themselves in action that are used over and over—after all, costumes and props for a cellist are not too different from one formal venue to another. Such photos will be forwarded, often months ahead of time, for the use of designers and publicists. All these situations highlight the potential for economic benefit to those tenacious photographers

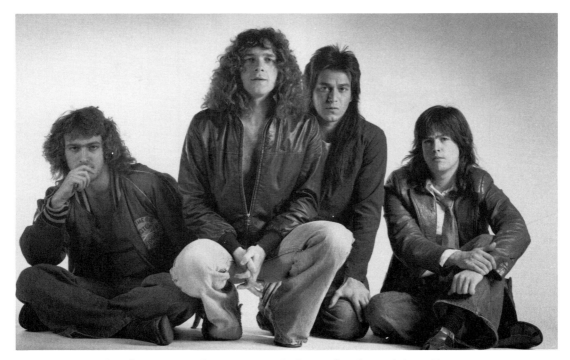

Figure 9 - 6. This shot is a simple promotional photo of rock musicians. It was made in the studio against a white background. Some care was taken to provide a wide tonal range for easy reproduction in newspapers or posters. [Leica camera, 50mm lens, Ilford FP4 film.]

who are able to retain reproduction rights for their work that extend beyond immediate use in the press.

Photographs that are made in the studio with real performers supported by actual props, costumes, and even parts of the set are more common. Since promotional efforts usually start at least a month before opening, the photography will have to occur at least a couple of weeks before that, in order to allow sufficient time for pre-press work and printing. Deep-pocketed institutions or movie companies might fly in feature performers just to appear in a poster photo, and alternately the actors or dancers could be local professionals or close at hand because they happen to be working under long-term contracts.

In most instances, a poster image evolves out of the collaboration between an artistic director and a graphic designer, with considerable input from the publicist and, possibly, the manager or producer. Sometimes the photographer is involved from the beginning, but on

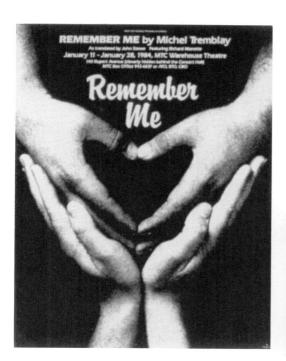

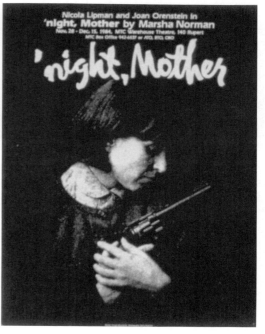

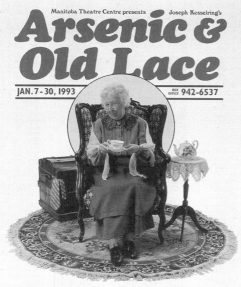

Figures 9 - 7a–c. Some of Steven Rosenberg's award-winning posters for the Manitoba Theater Center incorporating my photography. In the top left photo, two sets of male hands suggest a heart shape, appropriate for a play about gay lovers. In the bottom left photo, a carefully constructed studio shot after the style of Normam Rockwell advertises a traditional favorite. Props, costume, and actress were provided by the theater. The center photo is a simple but effective poster for a play about suicide.

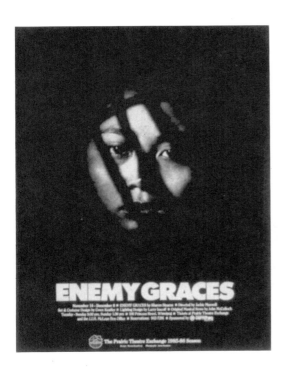

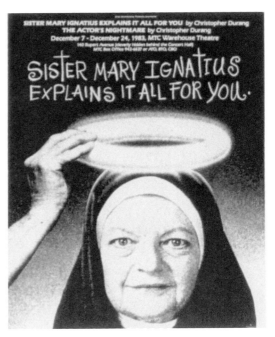

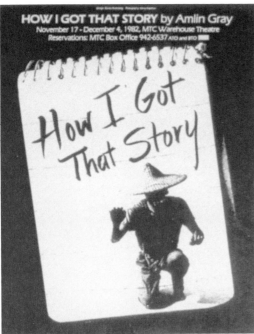

Figures 9 - 7d–f. The top left photo is a boldly graphic image for a play about the internment of Japanese Canadians during World War II. The bottom left photo uses two images superimposed in preproduction to make a grimly witty statement about the media participation in the Vietnamese conflagration. The center photo is another double image that yields a humorous introduction for a play about Roman Catholicism. The halo is a circular fluorescent fixture enhanced with some retouching.

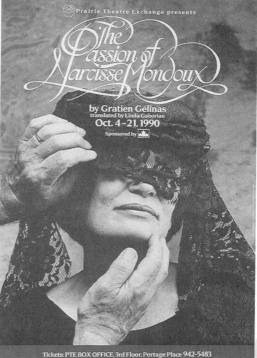

Figures 9 - 7g, 9 - 7h. The top photo is a Steven Rosenberg poster for a Prairie Theater Exchange play about the love affair of an older widow. The bottom photo is another Rosenberg effort for PTE; this time the play was about yuppie life in the suburbs.

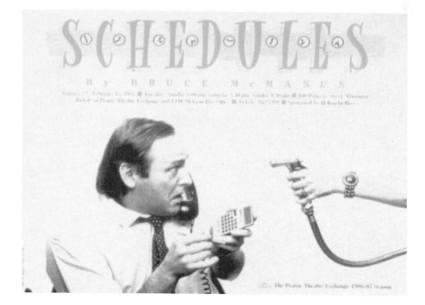

other occasions photography is an afterthought. In either case, how-ever, it is very helpful to read the play before attempting to produce representative illustrations. The photographic challenge is to visually suggest a moment of authentic dramatic impact. Costume, makeup, and hair expertise will be provided by the theater, as will sufficient furniture, drapery, or what have you.

Working with designers or other visually oriented performing arts professionals can provide a photographer with an insight into what it must be like for actors to work with directors. Photographers and actors share the same impulse to put a personal stamp, an esthetic spin, on the projects in which they are involved, yet they both are compelled to accept direction from outside. In both cases it is important—even prudent—to curb the creative impulse, at least to a degree that permits successful collaboration in what is, after all, a commercial enterprise.

Financial considerations greatly affect the final design, not only by defining the time and resources that can be allowed for photography, but also by determining what the final product will look and feel like as a physical object. There is a wide price spread between mono-chrome and one-, two-, or four-color reproduction. Size, paper finish and weight, as well as the use of varnish, embossing, and spot color also figure into the costs. Generally, photography is a small part of the total production budget, but it is safe to say that performing arts clients expect—even demand—that photographers' fees be held to modest levels: The thinking here is that a photo credit and wide distribution will compensate for low remuneration. Maybe so, but I advocate holding out for fair payment in addition to a photo credit. In my city, fees for such work range from a very modest $200 for a black-and-white studio shot, up to $750 for an elaborate color extravaganza. In larger markets two or three thousand dollars for a sophisticated image is not unheard of.

Producing images to order can be gratifying, even when fees are small. I always experience a measure of dissatisfaction with regular production photos since, regardless of how carefully one works, the combination of high-speed film and available light always yields pho-tographs that are technically inferior to photographs made on slow, fine-grained film under proper photographic lighting. I welcome the opportunity to exploit the full potential of the medium, especially when I know that my work will be incorporated into a large, well-printed poster.

Due to budget constraints, most of the posters I have done are black and white. Medium-format Ilford FP4 or Kodak T-MAX 100 negatives record sufficient detail for even very big enlargements, and I use them regularly. Occasionally, rather ornate photographs of

various props are required, and for this kind of work I still favor a view camera, which affords precise perspective and focus control. For those clients who prefer transparencies, I often shoot with a 6 × 7cm roll film back on my 4 × 5 Toyo G: This allows the required technical flexibility, while keeping costs down when bracketing or experimental effects are required. (Fire and smoke are quite popular in dramatic circles.)

The most challenging type of poster uses the specifics of a production as an inspiration rather than a definition. The correct methodology is a sort of creative brainstorming rather than a process of documentation. Again, individual designers and directors will expect different degrees of input from photographers, but because there is less need to be faithful to a particular text, early consultation is the rule rather than the exception. This can be a lot of fun, but it is important not to get carried away by collegial creativity—carefully consider all technical and financial restrictions before making difficult-to-keep photographic promises.

Record, Tape, and Compact Disc Covers

Photographs that are used for the packaging and promotional support of recorded music can be quite literal, such as a straightforward portrait of the artist, but often they are variations of the third type of theatrical poster—visual impressions of the music or of the creator or creators of that music. Whatever the style, the picture must be quite cleverly conceived in order to be truly useful, since one image is typically expected to serve as a 3" × 5" cassette cover, as an 8" × 10" point of sale piece, as a 16" × 22" or larger poster, or even as the basis of a magazine or newspaper advertisement. The same picture might turn up on the occasional billboard or theater marquee, as well.

How is this sort of compact visual power achieved? Successful record/tape/CD cover art results from a three-way collaboration among a recording artist, a designer, and a photographer. Unlike strictly theatrical poster work, where the performers tend to be considered as highly skilled mannequins only, most musicians retain a measure of control over how they and their music are portrayed. Exactly how much say musicians have in the process is a function of their own marketing sophistication and experience and the nature of their contracts with their record company and their management.

The music industry is highly competitive, to put it mildly, so those artists who have reached a position where their work is to be recorded have already paid some dues. They will be quite familiar with what

other artists in the genre have done on their covers and posters, and they will have some fairly firm ideas of what has worked and what hasn't. In my experience, working with musicians is always lively, sometimes stormy, but definitely not boring. All performers have very strong egos, and the music business, with its wildly unpredictable ups and downs, breeds some of the strongest egos around. It is necessary to remember that commercial photography is a service industry and that the intentions and expectations of the client must be accommodated, budget permitting.

Before the consultation begins in earnest, listen to the music in question, and, if possible, watch a live performance. A trip to the record store to see what the competition is doing is not a waste of time, either. Since there is a lot of first-class visual material out there, it will be fairly easy for the artist to collect sample images that represent both his or her preferences and treatments he or she wishes to avoid. Even modest projects can usually support fees of $250 for a cover shot.

Well-funded, heavy-duty performers might be planning a coordinated launch that will include a cassette tape, a CD, a poster, advertisements in the trade and fan magazines, a T-shirt, a souvenir concert program, and even a video. The scope and expense of an enterprise like this matches that of national or international advertising campaigns for other, more conventional products. On projects of this scale, photographers can expect to play less of a creative/design role—instead, the image or images required will likely be specified in great detail with comprehensive layouts. If special sets and costumes are created for videography, they will likely appear in the still photographs as well. Fees for this work escalate with the size of the undertaking—a few thousand dollars for a sophisticated signature image is not uncommon.

Images for Fund-Raising

Certain performing arts institutions are regarded by the movers and shakers in politics, business, and the academy as essential or desirable components of North American culture, and therefore worthy of public support through taxes and lottery revenues, as well as private and corporate donations. Consequently, high-minded but high-pressure fund-raising activities in the cultural sector are widely sanctioned. Suppliers to the advertising industry, such as designers, illustrators, full service agencies, typesetters, printers, paper suppliers, and, yes, even photographers, are expected to contribute their services from time to time. It is a rather bittersweet truth that most of the photographic images used in posters, pamphlets, and newspaper ads

to raise funds for the performing arts are produced for free, or for the cost of materials. This is partly convention and partly coercion, but it is nonetheless a fact of life.

Presumably any photographer who makes all or part of his or her income by servicing the performing arts will appreciate that in order to survive, the cultural industries do, in fact, require some financial support beyond ticket sales. Once this realization is achieved, it remains only to determine exactly how much support one is willing and can afford to give. An advanced amateur with some other source of income could spend, quite literally, every spare moment providing donated photographic services to needy institutions, but a professional cannot. My personal criteria are based on the simple principle of reciprocation—I will happily and enthusiastically provide photography for a couple of substantial fund-raising efforts per year for any performing arts institution with which I have a professional relationship during the balance of the year.

The type of photography required runs the gamut from grip-and-grin, flash-on-camera documentation through executive-type portraiture of the fund-raising chairperson to truly exotic poster art. In fact, some of this work can end up as quite wonderful portfolio and promotional pieces, not to mention the personal exposure to the community's best and brightest—those who donate their time for public service are usually fairly accomplished in some other field.

All and all, with the right attitude and with the nature of the involvement clearly defined, participation in a fund-raising effort can be very enjoyable.

Editorial Photography for Newspapers and Magazines

From time to time, any photographer who specializes in shooting the performing arts will be called upon to provide images suitable for illustrating a magazine article about a performing arts personality, a particular production, or even a particular institution. Such an assignment can present challenges on two levels—professional and moral.

The nature of the moral challenge may not be immediately obvious, but consider the following: The media approach culture-related stories from two perspectives, boosterism or criticism. For example, one of the newspapers in my city ran a scathing six-page 'analysis' of what was felt to be inappropriate use of government funding to the arts. Extensive lists of tax-supported outrages were offered, together with bilious articles decrying a flagrant disregard for the public purse

Figures 9 - 8a, 9 - 8b. Here are examples of how the media make editorial use of performing arts photographs. During the winter of 1992–1993, a controversy erupted in Winnipeg about the Manitoba Arts Council distributing government grant money to visual artists and performing arts groups. The photo reproduced in the paper above was made by Paul Martens.

and the public's sensibilities. Scattered throughout the text were photographs of performing arts personalities and events, some of which were produced by me. These photographs were willingly provided to the paper by the people and organizations who originally paid me to make them; consequently, I was not too upset that they were used to illustrate a highly negative piece. If I had been paid by the publication to provide the photographs, I would be in a much different situation—when one accepts a photo assignment from a magazine or newspaper, one generally surrenders all control over how the resulting photographs will be used. I happen to support public funding for artists, and of course, part of my income is derived, albeit indirectly, from government grants, so I would naturally avoid involvement in a cynical exposé, if I could.

Having said all this, let me backtrack a little by admitting that editorial assignments, particularly for national or international magazines, can be very attractive. It is very difficult to capture the essence of an individual, a stage production, or an institution in a single photograph. Editorial work in its highest form permits a photographic exploration that can encompass a tremendous intellectual scope. It is delightful and educational to spend a few hours or several days with interesting people in interesting situations.

The editorial assignment begins as discussion with the publication's editor, a person whose relationship to the written word is comparable to the relationship between an artistic director and a stage play. The editor will outline the approach that is required by explaining in general terms how the written part of the story deals with the subject at hand. Some editors do not involve themselves with organizing illustrations, so your contact may be the art director, who oversees all aspects of design. You will be told what sort of budget has been allotted to the shoot. If the story has already been written, you will be sent a copy via fax or courier. It is at this point that you are expected to state any reservations you might have about the way the story is being handled. Realistically, however, strong objections will inevitably result in a loss of work rather than any editorial changes. If you have a problem, it's better to bail out early rather than be involved in a fiasco later.

Assuming editorial harmony, however, it will be left to you to arrange with the subject for a time and place for the photography to happen. Some of this—formal portraiture, for example—will happen in the studio, but generally the subject's home or workplace is the preferred location. These days most magazines are more than satisfied with good quality 35mm color slides, although some still require medium-format transparencies. In either case, you will be expected to

provide images of very high technical quality in which any artificial lighting is tastefully, effectively, and unobtrusively employed. Bounce flash, filtered if necessary to complement the available light, is by far the most common approach. Some subjects will require more elaborate setups, and perhaps an assistant.

Once the job is shot, you will be required to ship *all* film to the publication—editing a shoot is an art director's traditional prerogative, and A.D.s look very dimly on photographers who hold back slides, for whatever reason. Some publications will want unprocessed film only, while others will specify that timely processing is the responsibility of the photographer.

Rates for this work vary widely. Some publications pay by the size and number of photographs used; others pay a day rate plus expenses. A local magazine or newspaper may pay $25 for an editorial image, while ten pictures in a national magazine might be worth two or three thousand dollars. Unfortunately, some of the most highly paid photographers are the paparazzi, those exploitative camera commandos who prey on celebrities of all kinds, including those involved in the performing arts—a single scandalous image may attract ten thousand dollars or more.

On the Temptations of Popular Culture

We all want to believe that we know right from wrong. Yet what is perceived to be a moral absolute varies from place to place and from one historical period to another. Many aspects of the culture of the Western world, particularly elements of the popular music industry— rap, heavy metal, punk rock, and the like—regularly use photographic imagery that some consider to be unsavory, degrading to women, or simply obscene.

It is difficult to establish ethical standards governing the production and use of photographs, particularly commercial photographs, because photography itself has an ambiguous relationship to the truth. Contrary to what many people would like to believe, photographs do not always accurately record objective reality. In addition, whatever the reality reflected in particular images, those images may serve many purposes—not all of which are wholesome.

In my view, ethical standards for commercial photography are shaped by the reactions of the photographer to the demands of the client and then further shaped by the treatment or modification of the resulting images by the designer, retoucher, production house, and so on. The integrity of the process is hard to gauge—it would require

knowing how the viewer's response to the final image would compare to the viewer's response to the real-life situation that the image purports to represent. I believe that if the image was produced in an ethical manner, the trusting viewer will benefit. If the image was produced in an unethical manner, the trusting viewer will be harmed.

The entire process is further complicated by the knowledge that the viewer is not necessarily an innocent. Many of the various target audiences for commercial photographs are jaded to some degree—depending on age, intelligence, and life experience. This is why photographers need a good education: We must understand the social milieu in which we work. Like lawyers, doctors, judges, journalists, and politicians, photographers are charged with serving the public well. Even though this obligation is not defined by law, it is morally binding.

Photography is, of course, only a part of the vast advertising machine, and individuals can only be responsible for their own deeds. However, if in the normal course of business a moral lesson is to be taught, I believe it is best taught by example—and sometimes this means refusing an assignment.

Free expression is a constitutional right in most enlightened democracies, but some people hold the view that there are limits to personal expression that transgresses normal community standards to such a degree as to warrant legal prohibition. It is essential to maintain a working awareness of what is acceptable and what is offensive to those with whom you must live. Common sense will tell you when your work might be considered obscene, but it is impossible to be absolutely certain exactly where the boundaries are. One's best defense is to contact a lawyer familiar with the issues before getting involved in questionable projects.

Commercial photography is deeply involved in the dissemination of basic cultural values. Many fundamental precepts of public morality were once taken for granted but are now being hotly debated. Violence, sex as a selling tool, the manipulation or exploitation of children, and the like cannot be safely left only to others to consider. There is no question that photographs advocate, educate, manipulate, and stimulate. Strong images are active catalysts for both good and evil. Photographers who work without conscience or consciousness inevitably become unattractive propagandists for those who have a stake in molding specific public opinions and public desires, benign or otherwise.

The responsibility for ethical photography is, of course, split between the users and manipulators of photographs and photographers themselves. Nevertheless, the photographer is the main creative instrument and the fundamental ethical filter. We are obliged, therefore, to consider the implications of our work.

10 Marketing Performing Arts Photography

Crossover Skills

Performing arts photography, as we have seen, is a mixture of available light work, formal and informal portraiture, plus a smattering of product photography, architectural photography, and copy work—all spiced with a fine-arts spin. In very large cities like New York or Los Angeles, there are photographers who make a living by specializing in shooting only food, or fashion, or architecture. A few, but not many, specialize in performing arts work. Everyone else, everywhere else, must be accomplished generalists, photographic Jacks-and-Jills-of-all-trades, in order to get by financially. Happily, those who are considering entering the performing arts marketplace from other photographic disciplines will find that many of the skills and much of the equipment they have acquired are transferable.

The following advice is intended as a guide to students, advanced amateurs, and professionals who wish to make a business of performing arts photography.

Breaking into the Industry

Volunteer and Community Service

Professionals provide their services free of charge to worthy causes because it is the right thing to do and because their clients and potential clients likely do the same thing. Beginners might consider

volunteering their services for the same reasons, plus one more—the opportunity to gain experience.

A Catch-22 encountered early on in one's career is the paradoxical logic that says you need a successful track record in order to get work, but you need work in order to establish a successful track record. Volunteering resolves this conundrum. When money is not directly involved, people are more likely to take a chance on someone who is enthusiastic but relatively inexperienced. This is not to say that professional standards can be disregarded but just that an opportunity exists to get one's foot in a door that may eventually lead to commercial work.

Many promotional and fund-raising campaigns on behalf of charitable or public-service-oriented organizations are quite sophisticated. Top-flight designers and photographers are commonly involved. Production and printing on large projects are usually excellent, and this usually results in some quality portfolio pieces. While providing even a very modest supporting role, one can learn a great deal by observation. In addition, the noncompetitive, community-minded atmosphere that characterizes most volunteerism encourages the building of a network of friends and associates.

Working on Speculation or for Cost

Having produced good photography as a volunteer or as an amateur does not automatically guarantee a flow of paid commercial work, but it can trigger curiosity about your potential. Some buyers of photography, however, cannot afford to risk the money or the time to find out for certain whether or not they will benefit by retaining your services. One response to such reluctance is to offer to shoot a noncritical job on speculation, which means that you absorb all costs if the job turns out poorly. If your samples demonstrate reasonable ability, most prospective clients will take a chance on an offer like this at least once. If things work out, you might be asked to shoot two or three more small assignments for the cost of materials alone. Accepting work on this basis accomplishes two things. First, it spreads the risk fairly evenly between you and the client—you risk your time, the client risks his or her reputation. Second, it is a low-cost device that the client can use to educate a new supplier. There is a slight possibility that overeager newcomers might be exploited by unscrupulous clients, but this occurs only rarely in real life.

Cold Calls and Direct Mail

Anyone who follows my earlier advice and starts off by first shooting amateur groups, followed by school or university productions, then part-time professionals, and so on, will inevitably develop an awareness of who's who in the professional performing arts scene. Ultimately, it is the well-established professional groups, both large and small, that generate the bread and butter income for any performing arts photography enterprise. Creating a list of institutions and organizations that might need photography is a necessary beginning, but institutions and organizations, per se, do not actually buy anything from anybody—only designated individuals within those institutions and organizations can do that—so the next major task is to identify the right people and then make personal contacts.

A cold call is marketing jargon for a one-on-one sales effort, either in person or through the telephone, that has not been preceded by a referral or an introduction of any sort. In these days of restricted budgets, virtually all performing arts organizations are operating at minimum staffing levels—public relations people are busy trying to attract audiences, and they often resist giving up precious time to hear a sales pitch from an unknown. The cold call was appropriate and commonplace in the bombastic business climate of ten or twenty years ago, but today it is a pretty tough way to create new business.

Research has proven direct mail to be the most efficient way of selling season tickets and seats for special events, so performing arts marketers are predisposed to pay attention to material that reaches them through the post office. In addition, direct mail does not have to be exotic or expensive to produce results. For photographers it can be a relatively inexpensive yet effective method of introducing one's work to potential customers and maintaining an ongoing awareness of your services once a client base has been established. A comprehensive list of potential clients for even a big city will have, at most, a few dozen entries. A short telephone conversation with the switchboard operator at each place is all that is required to get a complete address with zip code as well as the name of the person to whom promotional material should be directed.

Photographers with access to a darkroom can prepare suitable mailers for just a few dollars. You will need a high-contrast negative of your name, the name of your business, plus your address and phone number. It is not hard to make such a negative yourself with litho film, or simply have a typesetter run one off. Many graphic designers are receptive to trading services, so with a bit of effort you can have a

combination logo/address/letterhead professionally prepared for added effect.

Next, evaluate your photographic oeuvre and select a suitable image—you need something distinctive. The idea is to print this photograph together with the address information on the same sheet of photographic paper. Half of an ordinary 8" × 10" sheet makes a satisfactory post card. A simple printing frame can be fabricated out of glass, cardboard, and tape so that proper registration can be maintained while the exposures are being made. This procedure is simple and cheap: You can have an attractive piece on the way to a hundred prospects for well under a hundred dollars. If your mailer is really eye catching, it will be tacked up on walls and bulletin boards, where it will quietly broadcast your skills for days or even weeks. Two or three tasteful mailers will guarantee a civil reception when you come calling.

The Personal Meeting

Assuming the images you selected for printing are appropriate and appealing, a follow-up phone call a few days after your last mailing should result in an appointment to show some samples.

During your presentation, remember that you are talking to an experienced professional who can judge your work quickly. Each photograph might be reviewed for only a few seconds, but don't take offense. These people are busy, and fifteen or twenty minutes of their time is the maximum you can reasonably expect. Have your pitch well rehearsed and do not repeat yourself.

The perfect portfolio is not a showcase for all your favorite shots. Find out the kind of photography each of your potential customers usually buys and then present no more than twenty related images. It helps if everything in your portfolio is of a uniform size. Laminated but unbound 11" × 14" prints with large white borders are striking to look at, satisfyingly substantial to the touch, and durable: They fit nicely into an attaché case, and they are easy to edit and rearrange. Print ads, program covers, or even posters can be carefully copied and reprinted to the same format. A reliable rule of thumb—show your best image last, and your second-best first. Should your work be praised, a simple "Thank you" is sufficient. If a particular photo attracts negative attention, ask why, but never, never argue. Don't overstay your welcome. When you're done, leave gracefully.

If you don't get a promise of work or a modest assignment within the next month or so, try another mailer and follow-up phone call. If your work is good, gentle persistence will eventually pay off.

The Query Letter

In this age of instant electronic communication, it is comforting to note that an effective technique for making proposals to potential clients is a letter—typically one or at most two pages long—in which a specific idea is pitched to a specific client. The best query letters are simple and effective. The format is easy to master.

Say you are interested in rock 'n' roll—what sort of client would be as interested as you? Maybe *Rolling Stone* magazine? Why not think big? A query letter is your method of entry.

Include the following elements: Say why you are writing (you want to document the next Madonna tour), what you want (an assignment, film, processing, and a letter of reference), who you are, and why you are the best choice for the job (lots of experience—you just did a feature on Elvis for the *Nashville News*). Clarity and economy of expression should determine your language—competence and clear thinking should govern the tone.

Follow up your proposal with a phone call. Be prepared to take no for an answer six or seven or even nine times out of ten. Keep writing, however, and you will soon be shooting what appeals to you on a regular basis.

Educating Your Clients

Pricing

Establishing competitive rates is awkward for performing arts photographers, since many venues are decidedly cash poor. Commercial photographers used to servicing the advertising industry will find the fees that even large organizations are willing to pay will be 50 percent or less of what they are accustomed to. Low-end work can be brutally underpaid, with many semiprofessionals eager to work on speculation or just for the experience. I mentioned that working for the cost of materials alone provides clients with an opportunity to train new photographers, but such an arrangement has to be temporary for a business to survive and prosper.

Pricing in commercial photography is flexible and depends on the size of the job and the client's perception of the reputation of the photographer. This system applies to performing arts photography that is used to sell a highly profitable entertainment commodity such as a pop star or a Broadway show. Pricing for most everything else is limited by predetermined budgets that can be exceeded only in dire

circumstances. The trick is to find out what the upper limit is for each job you undertake. There are three ways to determine what your clients can afford. One is to ask the competition what they are paid—this is possible if you are friends with other photographers or if you belong to a professional association that maintains statistics on fees and charges. The second method is to raise prices incrementally until someone protests—this is fairly reliable, if your increases are modest and justifiable. The third is to ask the client. The third option is preferable but satisfactory only after a measure of trust has been established. The best working relationship involves an understanding that, over the long run, both parties must benefit equally.

Reproduction Rights, Credits, and Contra

Some photographs have value that extends beyond their original use. The owner of the reproduction rights to those photos can profit whenever they are used for another commercial purpose. Exactly who will retain reproduction rights should be negotiated along with the other conditions of an assignment. Standard practice dictates that when a photographer surrenders all future interest in an image, the initial fee should increase—local practices and an educated guess about the likely lifespan of an image determines by how much. In the smallish market in which I work, a premium of 25 percent to 100 percent beyond the initial fee buys full reproduction rights for commercial images. More generous arrangements are common when celebrities or high-profile productions are involved, but common sense will tell you that most ordinary performing arts images, being stylistically tied to specific, transient events, are of limited commercial value beyond their original purpose.

One value that is intrinsic to all performing photographs is the fact that they are widely exposed to the public. It costs purchasers of photography virtually nothing to insure that proper credit accompanies each image that they use, yet that credit is of great value to a photographer. It is a simple truth that the more familiar your name becomes in the community in which you work, the easier it will be to make a living. A proper credit, even in very small type, should accompany every image that appears in the press, in programs, on fundraising brochures, and on posters, but this will only happen if photographers speak up and make proper credit a nonnegotiable contractual condition.

Because photographs have value, they can be traded for other things of value. When services are traded between professionals, the exchange is called a *contra*. Performing arts organizations have something they

can trade besides money—advertising space in their programs. Many companies, particularly the smaller ones, will exchange an advertisement or a series of advertisements for photographic services. Since it is inevitable that a number of the people who see the programs will be buyers of photography or will be connected in some way to those who are, a well-produced ad may attract portrait or commercial assignments.

Selling to Performers

Some people, particularly upper-class patrons who volunteer for various administrative duties in performing arts institutions, harbor some very cavalier attitudes towards ordinary working stiffs. High-minded cultural pursuits can attract a rather elitist following, so notions of cultural purity tend to get in the way of more mundane matters. A photographer's role can be seen in very narrow terms: *We pay you to shoot the shows, period.* A photographer who does not happen to be a celebrity in his or her own right is a political lightweight, so efforts to generate extra cash by direct sales to performers are occasionally frowned upon as being somewhat crass. Objections can be raised about shooting portraits in costume backstage, the posting of order forms, the prices of prints, and the collection of money.

A contrary attitude can be moderated through patient negotiation. The most successful argument in favor of unfettered access to the cast consists of the ideas that production photography is a morale booster, a career-enhancing necessity for the performers, and a professional courtesy extended to their employees by a beneficent host institution— all true, of course, but it is rather discouraging to be in a position where such ideas need to be defended. Ultimately, there is no point in banging one's head against a wall, so when the opposition proves itself to be implacable, give up the struggle in a dignified way.

Should the opportunity exist for direct sales, however, there are some simple strategies that can be used to maximize income. First, set prices that will encourage multiple sales. Several years ago, when the economic squeeze was less severe, I found that performers—particularly the young, the ambitious, and the sentimental among them— were quite happy to buy packages of ten prints for sixty or seventy dollars. Nowadays, individual prints at twelve or fifteen dollars, three prints for twenty-five dollars, or five prints for thirty-five dollars are more popular.

Don't overlook secondary markets: The proofs for any productions that involve children or teenagers, especially amateur efforts, should be posted where parents can see them. For large shows, when substantial

sales are pretty well guaranteed, it makes sense to circulate more than one set of proofs, so that ordering is less of a hassle for the performers. Similarly, in those instances where proofs are posted on a wall or bulletin board, it stimulates orders if they are large enough to be seen without a magnifying glass. Rather than 35mm contacts, use 3" × 5" prints, or gang-proofs that have been enlarged to 11" × 14" or 16" × 20" with a large-format enlarger. At a minimum, make a sample 8" × 10" blow-up of the cast picture.

All sales should be cash on delivery. If possible, have the stage manager or whoever is helping out with the orders collect the money *before* the photos are distributed. There aren't many dishonest people, but there are lots who are forgetful and some who are irresponsible. It is prudent to arrange to have the orders and cash in hand early in the run, so that finished prints can be delivered well before the show closes and any mixups can be taken care of in good time.

One final thought—a 35mm frame is not the same proportion as a standard 8" × 10" piece of photographic paper. This means either cropping the negative—and possibly losing a face or two—or unsymmetrical borders on the enlargement. I prefer the uncropped approach, but then the prints look funny unmatted in standard frames. This small but irritating dilemma can be resolved with a check-off on your order forms for print buyers to indicate their preference.

Perks and Privileges

Not all rewards are financial in nature. The performing arts offer insiders formidable perks and privileges. First to mind is the stimulating company—most everyone involved in the performing arts is worth knowing. And certainly, one cannot slight the opportunity for expanding one's consciousness—I calculate that in the last twenty years I have witnessed at least four hundred productions, most of them two or three times each. Next are *comps*, also known as complementary tickets. Anybody involved with a production in any substantial way—and happily for us, photographers are considered sufficiently substantial—is gifted with an invitation to opening night and whatever social events happen to be associated with it. Comps for later in the run are not difficult to obtain if the show has unsold seats. All theater managers long for full houses, and unpaid patrons will do when no others are available. One doesn't want to be greedy, but the occasional pair of tickets can be had for friends, family, or even clients from outside the performing arts.

Another pleasure, and one that I have shared regularly with my children, is the opportunity to witness the impressive behind-the-scenes activity. To outsiders, the rehearsal process is glamorous, mysterious, and ordinarily inaccessible. If the process is going well, many artistic directors welcome a few additional warm bodies at rehearsals, if only as a preview in miniature of what a real audience might be like. Just ask first, and don't forget to prepare your guests for a possible last-minute disinvitation at the stage door: Conditions can change quickly, and a closed rehearsal is absolutely prohibited to strangers.

Dealing with the Competition

Longevity

All the performing arts share one common characteristic—constant change. Productions and production people come and go on a regular basis. Extravagant emotions, celebrities, and elevated artistic visions flash through the public's consciousness in weeks or days or minutes, replaced again and again with staggeringly abundant offerings from who knows where. We have to assume that creativity is inexhaustible.

Ordinary humans, of course, are not inexhaustible. Artistic fulminations engender administrative upheavals. Who does what for whom is determined as much or perhaps more by the politics of the moment as by memories of competent service rendered in even the recent past. So . . . those who serve the performing arts must be prepared to see the use of their talents wax and wane with the fortunes and the whims of their clients.

Money matters are sometimes the catalyst for change; therefore, don't take existing arrangements for granted. Maintain a relaxed schedule of financial reality checks. From time to time, poll your clients and the competition to insure that your prices do not drift beyond what is realistic. Your rates will have to shift to accommodate the financial climate. You should be aware of changes in government subsidy or grant policies, of the relative success or failure of individual productions, and of the significance of seasonal deficits or surpluses. Make sure your clients know that you want to help out when times are tight, perhaps with a few free slides for a TV ad to encourage ticket sales for a poorly selling show, for example.

Maintain a simple diary of the paid and unpaid services you have provided, including letters of reference, for each performing arts

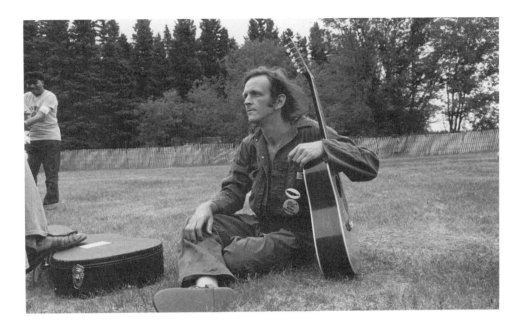

Figures 10 - 1a, 10 - 1b. Perform-
ing arts photography can be a long-
term affair. The top photo shows
young singer/songwriter Valdy
behind the scenes at the Winnipeg
Folk Festival in 1972. The photo on
the right is a studio portrait of the
mature Valdy made in 1992.
[Studio shot: Hasselblad, 150mm
lens, Fuji Reala Film. Outdoors
shot: Leica camera, 50mm lens,
Kodak Tri-X film.

organization you serve. When the person to whom you are responsible is replaced, make sure that his or her successor sees a brief but complete résumé and samples of your best work as soon as possible. Get on the telephone and offer the new person whatever help you can during the acclimatization process. No matter how big the organization, service contracts describe business relationships between individuals. In order to hire or rehire, they have to know you.

If a working relationship ends, don't be shy about immediately seeking out new work. Everyone in the industry understands that matters of competence are often superseded by other, less tangible, concerns. Always remember that your portfolio and your demeanor are your chief selling tools.

Managing Stress

With one eye on the clock and the other on the competition, photographers try to control tricky technical variables, assuage the worries of demanding clients, and make a decent living. Such potentially soul-consuming preoccupations have forced many artistically gifted people out of the marketplace. Nevertheless, lots of others do succeed in minimizing the destructive aspects of stress and carry on profitable and fulfilling careers. Fortunately, stress management can be learned.

Maintaining equilibrium in a frantic business milieu requires an ability to identify the different types of stress-inducing forces. There are two varieties—short term and long term. Each of these requires a different response.

To cope well over the long run, it is necessary to first catalog the controllable aspects of life in the photo business and then make some plans that eliminate the need for minute-by-minute review. This process is actually embedded in ordinary good management. Budgeting and planned capital expenditures, sensible marketing and advertising, honest and regular consultation with the bank, and controlled use of credit all contribute to long-term peace of mind.

Since we can only live in one moment at a time, all stress is, technically, a short-term concern. Remember not to worry. Focus your concentration on the task at hand. There is a saying in the Zen Buddhist tradition: "When walking, walk—when eating, eat—when sleeping, sleep." This can be extended to "when taking a picture, take a picture" That is to say, do only the task at hand at any given moment, but do it completely. Keep mental noise to a minimum. This can be done by consciously terminating or rejecting extraneous thoughts. A few weeks' continuous practice will turn this technique into a healthy habit.

Here is a simple but effective tip: Make detailed lists of what you have to do during the day. The list can be put together and prioritized at the end of the previous working day or first thing in the morning. New responsibilities can be added to the list as they arise. Every item should be a task that you can manage while not thinking about something else. Be hard-headed about what may be accomplished per day, and take on only that which can be properly handled with the time and resources available. What you are able to do will inevitably expand with experience, but that expansion is slowed or reversed if you insist on existing in a perpetually overextended state.

An effective coping strategy must accommodate the occasional failure, as well as the pressures associated with success. Unfortunately, there is not a lot of open discussion about failure in most business relationships. In fact, the unspoken agenda for business is the expectation of never-ending success. Goal setting and positive visualization is a growth-inducing process, but unsubstantiated expectation is not. Distinguish between those variables over which you have a degree of influence and those that are beyond your control.

The negative mantra *What if? What if? What if?* will diminish the enjoyment of the most spectacular achievements. Worry itself is both a cause and a result of burnout and boredom. The key is to recognize the symptoms of distress and attribute them to the appropriate causes. In other words, learn not to blame the messenger, but instead act on the message. Keep track of the fruits of your labors and remember to be amazed at how well most sober-minded endeavors turn out.

Interviews

David Cooper, Photographer

David Cooper is one of only a very few photographers in North America able to make a living shooting the performing arts exclusively. His unique career began some fifteen years ago when, over the opposition of his family, he abandoned the study of architecture at the University of Toronto and moved to the west coast. At an accidental meeting with some of the principals of the Vancouver Playhouse, a repertory theater, David talked his way into a very junior position in their fledgling communications department.

Cooper found the Playhouse to be animated by a vibrant counter-cultural excitement. The pleasures of photographing rehearsals and performances quickly eclipsed whatever attractions architecture had offered. Money was scarce—he earned only $95 per week—but his abilities were valued and encouraged. "It was a creative collaboration, a product of that particular time and that particular place," he told me. "Except for financial restrictions, I had total freedom to experiment . . . and lots of support."

The new association quickly blossomed into a productive enterprise. "I tried some pretty wild stuff then that I could not get away with now—like going right up on stage with the performers to shoot unusual angles."

Soon he was designing posters and newspaper ads: "I had to quickly figure out how to manage all the variables of mechanical reproduction—layout and typefaces, paper selection, printing and inks. I soon knew what was possible, what was not."

After a couple of years, David's photographic skills had become so sophisticated that he was shooting for several different performing

Figure J - 1. A picture from the Shaw Festival brochure photographed by David Cooper.

arts groups and making a decent living. Many of his colleagues at the Playhouse moved on to successful careers with other companies and are still included in Cooper's client list.

An early peak in David's development as a photographer was a substantial grant from the Canada Council for the Arts, a federally funded organization dedicated to supporting a broad spectrum of artists and arts institutions. Cooper used the money to produce an insightful black-and-white behind-the-scenes photoessay about the Royal Winnipeg Ballet. The result was a meticulously hand-printed leatherbound book. It was so well received that the RWB became a

Figure J - 2. Vancover-based performing arts photographer David
Cooper surrounded by samples of his work. Photographed by
Laine Harder.

regular client, for which he has photographically illustrated literally
dozens of fabulous posters, souvenir programs, and advertisements.

Cooper has loyal clients across Canada, such as the Shaw and
Stratford Festivals. Working with these large repertory companies
involves long photo calls, often three or four hours in length, for each
of up to ten shows. "Artistic and technical staff have to work together.
The input from lighting designers is critical," says David. "Their work
can make or break a show, visually speaking, since I can be only as

good as they are." Exhaustive documentation of a season's worth of plays over two or three weeks on location typically yields a hundred or more rolls of black-and-white and color slide film. David's shooting rates vary according to the resources of particular clients, but he is usually able to average several hundred dollars per day, plus travel expenses and materials.

Periodically work is so pressing and time is so short that Cooper must take on a helper. For big theatrical jobs, he works with an assistant, preferably someone he has carefully trained himself. They shoot as a team. Cooper stays close to the stage to capture tight groups and individual performers, while his assistant stays farther back to get wider views: "It is very satisfying to synchronize with another photographer. . . . We become attuned to the same dramatic moments, the same gestures and postures created by the performers on the stage. Often I hear our shutters click at virtually the same instant."

Cooper began working as a photographer in a highly collaborative environment, and fruitful collaboration remains a marker of his working style even now. He is becoming involved in management-level talks aimed at revitalizing photography/design/marketing strategies at several large, conservative arts institutions. "I used to be politically uptight. I would hide in a corner and leave decisions about how my work would be used to the artistic directors, the designers, or the marketing people," David revealed. "Now I feel an obligation to educate my clients to what I think is possible. I speak my mind. It is gratifying to change attitudes, to make exciting things happen."

A compelling demonstration of the potential of such an approach is the color brochure that announced the 1992 Shaw Festival season. Typically such an undertaking involves a simple listing of forthcoming plays together with suitably bumptious prose illustrated by production photos or drawings. In this case, however, the goal was to make a small gem to serve as a memorable direct-mail piece that would also fit the display racks at hotels, airports, and tourism offices. "Since the brochure was to be a catalog of the whole season's events, we wanted something that would be simply too enchanting, too beautiful to throw away," David told me.

The Shaw Festival is located in a lovely physical environment, so David suggested a series of highly stylized outdoor location photos peopled by the actual actors and artistic staff who put together the shows. He envisioned several quietly humorous, genteel tableaus brought to life with period costumes and props drawn from the inventory in storage at the Festival site. Since everyone involved knew Cooper well—Artistic Director Christopher Newton was his employer

at the Vancouver Playhouse—sufficient support for the idea was quickly gathered, and work began.

Final responsibility for the project rested with designer Scott McKowen—one of David's favorites because he is unusually imaginative and innovative in his use of photographs. Only a year or two earlier, they had worked together on an exquisitely reproduced set of theatrical postcards—now a collectors' item among theater aficionados—that mimicked the accordion-style foldouts sold at tourist attractions and national monuments.

They settled on an unusual format, a 10" × 3.5" folder that would stand out on display racks. The images themselves were to be tastefully atmospheric, slightly surrealistic photographic sketches—"scripted like little movies"—rather than literal representations of the plays. "It was a bit difficult, but great fun, to work outdoors subject to the whims of nature," David told me. "I found myself in the role of director, an exciting reversal to the disappearing act that photographers must perform when shooting theatrical events indoors."

The pictures were bled right to the edges of the paper on double-page spreads. Not only was the final product a very popular promotion, but it was an effective selling tool and has won a design award in a national competition.

Recession and budget cutbacks have cut into Cooper's business, but he has responded by expanding his services to include some in-house design work for his performing arts clients and by accepting commercial photography assignments from advertising agencies and corporate clients. According to David, "all those years of studying the clever techniques of accomplished theater directors" help him bring a distinctive style to a highly competitive field.

Robert Enright, Magazine Editor

His staccato speech and inquisitive stare offer a couple of obvious clues to Robert Enright's active and passionate intelligence. He is a radio and TV journalist for the Canadian Broadcasting Corporation, but I sought him out because he is also the longtime editor of *Border Crossings*, an internationally acclaimed magazine dedicated to the arts. Today all magazines depend on striking photographs for visual impact and editorial support, but *Border Crossings* is of special interest here because of its particular focus. The performing arts are well covered by commissioned photographs, by selected promotional and archival pictures from performing arts companies and individual

artists, and by insightful images created by photographer-artists with a personal or professional interest in the subject.

Robert and I began our conversation over a recent issue of his magazine that featured two very pleasing photographic portfolios. The color work of David MacMillan, professor and head of photography at the Faculty of Fine Arts, University of Manitoba, was represented by his documentation of a performance of the Royal Winnipeg Ballet's prima ballerina Evelyn Hart in Paris, France. Sheila Spence, by day staff photographer for the Winnipeg Art Gallery, was represented by her intimate black-and-white behind-the-scenes glimpses at the RWB company in rehearsal. "Just look at this wonderful work," declared Enright. "These underfunded, underappreciated photographers are creating a fragile archive of our culture. Where is the government support? Where is the private money to pay for all this effort? When the performers and the buildings are long gone, virtually all we will have left are collections of photographs."

Enright finds it very frustrating, almost criminal, that photographs of the performing arts are created mostly as promotional after-thoughts: "Eventually we will find ourselves in need of the stories these photographers can tell, but the stories will be incomplete because of our current shortsightedness."

Every issue of *Border Crossings*, despite ongoing funding limita-tions, presents photographs that explore those aspects of both the fine arts and the performing arts that Enright feels are important. "It's an obligation, a responsibility. . . . I wish we had more space, more money for higher fees and better printing," he laments. "We take some consolation in the knowledge that people at least keep the magazines around—the work is seen and discussed, occasionally even treasured."

How does Enright, constantly exposed to art of all kinds, evaluate photographs? "It's an instinctive, intuitive reaction," he says. "I find certain pictures so immediate, so insistent, that they can't be ignored. Not necessarily flashy, mind you. But really strong, both graphically and contextually." Where does he find the photographers? "They find us. Many accomplished people are looking for a vehicle for their work, some kind of conduit to the public."

I asked Enright about the responsibilities of performing arts insti-tutions toward photographers and photography. Reluctantly he admits that images with marketing appeal—lots of glitz, glamour, and melo-drama—are, in fact, required to do a certain job: "Everything must be overstated to survive in a newspaper or on a poster that is viewed in passing for only a second or two. Even so, some companies manage to retain a measure of dignity and power in their public relations efforts. Geoff Hayes's and Paul Martens's work for the RWB and the Winnipeg

Contemporary dancers stands out, for example. Still, I question whether or not the marketing directors who commission such work feel any responsibility as cultural historians."

I asked Robert if photographic standards were declining. He answered with the paradoxical insight that "It's actually a mad rush in both directions. Photographic materials are improving rapidly, so now marvelous images can be made under conditions that would have been impossible to deal with even a couple of years ago. The sad thing is that budgets for inspired, noncommercial work are minuscule. We can pay only twenty-five or fifty dollars for each of the images we publish—hardly enough to cover the cost of the materials. People just can't live on that kind of money, so some very good photographers simply fade away. We're seeing smaller performing arts companies cutting spending on photography entirely—they have to rely on newspaper photographers or dedicated amateurs."

Enright feels that a healthy future for excellent performing arts photography depends on government culture and heritage departments. "They have to recognize the value of the work and support it with direct funding to individual photographers or special grants to performing arts companies whose efforts are worth documenting." With a sigh, he admits such action by government is "highly unlikely, considering the current right-wing, anti-art political agenda."

Despite hard times, *Border Crossings* boldly carries on. A final comment from the editor: "I think it's fair to say that we depend on photographers as much as they depend on us."

Geoff Hayes, Designer and Marketing Director
Paul Martens, Photographer

Geoff Hayes first distinguished himself as an award-winning graphic artist and designer during his thirteen years with the Royal Winnipeg Ballet. Then he was persuaded to move to the Winnipeg Symphony Orchestra to become the first staff designer the WSO had ever employed and part of the aggressive marketing team that would help eliminate the company's long-term deficit. His imagination and drive were recognized a couple of years later when he was offered the position of marketing director: He accepted the job on condition that he would retain responsibility for design.

Paul Martens is a commercial photographer who was drawn into shooting the performing arts by Geoff Hayes. Nine years ago, just out of technical school, Martens turned up at the RWB to show his portfolio of photographs—soon a working partnership evolved that has produced

Figure J - 3. Designer/marketing director Geoff Hayes (left) and photographer Paul Martens study a Polaroid test shot on location in the lobby of the Winnipeg Centennial Concert Hall. [Hasselblad camera, 60mm lens, Kodak T-Max film.]

delightful posters, program covers, and newspaper ads for the RWB, the WSO, the Winnipeg Dance Collective, and others.

When I spoke to them at the Manitoba Centennial Concert Hall, the home of the Symphony, they were in the lobby very casually photographing a brand new Lexus automobile, the prize in a fund-raising lottery. After a few playfully deprecating remarks about the inevitability of such worldly activities, we spoke about the nature of performing arts photography and its status in the world of culture.

Geoff's work is almost always based on strong photography. I asked him why this is so. "First of all, I love looking at photographs

and handling photographs—when produced by a skilled photographer, they can be delightful artifacts, valuable art objects in themselves," he told me. "Second, photographs can tell a story with a depth and a level of detail that is rarely achieved by illustration." Hayes does not believe this elevated state to be uniformly typical of contemporary performing arts photography: "It requires a sensitive, experienced photographer and the cooperation of the performers, technicians, and the administration. That means patience and stamina all around, plus sufficient financial resources—a difficult combination to achieve."

I asked Martens why he thought his collaboration with Geoff Hayes was so productive. He replied, "He appreciates the work and understands the effort that goes into it. He acts like a diplomat, educating those who need the photographs to the needs of the photographer."

Because Paul is very active as a commercial photographer, I asked him how he deals with the restricted budgets for performing arts work: "It's a labor of love and an enjoyable diversion from the pressure of the commercial world. I have to account for my expenses and my time, of course, but I go into it without the expectation of making bags of money. It's almost a civic duty."

Hayes is a master of the art of the poster, and some of his most effective designs are built around a single photograph. I asked whether he directed Paul to aim for a particular image or whether the design came after a photograph was captured on film. "It differs according to the venue and the circumstances of the shoot," Geoff told me. "In photography of the ballet, several people—the dancers themselves, the choreographer, the public relations director—all have direct input, even veto power. Photo sessions are carefully managed so that the photographer can concentrate on capturing certain preselected moments. The technical perfection of the dancer's pose in the photo is the deciding factor."

"That is true of formal photo calls, but rehearsal shoots are a much more stream-of-consciousness thing," added Paul.

"It's a matter of anticipation, quick reflexes, and editing," Geoff continued. "We have the same situation with classical musicians in performance as opposed to in the studio. Some photos are found objects, moments captured in flight, so to speak. In the studio, with a cooperative artist, we can work more directly to match a layout."

"Cooperative is the key word," remarked Paul. "It always amazes me how uptight some otherwise perfectly professional performers can become in front of the still camera. It's as if an audience of one is more intimidating than an audience of hundreds or thousands."

Geoff agreed with this observation and added, "This problem creates an argument for the development of a long, continuous relationship

Figure J - 4. Photographer Rob Barrow and movie producer Vonnie Von Helmolt. [Minolta 9xi, 28-85 AF zoom lens, Kodak Ektar 100, flash.]

between a competent photographer and a performing arts group—familiarity and the sort of mutual respect that grows over time inevitably result in a more relaxed working environment for everyone concerned."

What is the cultural value of performing arts photography? Geoff responded with a story. "In this digitized world, photographs alone remain authentic, even precious records of the past. I vividly remember a picture taken by Bruce Monk, a dance instructor at the RWB. It showed the late Henny Jurriens, former RWB artistic director/choreographer, with prima ballerina Evelyn Hart. They were sitting on the floor in a rehearsal hall, face to face. Henny was gesturing delicately with his hands, obviously trying to explain some complicated choreographic problem—Evelyn was leaning forward, a look of puzzlement and concentration on her face. It was an intimate, tender, fleeting moment, and only a perfectly timed photograph could have captured it. In the future, people will look at such photographs and know in their guts that that's what it was really like, virtual reality and electronic imaging notwithstanding."

Vonnie Von Helmolt, Feature Film Producer
Robert Barrow, Feature Film Still Photographer

Winnipeg, Manitoba, is a popular place for feature film production. Since it is located precisely at the geographical center of North America, access from the east or west coast is easy. The city encompasses a wide variety of interesting architecture ranging from turn-of-the-century heritage office buildings and Victorian-style homes, through industrial structures of all vintages, to typical middle-America-type suburbs and shopping malls. Weather, too, is amazingly varied, and many productions parachute in just for the winter snow. Nearby geographical features like wide prairies, rolling hills, and large fresh-water lakes bordered by white-sand beaches are attractive to film producers, as well. The resident technical people, having been well trained at the

Figure J - 5. A Rob Barrow movie still, from *Black Ice*, produced by Vonnie Von Helmolt. The actor is Michael Ironside.

many performing arts venues in town, are highly skilled, enthusiastic, and very versatile.

Vonnie Von Helmolt and Rob Barrow have worked together on many cinematic ventures during the past several years. Helmolt is a producer with a reputation for careful management and consistently fair relations with the crews she assembles for directors from across the continent. She has a cheerful, direct manner and a no-nonsense attitude toward the crises that inevitably arise whenever movies are being shot on location. Barrow is a soft-spoken man with the much-sought-after ability to gracefully dodge and weave through the complex maze of equipment and people always associated with filmmaking. Technical competence and the finely honed instincts of a street shooter allow him to extract compelling still shots from the terrifically varied cinematic events he is paid to photograph.

I asked Vonnie and Rob to tell me about the significance of still photographs to the movie business. "An essential selling tool, first and foremost," replied Von Helmolt. "The success or failure of a feature film depends on marketing and distribution. Exciting stills are absolutely necessary, since they are a quick connection with the ticket-buying public."

"That's what I keep in mind when I'm shooting," added Barrow, "but there are secondary applications of nearly equal importance. Actors, designers, even directors, need photographs as permanent records of what they have done and as promotional tools for the development of their continuing careers. So I have a certain responsibility to them as well."

I wanted to know specifically how photographs from movies were used. Vonnie told me that multiple copies of eye-catching color and black-and-white photos are routinely included in the press kits sent out to theaters and to radio, TV, and newspaper movie reviewers. Photos play a very important role in selling films to distributors and audiences to markets outside of North America. Similarly, "Finding financing for future film projects is much easier when I have high-quality photographs of successful films to show to potential investors," Helmolt says.

Rob regularly sees his work incorporated in posters, billboards, lobby displays, and newspaper advertising as well as on invitations to celebrity screenings and on the covers of videos for sale or rent. "The technical quality of stills for film promotion—reproducibility—is paramount. This means grain, contrast, and image detail must always be carefully controlled." How is this accomplished? "By not pushing films chemically unless absolutely necessary and by using a tripod or monopod whenever light levels sink below hand holdable levels. Low light

on film sets is very common, a constant problem indoors particularly, since cinematographers just do not require the same technical conditions as still photographers." Do directors or lighting designers make changes to accommodate still photography? "Very, very rarely," says Robert. "Shooting schedules on big films are too short for that kind of consideration. Just finding a place to stand is difficult enough." What about the mechanics of shooting? "Some photographers use sound-deadening blimps and try to shoot during actual filming, but I would rather not risk interfering with the filmmakers, so I photograph the action during snatches of rehearsal or in very short setups between takes. Sometimes actors are released for photo sessions off the set so I can do my own lighting with portable flash."

Both Robert and Vonnie made interesting observations about shooting etiquette and on-set politics. "The director is king during filmmaking, and different directors have different attitudes toward still photography," Helmolt told me. "Egos vary, and the atmosphere during filming changes according to how well the shoot is going relative to time and budget. Sometimes the still photographer is treated as an intruder. It depends on whether the director and the photographer have worked together before, how the photographer handles him- or herself, what the mix of personalities on the set happens to be. Sometimes the creative types are in conflict with the bean-counters and the marketing types—this can put still photographers in awkward positions through no fault of their own."

According to Robert, "Film sets are often tense. A lot of money is at stake. I try to be diplomatic and discreet. In theater situations, the photographer and the actors are physically separated, but in movies everyone has to more or less live together. You have to learn to get along with people under a variety of circumstances."

I figured such a high-pressure industry might be closed to beginners, but both Vonnie and Robert were quite certain this need not be the case. "In any city there are film students making movies, low-budget commercial TV projects, and experimental or institutional films in production—most would welcome a photographer with some energy and ambition who will work for the cost of film and processing or just for the experience," said Von Helmolt.

"That's more or less how I started," explained Barrow. "For my own interest I began by doing location and character identification photographs in advance of proposed documentary films for the Winnipeg office of the National Film Board of Canada. Doing this, I met people in the industry and was soon invited to work on more commercial feature film projects that happened to be using Manitoba locations. Now I am quite busy and even fairly well paid."

Robert says that still photographers working on films are paid day rates somewhat lower than commercial photographers in the advertising industry. Big-budget productions with New York or Los Angeles producers will sometimes pay $800, $1,000, or even $1,500 for a day's work, but more modest projects can afford only half those rates or even less. "You generally don't get paid residuals for photographs that have many uses," Robert told me. "Film promoters don't think in those terms. However, I often make very decent money from multiple-print orders."

A typical film assignment might occupy several days in a row, but just as likely the photographer is on call and must appear to shoot certain critical scenes whenever they happen to occur within a complicated shooting schedule. Long standby periods during seemingly endless retakes or bad weather are not uncommon. Flexibility and patience are basic requirements. Robert has a day job as the in-house photographer for the Manitoba Museum of Man and Nature—happily his employers are very relaxed about him disappearing for days at a time when a production company is in town.

Feature film still photography could seem tedious work under the exacting conditions described above, but Robert doesn't see it that way: "It's almost always exciting. I find the personalities of the other professionals involved to be very stimulating. The location work is great fun!"

Von Helmolt agrees: "A truly professional still photographer can be very much appreciated. When the director, the actors, and the crew all understand how important good still photos are to their own success, then the photographer is welcomed and supported."

Max Tapper, Performing Arts Manager

Max Tapper was one of the first people to buy my performing arts photographs: We worked together back in the early seventies when Max gave up professional acting to become communications director at the Manitoba Theater Center, a large regional theater with two stages and a two-million-dollar budget. After several years at MTC, Max was conscripted as director of development at the internationally renowned Royal Winnipeg Ballet. His fund-raising skills garnered significant corporate support and prepared the way for the construction of the architecturally unique building that now houses the RWB's administrative offices, rehearsal halls, and school of dance. From the Ballet, Tapper was appointed executive director of the Winnipeg Symphony Orchestra, where his business skills resulted in the elimination

Figure J - 6. Winnipeg Symphony general manager Max Tapper and artistic director Bramwell Tovy during a rehearsal at the Winnipeg Centennial Concert Hall. [Hasselblad, 60mm lens, Kodak VPS film, mixed flash and available light.]

of a stubborn six-figure deficit, making the WSO the only orchestra in Canada that is now operating in the black.

I talked to Tapper in the green room at the Winnipeg Centennial Concert Hall during a WSO rehearsal—one of the last Max would attend, since he had just accepted an offer to take over as managing director of the Toronto Symphony.

What makes Max Tapper a very authoritative commentator on the present state of performing arts photography is his hands-on management style—he becomes involved in all operational aspects of the cultural institutions in his charge, and he takes a very serious interest in marketing and promotion. When I asked him about the reasons for

his personal involvement in marketing, he responded: "It's simply a sign of the times. Professional performing arts companies no longer survive at the whim of the wealthy or on the generosity of governments, so they have to compete in the wider entertainment marketplace. They have to be sold in clever and innovative ways." In this context, Tapper says that excellent performing arts photography "is a necessity and possibly the most direct and effective element in the promoter's arsenal."

As I mentioned, Tapper's career in performing arts management began as head of the public relations/communications department of a large theater. In this position he supervised advertising campaigns, selected artwork for posters and programs, and commissioned photographs for documentary, editorial, and marketing purposes. Although he had no formal graphic arts or design training, by trial and error and by seeking good advice he developed specific criteria for evaluating performing arts photography. "I relied on my intuitive responses to the work, on audience and editorial reaction to posters, ads, and lobby displays. I used professional graphic designers and bought the best printing I could afford for promotional materials."

When I asked Max what he considered to be the most important characteristic for a photographer of the performing arts, he startled me with the following response: "I believe it is the ability to become invisible. I have watched you, Gerry, virtually disappear while shooting a dress rehearsal at MTC." At six feet and 240 pounds, I am not an easy guy to miss, so I pressed Max for an explanation: "I believe invisibility results from a happy combination of technical skill with an instinctive ability to almost psychically merge with the action on stage. It's magic. The actors, the director, and the technical crew become aware that the photographer is working in total harmony with the performance, so for them he just disappears. When this happens, the photographs come alive—the photographs themselves become art."

Max listed other desirable characteristics he looks for—patience, diplomacy, and the ability to collaborate rather than compete with overstressed performers are all fundamental. Absolute reliability under tight deadlines and a respect for budgetary constraints are also critical.

Where does photography rank when scarce budgets are being allocated? Tapper answered by saying, "The WSO deficit was eliminated partly because I increased spending on things like photography. I raised eyebrows among board members by hiring a full-time graphic artist and then supported him in his imaginative use of photographs as basic elements in posters, programs, and advertising." How are photographers' fees determined? "I try to pay according to existing standards for commercial work, taking into account the reputation of

the photographer and the very real limitations under which performing arts companies must function today. I find that if their photography is respected and well presented, many top-notch professionals will work for significantly lower than their normal rates. I am not shy about asking, either."

Max is definitely not shy. In fact, I know him to be quite aggressive in pursuing the dual goals of excellence and financial stability for those performing arts companies he becomes involved with. In judging a photographer's performance, Max is very clear: "Photographs must be technically excellent, they must faithfully capture the mood and spirit of the performance, and they must be delivered on time and on budget. . . . That's not so difficult, is it?" He then went on to answer his own rhetorical question by saying that, in the case of symphony orchestras, the opportunities for interesting photographs are limited. "Classical musicians are, frankly, rather boring to look at—they all have to dress more or less the same, and except for the conductor, they don't move around much. The problem is compounded by the predictable publicity stills provided by the guest artists and conductors who come in from out of town. That's why we have tried, at least in the last couple of years, to photograph our own players away from the stage in studio situations with more interesting lighting and uncluttered backgrounds. We have also experimented successfully with still-life setups of instruments and other musical paraphernalia."

I asked Max to whom he thinks performing arts photographers are accountable. He replied instantly, "If I am paying them, they are accountable to me." Does he argue with performers, marketing directors, or designers about the merits of a particular photograph or the skills of particular photographers? "Performing arts institutions in big cities can become as complex as big commercial corporations. Responsibilities have to be delegated so that competent specialists can take care of specialized tasks. Nevertheless, I believe that marketing is critical, and good photography is indispensable for effective marketing. So, yes, I do insist on seeing what pictures are being considered for every printed piece that the public will see. And yes, I do put my two cents in—tactfully, of course. This is not necessarily standard practice for general managers throughout the industry, however."

Having just heard a description of his very strict regimen of quality and spending control in the production of promotional materials, I was curious to learn what Tapper believes aspiring photographers can expect when looking for work. "It is true that budgets are tight and standards are high. But newcomers should be encouraged by this state of affairs simply because in difficult times good managers will never discount the possibility of discovering and exploiting new talent.

Financial restraint makes many organizations receptive to offers from photographers with an interesting portfolio who are willing to shoot for the cost of materials or for a credit line. Sensitivity and flair are always scarce commodities, but beginners should acquire experience by first working in less pressurized venues such as amateur theater. They must develop both a personal style and some confidence. Photographers need to be sure of themselves—there are some very big egos in this business."

Bill Williams, Lighting Designer

Just over two hundred theatrical lighting experts work in all of Canada and the United States—virtually all of them are freelancers. Europe supports a proportionately larger number of designers, most of whom are tenured employees of various state agencies for the performing arts.

Figure J - 7. This is Bill Williams, lighting designer, surrounded by racks filled with the tools of his trade. [Nikon F3 camera, 35mm lens, Ilford FP4 film.]

During fifteen years as a freelance lighting designer, Bill Williams has lit over five hundred productions of theater, opera, dance, music, television, and large-scale special events. His career began with high-school plays. He went on to study at the New York Institute of Photography and the Lester Polakov Institute of Stage Design and now regularly travels the world from his base in Winnipeg. When I interviewed him around Christmas 1991, he was home on holiday from a yearlong assignment as technical director of *Produccions Arco Iris*—the European firm in charge of forty multimillion-dollar exhibits and pavilions at Expo '92 in Seville, Spain. His rich experience with the performing arts combined with his training in photography make his advice to photographers particularly useful.

Bill says that "Both effective stage lighting and effective stage photography require that concerned professionals make a constant effort to *see*, rather than just *look*." By this he means that one's perceptions of the visual world should not be based on casual observations of surfaces and shapes—instead, those who create and record powerful images must be ardent students of the infinite manifestations of light. In the special case of photography for the performing arts, lighting designers and photographers "must work together as colleagues, respectful of the tools and limitations of their respective technologies."

Since he regards excellent photography as fundamental to the survival of the performing arts, Bill was very generous with his hard-earned knowledge. By way of practical advice, he first spoke about a designer's structural/procedural involvement in professional live theater, and later he made several cogent suggestions on how photographers best fit within that process.

"The designer's work begins with a phone call from the director—usually several months before a work is to be staged. The director's choice is the result of a subtle evaluation of the designer's working style and past experience. The first conversation should result in preliminary agreement about artistic approach—disagreement at this early stage sometimes leads to a split. However, if things proceed harmoniously, a copy of the text will be forwarded for the designer to study in detail." At this point, sketches and working drawings are exchanged among the artistic director, the lighting designer, the costume designer, and the technical producer. Three or four weeks before opening, everyone involved in the production (designers, performers, director, technical people, and sometimes the author) more or less take up residence at the theater. For the lighting designer, this is the beginning of an intense period of hands-on work—the setup and fine-tuning of dozens of specialized theatrical lighting instruments.

"Lighting really large shows might require up to 500 hours of work with over a thousand fixtures, but the typical regional theater production involves about 200 lights and 150 hours for design and setup," Williams says. Designers' fees range from $500 to $5,000. By the time a production reaches the point of final dress rehearsals, the whole company has coalesced into a very close-knit family: Paradoxically, this condition is good for the production but sometimes not so good for the photographer who is to document the show. This is because the photographer is usually called in for the last dress rehearsal before opening night—a time when the theater family is at the height of their working intimacy and, simultaneously, at the height of opening-night anxiety. According to Bill, "The electronic media, newspaper reviewers, or photographers—in fact, anyone who has not been involved in the rehearsal process from the very beginning—is quite naturally viewed as an outsider and possibly hostile."

Photographers have something of an advantage over reviewers and the media in that they usually are working for the theater, at least on a freelance basis. Williams advises that this slight edge be augmented by a simple strategy combining anticipation, preparation, and cooperation. He says, "Even though theater photography is typically a last-minute affair, it is possible to anticipate the rush and involve oneself earlier on. Almost any professional lighting designer would be more than willing to spend some time discussing the technical nuances of the show, if only to satisfy his own need for excellent pictures of what is, after all, a very transient art form."

More good advice: "Photographers should ask the lighting, set, and costume designers individually what they want avoided and what they want included in the pictures." Bill emphasizes, as well, that the photographer should definitely watch a run-through in advance of the photo call—this is a good opportunity to discuss the upcoming shoot with the director and stage manager. "Photographers should be tactful but fairly bold in these discussions—most lighting designers are willing to make some accommodations for the differences in response between photographic film and the human eye, provided that the needs of the photographer are clearly stated in a diplomatic way." In fact, conventional contracts between theaters and designers state that the designer must attend photo calls and help expedite the proceedings. "The critical factor is time," Bill believes. "If everything is moving on schedule, then adjustments to the lighting will usually be made willingly. If the show has been delayed by technical or artistic problems, however, everyone will be less flexible."

According to Williams, "A photo call involving, say, twelve predetermined shots requires about an hour if the lighting designer is to

reset the lights to advantage for each scene: A cooperative, competent lighting designer will insure that luminance levels on faces, props, and sets (as well as special effects) are balanced for good photography." Since they share an understanding of the technical problems involved in performing arts photography, Williams has seen designers sometimes "actually act as advocates for photographers in high-pressure situations."

Regarding esthetic matters, Bill reminds photographers that lighting designers are critically interested in the intensity, color, and direction of light, just as they are—but designers also have an interest in two additional qualities specific to theatrical situations—namely, movement and distribution. "By definition, still photography is in conflict with movement of any kind, so special study is required to cope with the way lights can be made to shift and slide around the stage. Distribution is an important factor to consider because a theater stage is very big compared to a typical photographic studio or tabletop setup and because so many light sources are used. Some productions require many localized areas of different light levels and qualities, while some need broad, more consistent washes of light." Obviously, some thought is required before photography can commence.

Williams says that lighting designers love to talk about their work—but he encourages photographers to talk to designers early in the rehearsal process for best results.

Steve Rosenberg, Graphic Designer

Steve Rosenberg is an award-winning designer and a specialist in the creation of promotional print materials for performing arts institutions. I asked him how he decides when to use illustration and when to use photography. He follows a simple rule: "Whenever a design concept requires reality to be molded or exaggerated, illustration is best. Whenever a powerful and believable portrayal of some condition of real life is required, photography is best. If a designer finds him- or herself in need of a photograph as a reference before starting an illustration, likely a well-produced photo should be used instead."

Photography and illustration each evoke a different family of moods, according to Steve. "Illustration," he says, "is naturally lighter. What might be painful or ugly in a photo can be exploited as irony or as satire—a caricature, rather than a portrait, for example. Photography, on the other hand, has a capacity to convey darker, more serious overtones, since viewers more easily identify with people or situations that look real."

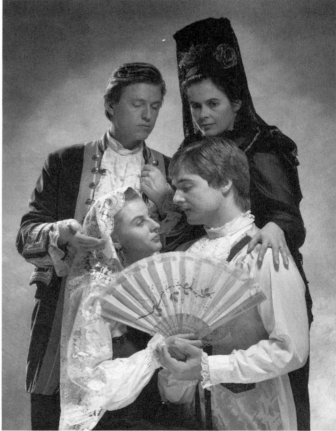

Figures J - 8a, J - 8b. Left photo: Doowah Design's original sketch of the Manitoba Opera Association's poster for *The Marriage of Figaro*. Bottom photo: The original photo.

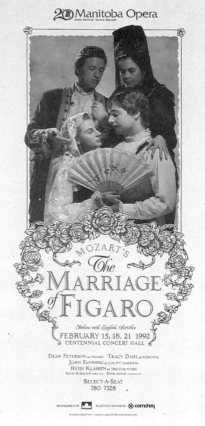

Figures J - 8c, J - 8d. Top photo: Designers Steve Rosenberg and Margaret Kampff, publication relations director Jeanne Dubberly, and the four actors. Note the studio lighting setup—a small softbox above, hard back light, and a large white reflector, which is supported by Margaret's left hand. The chrome boom stand has been draped with black cloth to eliminate reflections. Right photo: The final poster.

I asked Steve how he decides which photographer to choose for a particular job. He has found that temperament and abilities vary, and he prefers to call on certain individuals to shoot inanimate objects and others to shoot people. He knows photographers who work best in a highly controlled environment and others who can reliably capture the spontaneous and the unexpected on the fly: "I respect photographers who can actually see the perfect moment as it unfolds, as opposed to those who edit the random output of a motor-driven camera." Equipment, location, format, rates, and delivery time also factor into the choice. According to Steve, anyone who wants to do high-level work must be a resourceful problem solver and mechanically handy, since theatrical props and backgrounds are fabricated from a phenomenal range of materials. Unfortunately, the graphic artist's preferences might be overlooked on those not-so-rare occasions when "a designer and a photographer are pitched together by an insistent client."

On a practical level, Steve prefers to develop a concept before making a preliminary proposal/presentation to the client. Then production values and an appropriate photographic approach are discussed. Shrinking budgets now demand that two or three quotes be obtained; then a photographer is selected and invited into the final planning. Steve never works on speculation and does not expect photographers to do so, either. Fees are negotiated to suit the complexity of the job, the budget, and the expectations of the photographer.

On an esthetic level, Steve starts with the idea that a theatrical poster or advertisement is, fundamentally, an announcement: "In five seconds or less, it must convey the essence of the performance and call up an emotional response which echoes what will happen on stage." For maximum impact, Steve prefers to build his designs around a single, powerful image for all materials—poster, newspaper ads, program cover, bus cards, billboards, TV, and handbills—promoting a particular event.Fees are negotiated to suit the complexity of the job, the budget, and the expetations of the photographer.

Beyond commercial applications, Steve sees theatrical art as an important element of urban culture and feels an obligation to create designs that will enhance and sustain a vibrant quality of life. He relishes the opportunity to work on a poster that will be well produced and distributed—he calls posters "designer's drugs." Although all photography is rooted in reality, Steve believes it is the joint duty of photographer and designer to transcend the literal through wit and style and the imaginative or unexpected juxtaposition of otherwise familiar visual elements.

Figure J - 9. Communications director Pat Elsworth and artistic director Michael Springate, Prairie Theater Exchange, Winnipeg. [Minolta 9xi, 28-85 AF zoom lens, Kodak Ektar 100, flash.]

Pat Elsworth, Communications Director
Prairie Theater Exchange
Michael Springate, Artistic Director
Prairie Theater Exchange

I asked Pat and Michael to distinguish between the photographs they chose to send to the newspaper and those they retained for other, less commercial purposes. The discussion centered around a series of photographs of *Dog and Crow*, a provocative play directed by Michael about Ezra Pound's involvement with the fascists in Italy during World War II.

Springate had specifically requested I take some "more abstract and emotional" pictures, in addition to the usual documentary and public relations variety. The request resulted in extra expenses for film

and processing, but the results were worth it. Michael laughed out loud on seeing the two piles of images, knowing full well that the ones he preferred could never be used for ordinary public relations purposes.

"There are no fixed moments in theater," says Springate, "only transitions. But capturing the essence of transition is more difficult than grabbing a couple of heads close together for the paper. The photographs I like preserve the spirit of the show, its design, and its purpose."

"We serve two purposes," says Pat, "and we have to limit our esthetic choices to get coverage in the press. Photos for the newspaper have to show an obvious relationship between two or more people. The characters must be close together and fairly large. The prints must be sharp and clear." She says that shooting during a full dress rehearsal is best because it is easier to extract a full range of emotions. "The newspapers are visual illiterates," Michael laments. "Their choices are either too pretentious and artsy or too predictable. But we are always happy to get something published, and I do see some improvement."

"We don't want people to think of a play in terms of faces; we want to create a sculptural, layered presence, something with depth and bite. . . . Unfortunately, fractured, changing light and shifting focus don't reproduce well," says Michael. "A play is a set of complex concerns, and we try to get audiences to identify with a 'thickness of associations.' Unless special care is taken, photos tend to work against this idea and flatten things out." Pat says that the media are fixated on stars—they want conflict and personality rather than texture or mystery. "On the plus side," adds Michael, "good photos can break traditional linear cognitive patterns, moving people away from a dependence on plot and narrative toward contemplation of the underlying moral issues."

According to Pat, photographers cannot expect a lot of time to do all this. "Deadlines are always tight."

"Even so," Michael concludes, "we expect a photographer to have an independent voice, to show us something new about our work."

Index